tips, inspiration and instruction in all mediums

How did you paint that?

100 ways to paint
LANDSCAPES
VOLUME 1

international
artist

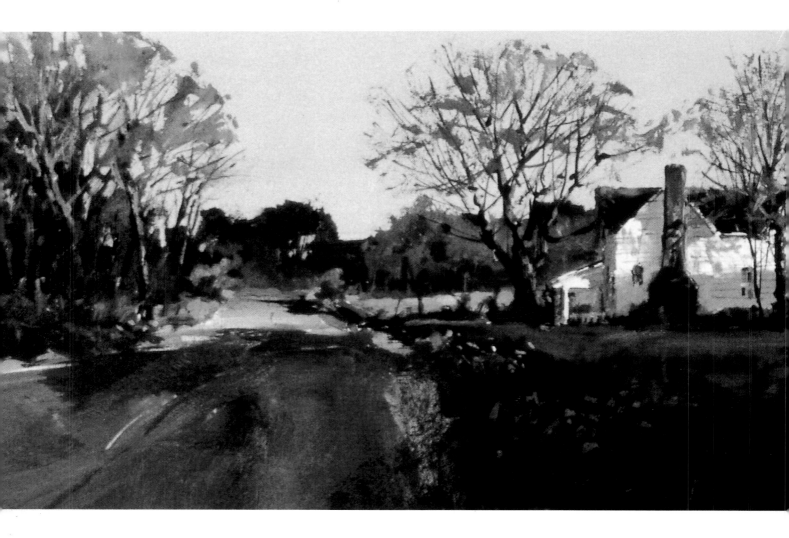

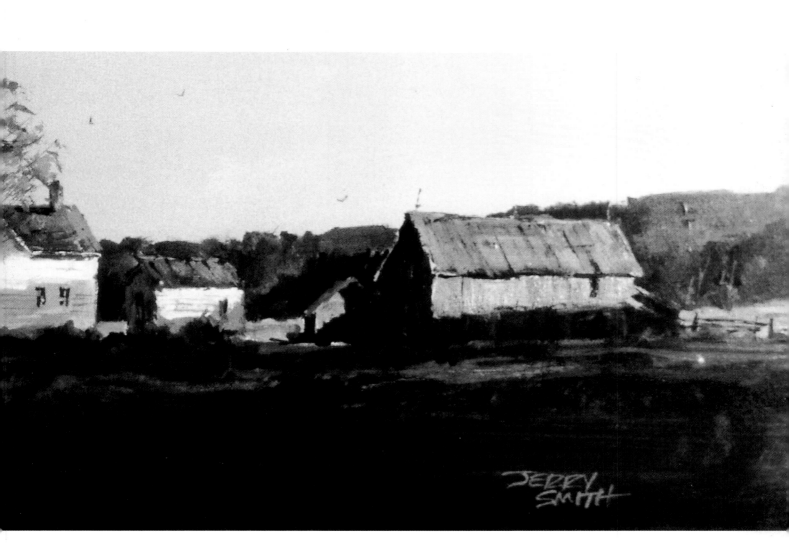

tips, inspiration and instruction in all mediums

How did you paint that?

100 ways to paint
LANDSCAPES

VOLUME 1

international
artist

international
artist

International Artist Publishing, Inc
2775 Old Highway 40
P.O. Box 1450
Verdi, Nevada 89439

Website: www.internationalartist.com

© International Artist 2004

Edited by Terri Dodd and Jennifer King
Designed by Vincent Miller
Typeset by Ilse Holloway, Lisa Rowsell and Cara Herald
Editorial Assistance by Dianne Miller

ISBN 1-929834-41-1

Printed in Hong Kong
First printed in hardcover 2004
08 07 06 05 04 6 5 4 3 2 1

Distributed to the trade and art markets in North America by:
North Light Books, an imprint of
F&W Publications, Inc
4700 East Galbraith Road
Cincinnati, OH 45236
(800) 289-0963

Oil
3, 4, 5, 8, 9, 10, 11, 13, 17, 18, 19, 20, 21, 25, 29, 30, 31, 32, 33, 37, 38, 39, 40, 43, 48, 49, 51, 52, 54, 55, 56, 59, 62, 63, 66, 67, 69, 70, 71, 72, 73, 75, 78, 79, 81, 83, 88, 89, 90, 91, 92, 93, 94, 97, 98

Watercolor
2, 7, 12, 22, 23, 26, 27, 28, 46, 47, 58, 60, 61, 64, 65, 74, 77, 80, 82, 84, 86, 96, 100

Acrylic
1, 6, 14, 15, 35, 44, 45, 53, 57, 76

Pastel
16, 34, 36, 41, 42, 50, 68, 85, 87, 95, 99

Gouache
24

Acknowledgments

International Artist Publishing Inc. would like to thank the master artists whose generosity of spirit made this book possible.

Linda R. Abbott **62**
Evelyn S. Albanese 4
V. H. Alexander 7
Elizabeth Allen **94**
Georges Artaud 2
John Atkinson 14
Patti MacHale Bartol **64**
Nancy Bass **63**
Anthony J. Batten 10
Kathleen Bergstrom 24
Darrell Berry 13
Larry Blovits **68**
Candice Bohannon 3
Keith Bowen 8
Ginger Bowen 18
Janet Broussard **30**
Roger Dale Brown 89
Kevin Brunner 88
Pris Buttler **48**
Annie Chemin **100**
Bethanne K Cople **49**
Andrew Dibben 28
Sy Ellens 6
Pamela Erickson **46**
Rob Evison 87
Cynthia Eyton **45**
Xinlin Fan **44**
Mark Farina **91**
Susan Flanagan 16
Richard French **35**
Claudette Gamache **34**
Lynn Gertenbach **33**
Michael Gibbons **20**
Gilbert Gorski **32**
Dick Green **61**
Chari Grenfell 5
William Grinnell **66**
Peter Haynes **23**
Ron Hazell **65**
Karen Hennessy 11
Steven Hileman **67**
Shu-Ping Hsieh 17
Keith Alan Huey **51**
John Hulsey **60**
Bill James **59**
Nancy Davis Johnson **58**
Virginia Jonynas 57
Kristina Jurick **47**
Mostafa Keyhani 26
Barry Kooser **56**

Mark Lagüe **55**
Lilianne Laurin **54**
Christopher Leeper **53**
Madeleine Lemire **52**
Deanne Lemley **43**
Scott Leonard **40**
Marge Levine **41**
Suzi Marquess Long **99**
Cheryl Lynch 19
Jerry Markham **98**
D. Matzen 21
Ann McEachron **74**
Lee H McVey **95**
Don Nagel **42**
Barbara Benedetti Newton **36**
Rosemary Nothwanger **22**
Barbara Nuss **37**
Juan Peña **96**
Don Pierson **38**
J. Richard Plincke **27**
Julie Gilbert Pollard **77**
John Pototschnik **39**
Julio Pro **92**
Richard H Probert **31**
Vaneerat Ratanatharathorn **29**
Joan Reeves 80
Jolanda Richter **90**
Ken Samuelson 12
Sheila Savannah **69**
Howard Scherer **50**
Grace Charlotte Schlesier **70**
Betty Schmidt **71**
William Schneider **72**
Michael Schoenig **73**
Rachel Shirley 25
Michael Situ **75**
Jerry Smith 1
Glenn Smith **76**
John Stoa 15
Gabor Svagrik **78**
Carol Swinney **79**
Alexandra Tyng 81
Marc van der Leeden 82
Diane Van Noord 9
Sandra Vanderwall **93**
Jiemei Wang 83
Thomas A. Wayne 84
Marcia Wegman 85
Beatriz Welch **97**
Elizabeth Wiltzen 86

With special thanks to David Wright
whose painting appears on the front cover

Message from the Publisher

We have taken the "learn by observing" approach six huge steps further.

Welcome to the latest title in our innovative 6-Volume series. Each volume contains 100 different interpretations of the subject by some outstanding artists working in the world today — in all mediums.

There are five more Volumes in the series, each tackling a popular subject. Titles you can collect are:

100 ways to paint Still Life & Florals

100 ways to paint People & Figures

100 ways to paint Flowers & Gardens

100 ways to paint Seascapes, Rivers & Lakes

100 ways to paint Favorite Subjects

Turn to page 128 for more details on how you can order each volume.

Studying the work of other artists is one of the best ways to learn, but in this series of Volumes the artists give much more information about a favorite painting. Here's what you can expect:

- 100 different artists give 100 different interpretations of the subject category.

- Each one gives tips, instruction and insight.

- The range of paintings shows the variety of effects possible in every medium.

- A list of colors, supports used, brushes and other tools accompanies each picture.

- The artists reveal what they wanted to say when they painted the picture — the meaning behind the painting and its message.

- Each artist explains their inspiration, motivation and the working methodology for their painting.

- Artists say what they think is so special about their painting, telling how and why they arrived at the design, color and techniques in their composition.

- The artists describe the main challenges in painting their picture, and how they solved problems along the way.

- They offer suggestions and exercises that you can try yourself.

- They give their best advice on painting each subject based on their experience.

- Others explain why they work with their chosen medium and why they choose the supports and tools they do.

- The main learning point of each painting is identified in the headline.

Each of the explanations shown in **100 ways to paint Landscapes** was generously provided by artists who want you to share their joy of painting. Take the time to read each description fully, because you never know which piece of advice will be the turning point in your own career.

Vincent Miller

Vincent Miller
Publisher

If you were standing beside David Wright, the Canadian artist who created this painting, the first thing you would ask is, "David, how did you paint that?" Then a multitude of other questions would follow, fed by your insatiable hunger to know what it is that goes into making a masterpiece like this.

Our series of books is the next best thing to having direct access to exemplary artists like David Wright. On your behalf, we asked 100 artists the burning questions that you would ask if you met them face to face.

Here's the kind of information and insight you can expect to find on the following pages from the 100 generous artists in this book.

I wanted to keep the tones true and

my inspiration

My intention was to capture the sparse, transcendental beauty of the Mexican highlands, in particular I wanted to convey the sense of the mysterious (non-verbal) dialogue that I saw between the individual forms of the landscape and the light that displayed and harmonized them.

my challenge

The canvas was large, 42 x 60" (107 x 153cm), so my challenge was to keep the sense of direct experience, freshness and spontaneity in a painting that could not be completed in one sitting.

my design

The compositional geometry was worked out at basically one-third land to two-thirds sky. The main tree group occupied the square within the rectangle, and the secondary solo tree on the right was placed at the golden section division of the distance between the tree grouping and the right edge of the composition.

the eye-path

I wanted the viewer to enjoy the deep space between the dark foreground tree/cactus group and the sky/horizon. The eye-path was manipulated so the viewer's eye follows the horizon to the setting sun and then discovers the complexity of the sky.

paint that?

use as little color as possible.

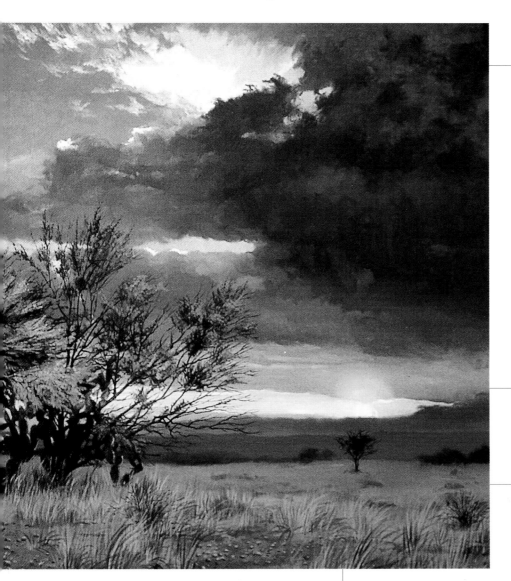

Central Highlands, oil, 42 x 60" (107 x 153cm)

my materials

oil palette

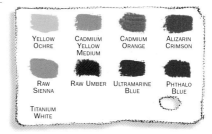

YELLOW OCHRE CADMIUM YELLOW MEDIUM CADMIUM ORANGE ALIZARIN CRIMSON

RAW SIENNA RAW UMBER ULTRAMARINE BLUE PHTHALO BLUE

TITANIUM WHITE

brushes
Variety of bristle brushes from No. 12 to No. 1

canvas
cotton

other
Palette knife
Acrylic gesso

color plan

My strategy was to keep the values true and use as little color as necessary

my working method

I worked from pencil thumbnails (which usually emphasize the simple graphics and initial attraction of the subject). I made some rough color notes, preliminary watercolor studies and took photo reference for some details missing in the roughs. My goal was to stay true to the initial concept without including too much detail.

tonal value plan

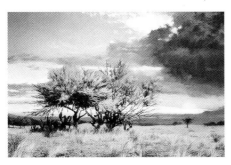

If you study this illustration you will discover a subtle arrow-shape of tone that leads the eye to the main area.

David Wright lives in Canada.
www.davidtwright.com

acrylic paint

Fast drying, waterproof, long lasting acrylic is an elastic paint that flexes and resists cracking.

Use it straight from the tube for intense color, dilute with water for transparent washes, or mix with an assortment of mediums to create texture. Available in tubes or jars, liquid or impasto, matte or gloss finish.

Acrylic is bound with resin emulsified with water. You can use flexible and inflexible, primed or unprimed surfaces.

alkyd

Looks similar to oil paints and can be mixed with them. Alkyds resist yellowing and they dry faster than oils.

Alkyds are bound with alcohol and acid oil modified resin. Before you paint, prime flexible or inflexible surfaces first with oil or acrylic primer.

casein

This old medium, bound with skim milk curds, has mostly been overtaken by acrylic paints. However, casein is still available and many artists swear by it. The medium dries quickly to a velvety matte finish and is water-resistant when dry. It does become brittle, and if you apply too much, it can crack. Like acrylic paint, casein is versatile and can be applied as a thin wash or as an underpainting for oils and oil glazes. When it is varnished it looks like oil paint.

Because casein does not flex like acrylics it is not suitable for canvas. Instead, use watercolor paper or rigid surfaces, either primed or unprimed.

egg tempera

This product uses egg yolk in oil emulsion as its binder. It dries quickly, doesn't yellow and can be used just as it is or diluted with water. Egg tempera will crack on canvas, so only use rigid supports. It can also be used as an underpainting for oils and oil glazes.

gouache

This medium is opaque and can be rewetted and reworked. It comes in vivid colors.

Gouache uses gum arabic as its binder. Paint on paper and paper boards. Dilute with water or use neat. Don't apply gouache too thickly or it will crack.

acrylic gouache

This gouache uses water-soluble acrylic resin as its binder. Use it just like gouache, but notice that because it is water-resistant you can layer paint to intensify color.

oil

The classic painting medium. You can achieve everything from luminous glazes to opaque impasto. As the paintings from the Old Masters show, oil paintings can crack, yellow

pastel with a finger, cotton bud or soft brush. Hard pastels enable finer detail to be added as the work progresses, or they can be used as a primary drawing medium for planning sketches and for outdoor studies. Pastel pencils are good for drawing and for adding extra fine detail.

You can combine pastel with acrylic, gouache and watercolor. As long as the surface upon which you are working has a "tooth" (a textured surface that provides grip), then it is suitable for pastel.

You can use pastel on a variety of papers in different grades and textures. Some have a different texture on each side. These days you can buy sandpaper type surfaces either already colored, or you can prime them yourself with a colored pastel primer. Some artists prepaint watercolor paper with a wash and apply pastel on top of that.

water-thinned oil

A recent development. This product looks like oil paint but cleans up in water instead of solvent. It dries like traditional oil. Use straight or modify with traditional oils and oil painting medium. Transparent or impasto. You can paint on canvas or wood.

watercolor

This is an ancient medium. The pigment in the best brands are very finely ground so that when the watercolor paint is mixed with water the paint goes on evenly. Some pigments do retain a grainy appearance, but this can be used to advantage. Provided you let previous washes dry, you can apply other washes (glazes) on top without disturbing the color beneath. Know that watercolor dries lighter than it looks.

Watercolor is diluted with different ratios of pigment to water to achieve thin, transparent glazes or rich, pigment-filled accents of color. Watercolor pigments can be divided into transparent, semi-transparent and opaque. It is important to know which colors are opaque, because it is difficult to regain transparency once it is lost. Watercolor can be lifted out with a sponge, a damp brush or tissue.

There are many different grade watercolor papers available from very rough, dimply surfaces to smooth and shiny. Different effects are achieved with each. Although many traditional watercolorists allow the white of the paper to show through, there are also colored watercolor papers available.

and darken with age. Oil paint dries slowly on its own, or the process can be accelerated using drying medium. There are many mediums that facilitate oil painting, including low odor types. Turps is widely used to thin oil paint in the early layers. Oils can be applied transparently in glazes or as thick impasto. You can blend totally or take advantage of brush marks, depending on your intention. Oil can be used on both flexible and inflexible surfaces. Prime these first with oil or acrylic primers. Many artists underpaint using flexible acrylic paint and then apply oil paint in layers. You can work oils all in one go (the alla prima method), or allow previous layers to dry before overpainting. Once the painting is finished, allow as much time as possible before varnishing.

Oil paint can be bound with linseed, poppy, safflower or sunflower oil. Paint on canvas or wood.

oil stick

This relatively new medium is artist quality oil paint in stick form. This product dries faster than tube oils. Oil sticks allow calligraphic effects and they can be used with traditional oils and oil medium. Oil stick work can be varnished.

pastel

Soft pastels can be blocked in to cover large areas of a painting. Use the side of the pastel to rapidly cover an area, either thickly or in a thin restrained manner. You can blend

Find-it-Faster Directory

Color coded numbers let you quickly find the paintings you like,
all the methods and materials used and how each artist painted them

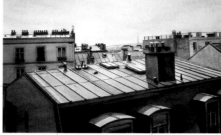

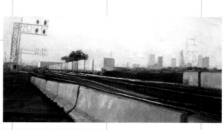

1 **Jerry Smith**
Shades of October
7 x 20" (18 x 51cm)
ACRYLIC

Complementary color

2 **Georges Artaud**
Les Toits de Paris
15 x 20" (38 x 51cm)
WATERCOLOR

Luminous grays

3 **Candice Bohannon**
Sunset Over Los Angeles
18 x 36" (46 x 92cm)
OIL

Bold diagonals

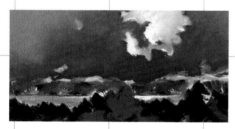

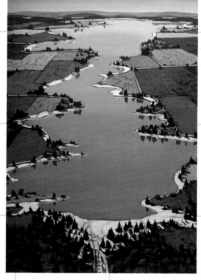

4 **Evelyne S Albanese**
Spirit of Night
16 x 30" (41 x 76cm)
OIL

Monochromatic color

5 **Chari Grenfell**
Finale
40 x 30" (102 x 76cm)
OIL

Mood

6 **Sy Ellens**
Over Long Lake
64 x 42" (163 x 107cm)
ACRYLIC

Viewpoint

Valerie H Alexander
Fishing by Dinham Bridge, Ludlow
13 x 18½" (33 x 47cm)
WATERCOLOR

Backlight

Keith Bowen
Wintering Herdwicks, Cumbria
32 x 42" (81 x 107cm)
OIL

Mood with marks

Diane Van Noord
California Coast
6 x 8" (15 x 20cm)
OIL

Distance

10 **Anthony J Batten**
Glory Days
36 x 48" (91 x 122cm) each panel
OIL

Design

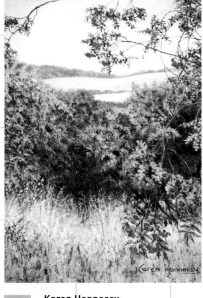

11 **Karen Hennessy**
Longstock, Hampshire
14 x 10" (36 x 26cm)
OIL/EGG TEMPERA

Color glazes

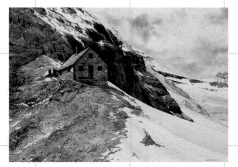

12 **Ken Samuelson**
The Hikers — Abbot Hut
20 x 28" (51 x 71cm)
WATERCOLOR

Texture

Find-it-Faster Directory

Color coded numbers let you quickly find the paintings you like,
all the methods and materials used and how each artist painted them

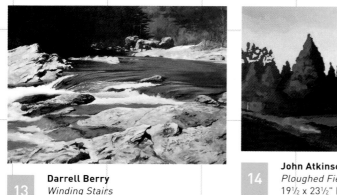

13 **Darrell Berry**
Winding Stairs
36 x 48" (92 x 122cm)
OIL

Design

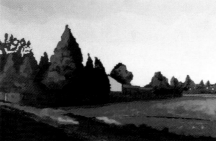

14 **John Atkinson**
Ploughed Field
19½ x 23½" (50 x 60cm)
ACRYLIC

Color

15 **John Stoa**
St Pierre Le Viger
16 x 20" (41 x 51cm)
ACRYLIC

Color and contrast

16 **Susan Flanagan**
Take the Path
9 x 12" (23 x 31cm)
PASTEL

Tone and color temperature

17 **Shu-Ping Hsieh**
California
20 x 30" (51 x 76cm)
OIL

Composition

18 **Ginger Bowen**
Fall in the Fish Hatchery
10 x 12" (26 x 31cm)
OIL

Mood and color

You'll find all the information you want about how each painting was created by turning to the tab number indicated, in sequence from 1 to 100

19 Cheryl Lynch
Dragons Mountain
24 x 36" (61 x 92cm)
OIL

Shape

20 Michael Gibbons
Quiet Lane on Hollister Ranch
9 x 12" (23 x 31cm)
OIL

Texture and mood

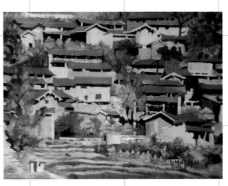

21 D Matzen
Rammed Earth Houses, Yunnan Province
11 x 14" (28 x 36cm)
OIL

Shape

22 Rosemary Nothwanger
Botanica
20 x 28" (51 x 71cm)
WATERCOLOR

Technique

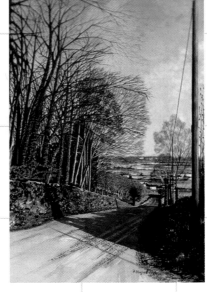

23 Peter Haynes
Long Lane, Devon
22 x 16" (56 x 41cm)
WATERCOLOR

Design and tone

24 Kathleen Bergstrom
Humboldt & North
22 x 30" (56 x 76cm)
GOUACHE

Contrast and perspective

Find-it-Faster Directory

Color coded numbers let you quickly find the paintings you like, all the methods and materials used and how each artist painted them

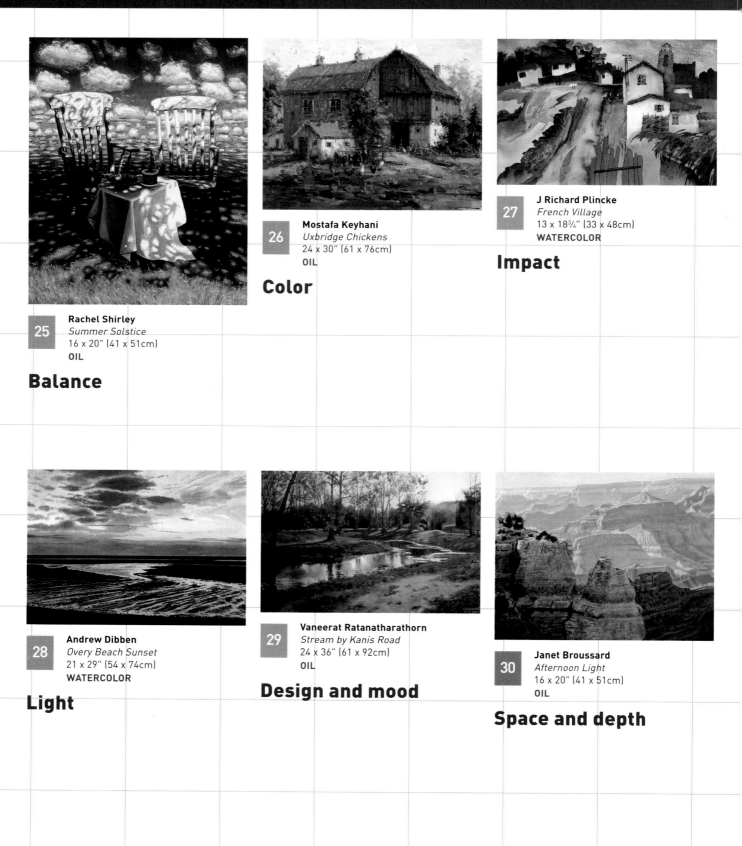

26 Mostafa Keyhani
Uxbridge Chickens
24 x 30" (61 x 76cm)
OIL

Color

27 J Richard Plincke
French Village
13 x 18¾" (33 x 48cm)
WATERCOLOR

Impact

25 Rachel Shirley
Summer Solstice
16 x 20" (41 x 51cm)
OIL

Balance

28 Andrew Dibben
Overy Beach Sunset
21 x 29" (54 x 74cm)
WATERCOLOR

Light

29 Vaneerat Ratanatharathorn
Stream by Kanis Road
24 x 36" (61 x 92cm)
OIL

Design and mood

30 Janet Broussard
Afternoon Light
16 x 20" (41 x 51cm)
OIL

Space and depth

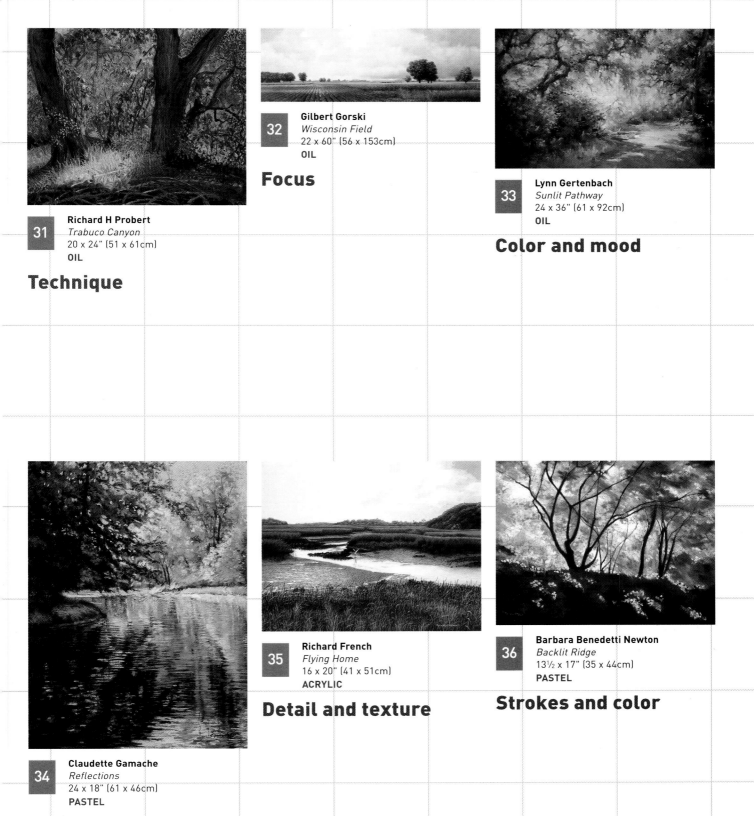

32
Gilbert Gorski
Wisconsin Field
22 x 60" (56 x 153cm)
OIL

Focus

33
Lynn Gertenbach
Sunlit Pathway
24 x 36" (61 x 92cm)
OIL

Color and mood

31
Richard H Probert
Trabuco Canyon
20 x 24" (51 x 61cm)
OIL

Technique

35
Richard French
Flying Home
16 x 20" (41 x 51cm)
ACRYLIC

Detail and texture

36
Barbara Benedetti Newton
Backlit Ridge
13½ x 17" (35 x 44cm)
PASTEL

Strokes and color

34
Claudette Gamache
Reflections
24 x 18" (61 x 46cm)
PASTEL

Contrast and mood

Barbara Nuss
Afternoon on the Towpath
16 x 24" (41 x 61cm)
OIL

37

Composition

Don H Pierson
Sedona, Early Snow
30 x 40" (76 x 102cm)
OIL

38

Design with shape

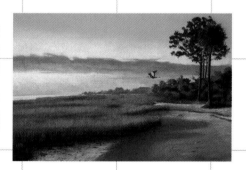

John Pototschnik
Autumn Leaves
16 x 24" (41 x 61cm)
OIL

39

Contrast

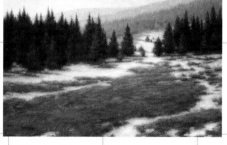

Scott Leonard
Windswept
20 x 30" (51 x 76cm)
OIL

40

Value and color

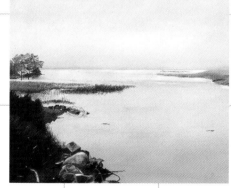

Marge Levine
Still Waters
10 x 10" (26 x 26cm)
PASTEL

41

Technique

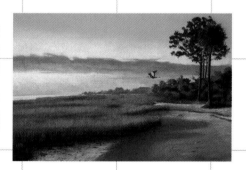

Don Nagel
Dawn Over Port Royal
18 x 26" (46 x 66cm)
PASTEL

42

Value and color

43 Deanne Lemley
Enter by the Narrow Gate
14 x 18" (36 x 46cm)
OIL

Shape and tone

44 Xinlin Fan
Sunlight on Rocky Slope
18 x 24" (46 x 61cm)
ACRYLIC

Backlighting

45 Cynthia Eyton
Summer Afternoon
12 x 16" (31 x 41cm)
ACRYLIC

Design

46 Pamela Erickson
Solitude
20 x 30" (51 x 76cm)
WATERCOLOR

Technique

47 Kristina Jurick
Against the Light
13½ x 21" (35 x 54cm)
WATERCOLOR

Design

48 Pris Buttler
Silverthorne, Colorado
16 x 20" (41 x 51cm)
OIL

Depth

Find-it-Faster Directory
Color coded numbers let you quickly find the paintings you like,
all the methods and materials used and how each artist painted them

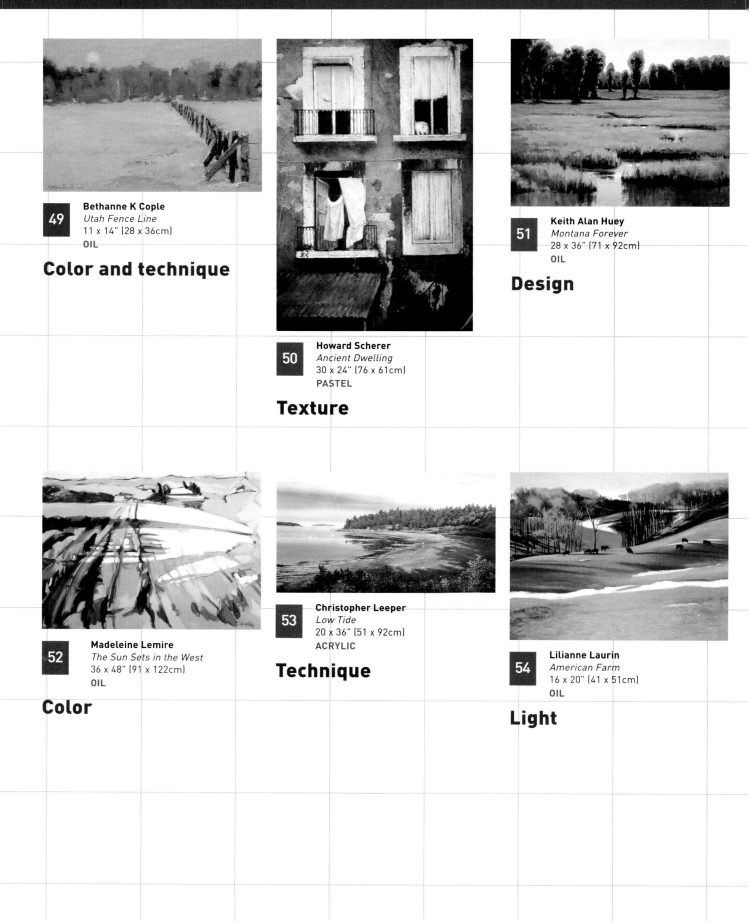

49 Bethanne K Cople
Utah Fence Line
11 x 14" (28 x 36cm)
OIL

Color and technique

50 Howard Scherer
Ancient Dwelling
30 x 24" (76 x 61cm)
PASTEL

Texture

51 Keith Alan Huey
Montana Forever
28 x 36" (71 x 92cm)
OIL

Design

52 Madeleine Lemire
The Sun Sets in the West
36 x 48" (91 x 122cm)
OIL

Color

53 Christopher Leeper
Low Tide
20 x 36" (51 x 92cm)
ACRYLIC

Technique

54 Lilianne Laurin
American Farm
16 x 20" (41 x 51cm)
OIL

Light

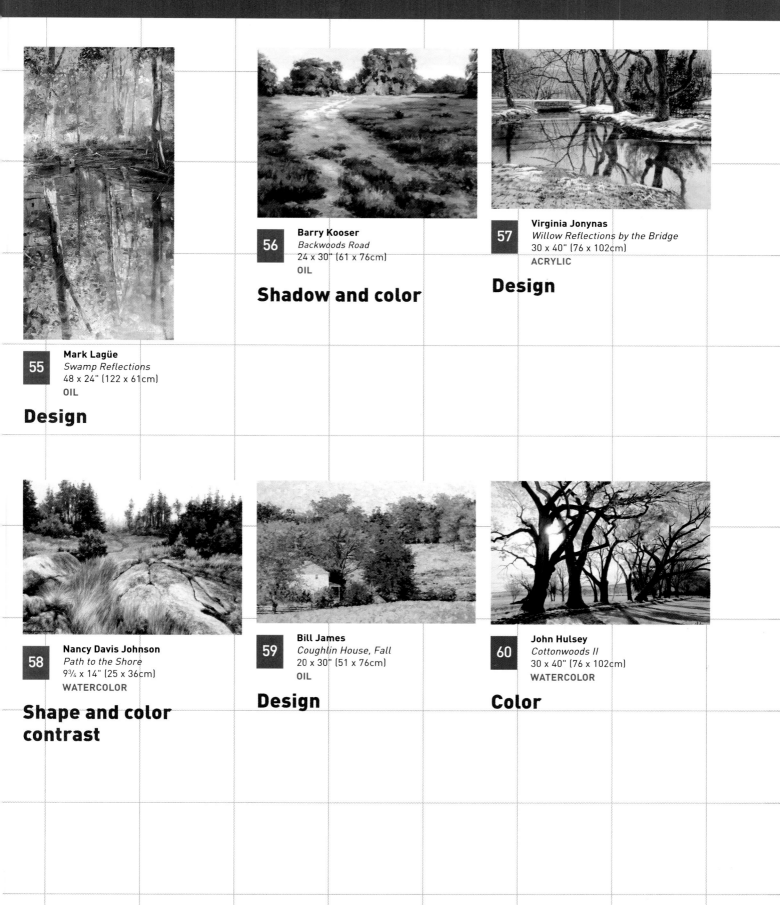

55
Mark Lagüe
Swamp Reflections
48 x 24" (122 x 61cm)
OIL

Design

56
Barry Kooser
Backwoods Road
24 x 30" (61 x 76cm)
OIL

Shadow and color

57
Virginia Jonynas
Willow Reflections by the Bridge
30 x 40" (76 x 102cm)
ACRYLIC

Design

58
Nancy Davis Johnson
Path to the Shore
9¾ x 14" (25 x 36cm)
WATERCOLOR

Shape and color contrast

59
Bill James
Coughlin House, Fall
20 x 30" (51 x 76cm)
OIL

Design

60
John Hulsey
Cottonwoods II
30 x 40" (76 x 102cm)
WATERCOLOR

Color

↓ Find-it-Faster Directory
**Color coded numbers let you quickly find the paintings you like,
all the methods and materials used and how each artist painted them**

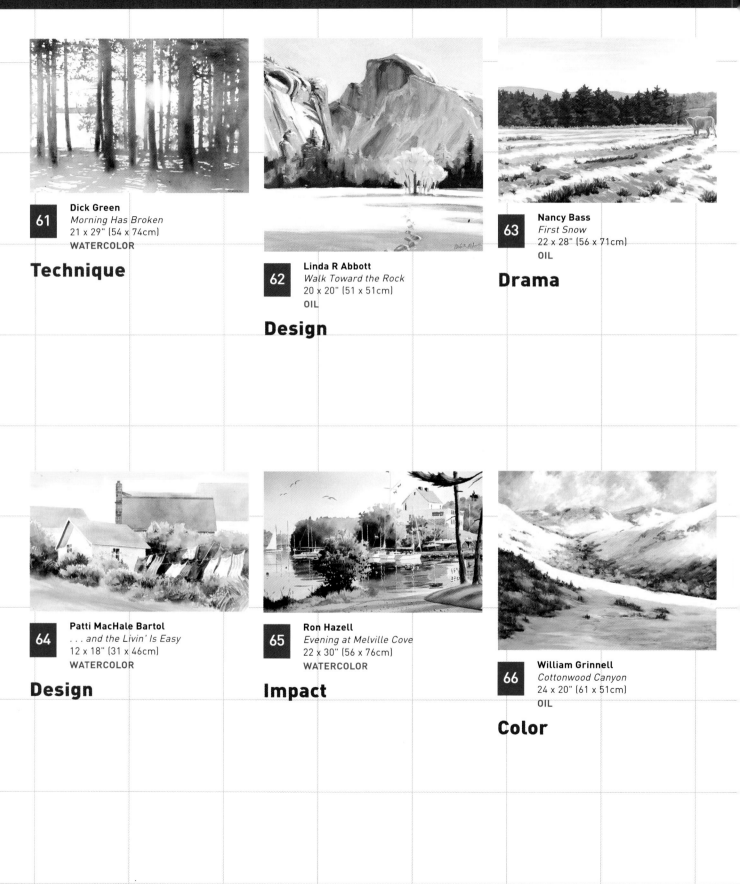

61 **Dick Green**
Morning Has Broken
21 x 29" (54 x 74cm)
WATERCOLOR

Technique

62 **Linda R Abbott**
Walk Toward the Rock
20 x 20" (51 x 51cm)
OIL

Design

63 **Nancy Bass**
First Snow
22 x 28" (56 x 71cm)
OIL

Drama

64 **Patti MacHale Bartol**
. . . and the Livin' Is Easy
12 x 18" (31 x 46cm)
WATERCOLOR

Design

65 **Ron Hazell**
Evening at Melville Cove
22 x 30" (56 x 76cm)
WATERCOLOR

Impact

66 **William Grinnell**
Cottonwood Canyon
24 x 20" (61 x 51cm)
OIL

Color

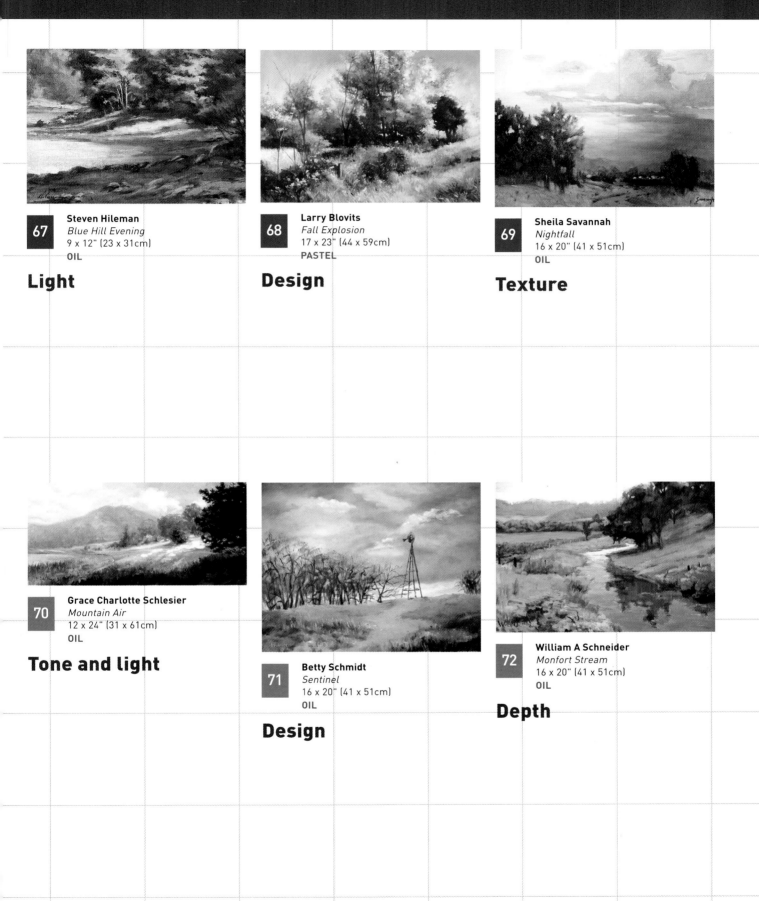

67
Steven Hileman
Blue Hill Evening
9 x 12" (23 x 31cm)
OIL

Light

68
Larry Blovits
Fall Explosion
17 x 23" (44 x 59cm)
PASTEL

Design

69
Sheila Savannah
Nightfall
16 x 20" (41 x 51cm)
OIL

Texture

70
Grace Charlotte Schlesier
Mountain Air
12 x 24" (31 x 61cm)
OIL

Tone and light

71
Betty Schmidt
Sentinel
16 x 20" (41 x 51cm)
OIL

Design

72
William A Schneider
Monfort Stream
16 x 20" (41 x 51cm)
OIL

Depth

↓ Find-it-Faster Directory

Color coded numbers let you quickly find the paintings you like,
all the methods and materials used and how each artist painted them

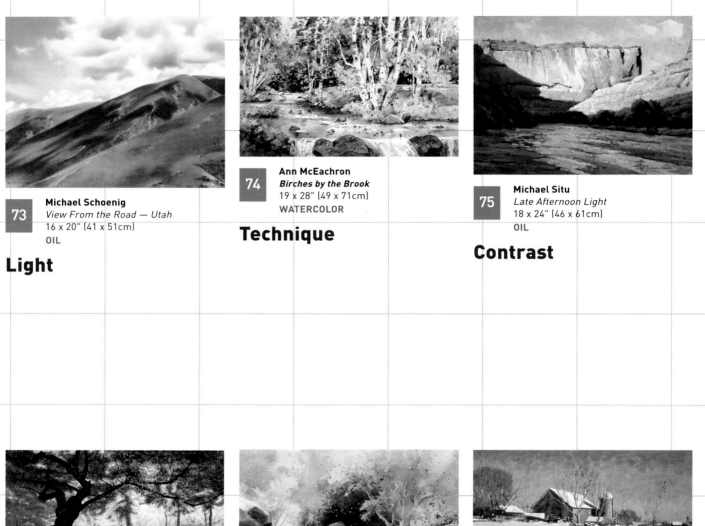

73
Michael Schoenig
View From the Road — Utah
16 x 20" (41 x 51cm)
OIL

Light

74
Ann McEachron
Birches by the Brook
19 x 28" (49 x 71cm)
WATERCOLOR

Technique

75
Michael Situ
Late Afternoon Light
18 x 24" (46 x 61cm)
OIL

Contrast

76
Glenn Smith
Afternoon Shadows
18 x 24" (46 x 61cm)
ACRYLIC

Tone and color

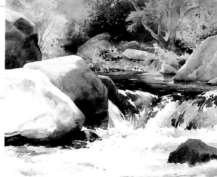

77
Julie Gilbert Pollard
Early Light
24 x 22" (61 x 56cm)
WATERCOLOR

Design

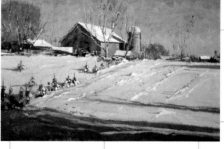

78
Gabor Svagrik
Route 22
18 x 24" (46 x 61cm)
OIL

Color temperature

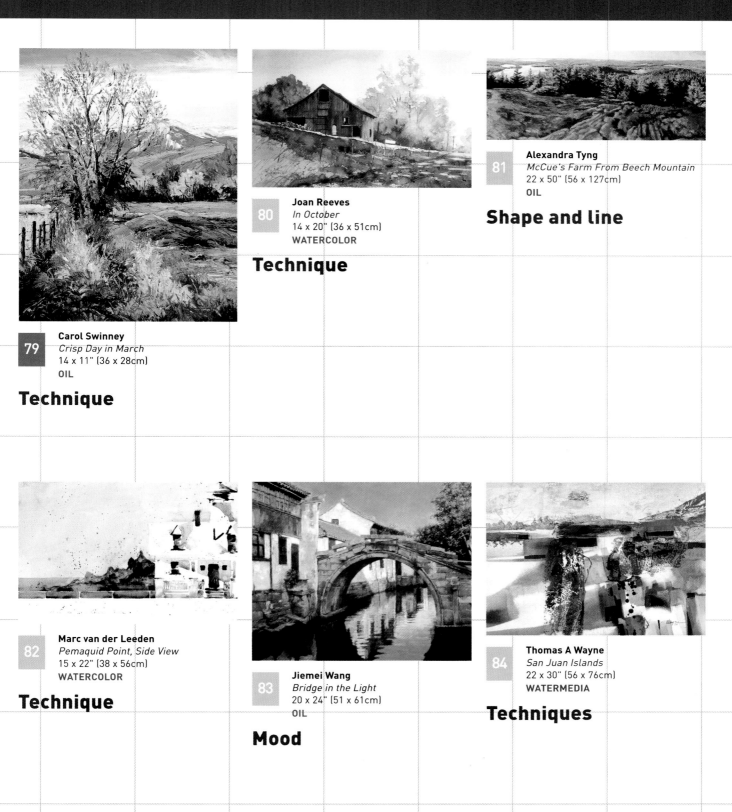

79

Carol Swinney
Crisp Day in March
14 x 11" (36 x 28cm)
OIL

Technique

80

Joan Reeves
In October
14 x 20" (36 x 51cm)
WATERCOLOR

Technique

81

Alexandra Tyng
McCue's Farm From Beech Mountain
22 x 50" (56 x 127cm)
OIL

Shape and line

82

Marc van der Leeden
Pemaquid Point, Side View
15 x 22" (38 x 56cm)
WATERCOLOR

Technique

83

Jiemei Wang
Bridge in the Light
20 x 24" (51 x 61cm)
OIL

Mood

84

Thomas A Wayne
San Juan Islands
22 x 30" (56 x 76cm)
WATERMEDIA

Techniques

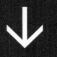

Find-it-Faster Directory

Color coded numbers let you quickly find the paintings you like,
all the methods and materials used and how each artist painted them

86
Elizabeth Wiltzen
Starry Night
14 x 21" (36 x 54cm)
WATERCOLOR

Color and tone

87
Rob Evison
Clouds Over Haystacks
19 x 26" (49 x 66cm)
PASTEL

Color

85
Marcia Wegman
Dawn Fields
24 x 24" (61 x 61cm)
PASTEL

Color and light

88
Kevin Brunner
Jumpin' Off, St Joe
22 x 28" (56 x 71cm)
OIL

Color

89
Roger Dale Brown
Edge of Field
24 x 30" (61 x 76cm)
OIL

Technique

90
Jolanda Richter
Secret of the Lakes
12 x 15½" (31 x 40cm)
OIL

Color and edges

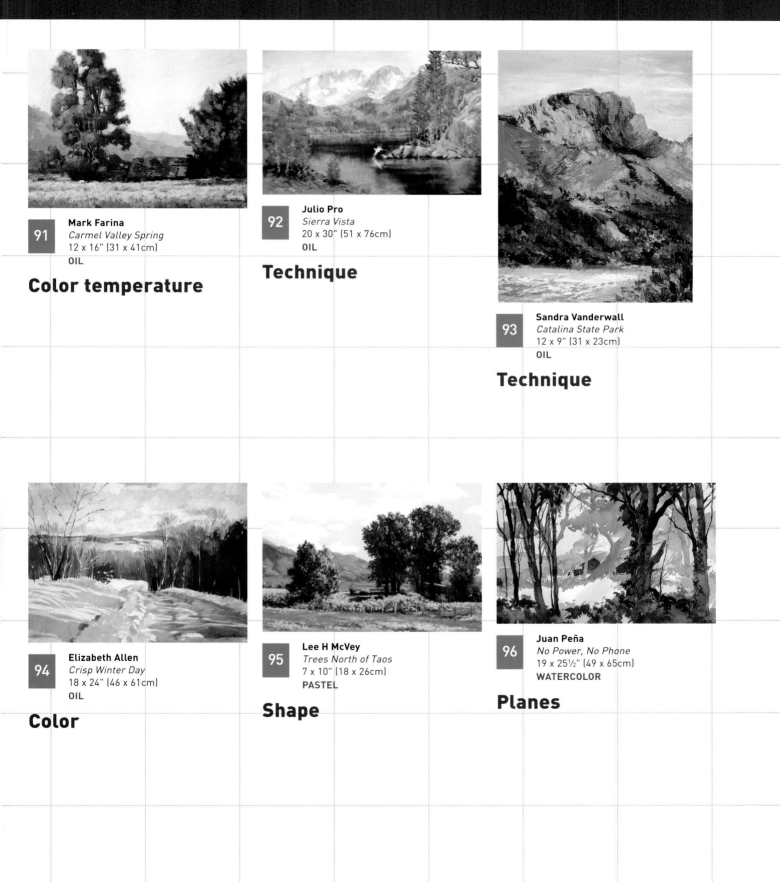

91 **Mark Farina**
Carmel Valley Spring
12 x 16" (31 x 41cm)
OIL

Color temperature

92 **Julio Pro**
Sierra Vista
20 x 30" (51 x 76cm)
OIL

Technique

93 **Sandra Vanderwall**
Catalina State Park
12 x 9" (31 x 23cm)
OIL

Technique

94 **Elizabeth Allen**
Crisp Winter Day
18 x 24" (46 x 61cm)
OIL

Color

95 **Lee H McVey**
Trees North of Taos
7 x 10" (18 x 26cm)
PASTEL

Shape

96 **Juan Peña**
No Power, No Phone
19 x 25½" (49 x 65cm)
WATERCOLOR

Planes

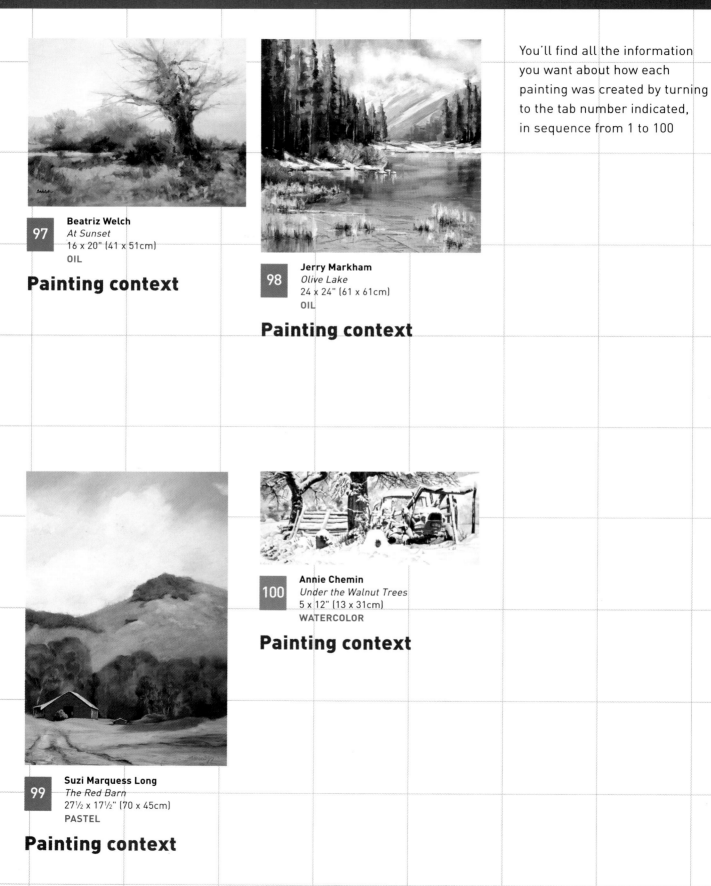

Find-it-Faster Directory

Color coded numbers let you quickly find the paintings you like,
all the methods and materials used and how each artist painted them

You'll find all the information you want about how each painting was created by turning to the tab number indicated, in sequence from 1 to 100

97 **Beatriz Welch**
At Sunset
16 x 20" (41 x 51cm)
OIL

Painting context

98 **Jerry Markham**
Olive Lake
24 x 24" (61 x 61cm)
OIL

Painting context

100 **Annie Chemin**
Under the Walnut Trees
5 x 12" (13 x 31cm)
WATERCOLOR

Painting context

99 **Suzi Marquess Long**
The Red Barn
27½ x 17½" (70 x 45cm)
PASTEL

Painting context

Complementing warm yellows against cool violets made the sunlight in my scene "pop".

Shades of October, acrylic, 7 x 20" (18 x 51cm)

my inspiration

The inspiration for this painting was the late afternoon light streaming across the fields and striking the buildings. For a brief period, even the most ordinary landscape can become a "light show". Whites take on a golden glow and all sunlit areas are intensified. The elongated shadows contributed to the effect.

my design strategy

I had been doing a series of long, narrow paintings and this farm surrounded by long shadows seemed a perfect match for these proportions. I felt the shadows helped unify the design by tying the road, buildings and distant fields together. They also kept the road from leading the eye into the painting too severely.

about light and color

The most significant design principles were color, tonal value and texture. I wanted the sunlight on the buildings to really "pop". The dominant violets and cool browns serve to heighten the intensity of the warmer golds and yellows. Values were another important consideration in emphasizing the light on the buildings. The rather brushy texture of the foreground and trees was balanced with a simple, flatly painted sky.

my working process

- Once I had done a couple of preliminary sketches to work out my design, I began painting without a drawing on my painting surface. I started with the sky, mixing enough paint for two coats.

- After the sky had dried, I blocked in the rest of the painting in midtones, painting around the white house to maintain the translucence of the white primer coat.

- When the undercoat had dried, I began adding highlights and texture, cleaning up edges and adding detail. Because of acrylics' drying speed, I was able to apply many layers to get the desired effects.

- The painting was completed with warm yellows in my color mixes for the sunlit buildings and fields.

try these tactics yourself

- Pick a subject that inspires you. Focus on the thing that attracts you the most and build your painting around it.

- Use only what you need from your subject to support your center of interest and express what you want to say. Any element or detail in a painting that doesn't contribute will probably detract.

- Whether painting on location or in the studio, take a little time to think, sketch and plan your attack before you start painting. It might save time in the long run.

what I used

support
Cold-pressed illustration board primed with a mixture of gesso and acrylic medium (about 4 to 1)

brushes
Synthetic water media brushes in various sizes of rounds and flats; rigger brush

acrylic colors

NAPLES YELLOW YELLOW ORANGE AZO RAW SIENNA BURNT SIENNA

PRISM VIOLET FRENCH ULTRAMARINE BLUE PHTHALO BLUE DIOXAZINE PURPLE

BURNT UMBER TITANIUM WHITE

Jerry Smith lives in Indiana, USA → www.jsmithstudio.com

Georges Artaud

Shades of transparent grays laced with pinks, purples, blues and oranges helped me create luminosity.

Les Toits de Paris, watercolor, 15 x 20" (38 x 51cm)

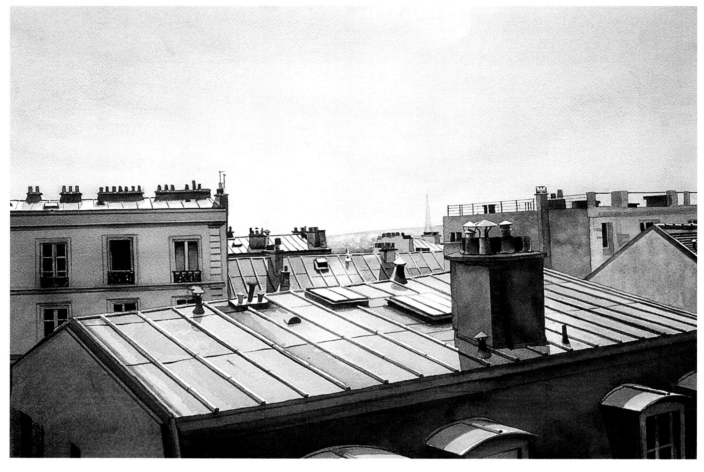

my inspiration

I lived in Paris for about 30 years on the fifth floor of a building. Day by day, I learned to like this ocean of roofs in front of my window. I learned how to appreciate the changes of light during the day and through the seasons. Although the zinc roofs were gray in actuality, they became tinted with pink, purple, blue or orange under the rain or in the glow of the setting sun. It is a great spectacle for those who see it.

design notes

Because I now live in the French provinces, I had to return to Paris armed with my camera — my 21st century sketchbook — to get this subject. I carefully framed the composition, using the opening between the buildings to lead the viewer to the important point, the Eiffel Tower. Then I waited for the moment when the light was at its most interesting. Above all,

I looked at and immersed myself in the atmosphere of the place.

my painting strategy

Later, in the silence of my studio, facing my photographs, I mentally constructed my watercolor, allowing myself enough time until I was mentally ready. I visualized my painting in my head — it was there, present, already made. The cropping, lighting and drawing of the subject was complete. All that was left for me to do was to lay it on paper; it was nothing more than a question of technique, of cooking.

my working process

- I transferred my drawing to my stretched watercolor paper with tracing paper in order not to damage the surface of the paper.

- For the sky, I worked wet-on-wet because my sky was clear of clouds, the colors having to fade into one another. I selected a

large brush and wet my paper. I silhouetted the roofs as I applied my colors. When the result was satisfying and corresponded to my expectations, I let it dry.

- For the roofs, I used another brush of average size, this time working wet-on-dry around the lights. I began with the light colors and gradually, by successive washes, moved

toward the darkest ones. Because I used colorful grays, my painting is full of light.

- I made my foreground very strong to reinforce the effect of depth.

why I chose watercolor

I chose watercolor because it allowed me to create very subtle, light and luminous colors, perfect for this subject.

what I used

support
Fine grain 300gsm

brushes
Several types in size No. 4

other materials
Ceramic palette
Sponge
Masking fluid

watercolors

Cadmium Yellow	Raw Umber
Cadmium Orange	Van Dyke Brown
Cadmium Red	Cerulean Blue
Permanent Rose	Ultramarine Blue
Yellow Ochre	Paynes Gray
Burnt Sienna	Ivory Black

Georges Artaud lives in Le Mans, France → georges-artaud@wanadoo.fr

Bold diagonals and well-grouped lights are my painting's strong points.

Sunset Over Los Angeles, oil, 18 x 36" (46 x 92cm)

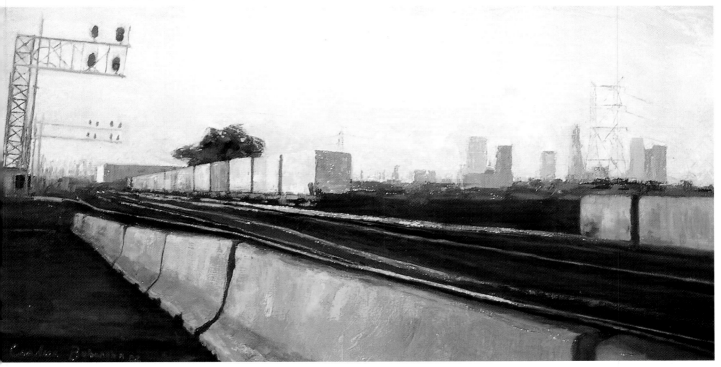

my inspiration

Up until the past few years, I had spent my entire life in the foothills of the Sierra Nevada Mountains. Moving into the never-ending sprawl of the LA area was quite a change. The city was ugly at first, but after I adjusted to the change, I found the smog made for fabulous sunsets, the buildings and freeways created endless dynamic compositions and the electrical poles and wires mimicked the trees of my old home.

my design strategy

This composition takes strength in bold diagonals and well grouped lights. The barriers in the foreground direct the eye to follow the train tracks into the background, where a single light on the end of a building stops that travel and directs it back up to the train cars. The break in light moves your eye upward to the sky and distant buildings.

my working process

- On a well-primed canvas, I used a large brush to generally map out the painting with turpentine and Burnt Sienna.
- Using a limited palette, I started to bring the image into better focus, establishing the lights and darks in all areas.
- I then used a palette knife to boldly lay in the textured sky, buildings and train cars.
- After several more layers of color, the finest details of the electrical poles and wires were etched in with the side of my palette knife in the wet paint.
- When completely dry (6 months later), I put a varnish on to bring the colors back to life.

try these tactics yourself

- Experiment with using a palette knife for large areas, flat areas and fine details like wires and poles.
- Mix Blue Ochre and Indian Yellow to get a large variety of greens.
- Use larger brushes than you think necessary. It will keep you true to the main shapes, not the details.

what I used

support

Canvas, primed three or four times, sanded between layers to get a good, non-absorbent surface

brushes

Synthetic flats; palette knives; rubber-tipped clay tools

oil colors

CREMNITZ WHITE	NICKEL TITANATE YELLOW	CADMIUM YELLOW MEDIUM	YELLOW OCHRE
CADMIUM-BARIUM RED LIGHT	CADMIUM-BARIUM RED DEEP	BAROQUE RED	OLIVE GREEN
INDANTHRONE BLUE	PRUSSIAN BLUE		

Candice Bohannon lives in California, USA → squarehair2@aol.com

I used just enough color in this monochromatic work to lead the eye around.

Spirit of Night, oil, 16 x 30" (41 x 76cm)

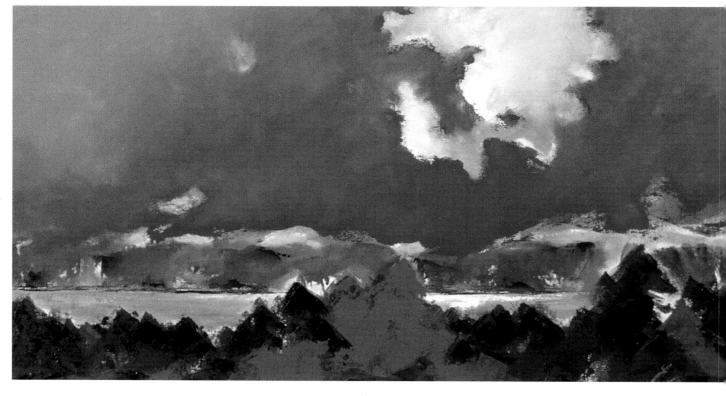

what I wanted to say

Believe it or not, this is the view from my deck overlooking Canandaigua Lake. This particular evening was so dramatic that I had to capture it on canvas. I wanted to say that nature is always speaking to us, some days more strongly than others. It reaches out to us and blesses us at times with the most uplifting experiences. It makes us reflect on what really has value in life.

about light and color

In order to achieve the dramatic impact I felt when I saw this, I decided to keep my color palette monochromatic in many shades of blues and grays. I wanted a very subtle use of color in most of the painting, just enough to pull the eye around.

Notice how the off-center focal point received the most value contrast. The foreground land mass needed to be subordinate

to the sky and focal point, so I kept it dark and muted. Only one area has a lighter blue that I thought would tie the bottom of the painting to the focal point. The reflections on the water pull your eye to the background, which I chose to leave soft and unfocused.

my working process

- I stretched and primed my canvas with two coats of rabbit skin glue and two more coats of gel medium to make the canvas tight.

- After choosing about seven colors to put on my palette, I spent a long time creating my own colors out of these.

- I then began to create layers upon layers of washes, eventually getting thicker as I went along. Instead of brushes, I used scraps of old sheets to move and blend my colors, which created extremely subtle transitions.

- Eventually, I began to use the palette knife to define some areas.

- Finally, I went back and blended some more so that the piece looked unified. There were probably 15 to 20 layers by the time I was done.

my advice to you

Don't get so caught up in technique that you lose the emotional impact of what you're painting. Listen to the painting to discover what is working and what is not, and follow its lead. For me, the process of expressing the emotion is the most meaningful part of painting. It teaches me the most about painting and about myself.

what I used

support
Cotton stretched canvas with two coats each of rabbit skin glue and gel medium

other materials
Oil medium
Cotton rags
Palette knives

oil colors

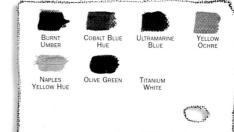

BURNT UMBER COBALT BLUE HUE ULTRAMARINE BLUE YELLOW OCHRE

NAPLES YELLOW HUE OLIVE GREEN TITANIUM WHITE

Clearly defining the mood I was after helped me stay focused while I painted this tribute to a friend.

Finale, oil, 40 x 30" (102 x 76cm)

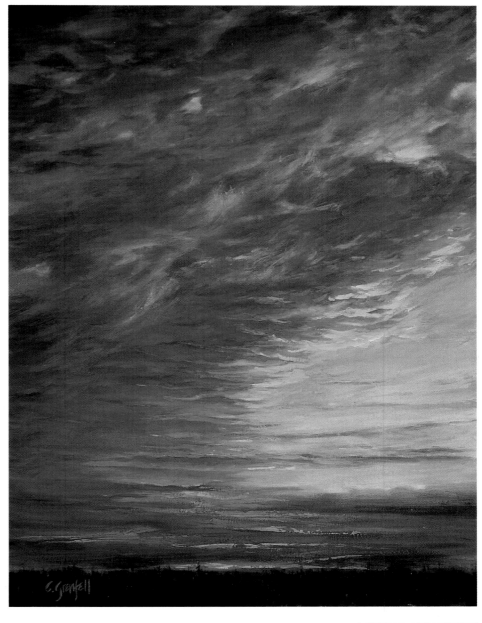

what I wanted to say

"Finale" was painted because I had no words to adequately describe the last five days of a friend's life. Last-stage cancer had left her in a coma, but the touching tributes and caring gestures by her family and hospital staff made the word "love" seem inadequate. It was an uplifting reciprocation of all the love that she had given to others in her life. It left an indelible impression on me, and I knew I had to express it.

my design strategy

Weeks earlier, I had seen a radiant sunset reveal itself as a symphony, building to a crescendo that enveloped us in hues of yellows, reds, oranges, pinks and violets. Since this painting was to signify someone's earthly exit, I chose the last notes of the symphony as my subject. Wanting the clouds to appear as luminous wafts of water vapor, I chose to experiment with transparent oil glazes. A poor-quality photo served as my initial reference; the color came from memory.

my working process

- After loosely drawing the design on the canvas, I mixed only one color per area to represent the overall color of each of the few masses.

- Starting with the uppermost clouds, I defined the cool shapes with additional, analogous colors and added sky holes, repeating this with the warm shapes.

- Now for the fun! I mixed different colors with alkyd medium and mineral spirits and, using fingers, palms, rags and sable brushes, I layered glaze upon glaze to mimic the subtle color changes of sunset clouds, going from cool to warm. Glazes dried between applications.

- After loosely applying the forest against the initial blue-violet underpainting, I used both a knife and bristle brush to create an impasto effect on the clouds' highlights.

- Unable to resolve the painting, I set it aside for many months. Later, by glazing in wispy foreground clouds, I think several problems were solved: the value and color of the clouds served as a foil to the darker clouds behind it and unified the cool side of the painting with the warm side. At the same time they acted as an ethereal accent, which helped capture the essence of the painting.

staying focused

In order to keep myself focused on the mood I was after, I first jotted down the adjectives "radiant","uplifting","dynamic" and "all-encompassing" to describe my feelings.

what I used

support
Stretched canvas

brushes
Filbert bristle brushes
Nos. 6, 8, 10, 12;
sables
Nos. 12, 20; 3"
painting knife

medium
Odorless mineral spirits

oil colors

To keep this painting lively and inviting, I dabbed on the paint, allowing the sparkling underpainting to show through.

Over Long Lake, acrylic, 64 x 42" (163 x 107cm)

my inspiration

When I was young and living on a farm, I would dream about what the earth would look like if I were in an airplane looking down on it. Now, when I have the opportunity to travel by plane, I try to get a seat next to the window so that I can watch the patterns unfold below me. I store these patterns in my mind and paint them without using any other reference material when I get to my studio.

my design strategy

I created a lighter area between the trees in the foreground to allow the viewer into the painting. Once on the lake, the viewer floats to the top, aided by the curved edges of the lake and the converging straight lines of the field. I used many different shades and tints and mixtures of colors to create a harmonious relationship and balance between the colors of the fields. I wanted to create a painting in such a way that everyone who saw it would want to go there.

my working process

- First, I stretched a cotton duck canvas and painted two coats of gesso on it. When that was dry I painted it with thinned Cadmium Red acrylic paint to create a warm tone. This was all done with a 2" nylon bristle brush.

- Next, I painted the sky with Cobalt Blue, darker at the top and lighter at the horizon line to show distance.

- Then I painted the distant hills with light tones of purple.

- Next, I painted the lake, starting with lighter tones of Cobalt Blue and Cerulean Blue at the top to darker ones at the bottom. I used a flat, 1" golden nylon and natural hair brush.

- Moving to smaller brushes, I painted the light edges of the lake and blocked out the edge of the fields. I used Dioxazine Purple for that. Then I painted the field using the same flat brush as before.

- Finally, I painted in the trees, buildings, roads and sailboat. I used a dabbing and scumbling technique to keep it loose and lively, allowing the red underpainting to show through.

what I used

brushes
2" flat nylon bristle; 1" flat golden nylon and natural hair; ½" flat golden nylon and natural hair; No. 10 round pointed nylon and natural hair; No. 1 round pointed nylon and natural hair

medium
Gesso

acrylic colors

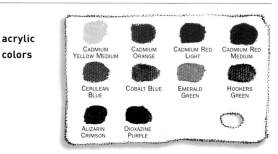

CADMIUM YELLOW MEDIUM | CADMIUM ORANGE | CADMIUM RED LIGHT | CADMIUM RED MEDIUM

CERULEAN BLUE | COBALT BLUE | EMERALD GREEN | HOOKERS GREEN

ALIZARIN CRIMSON | DIOXAZINE PURPLE

Sy Ellens lives in Michigan, USA → www.syellens.com

I called on the drama of backlighting.

Fishing by Dinham Bridge, Ludlow, watercolor, 13 x 18½" (33 x 47cm)

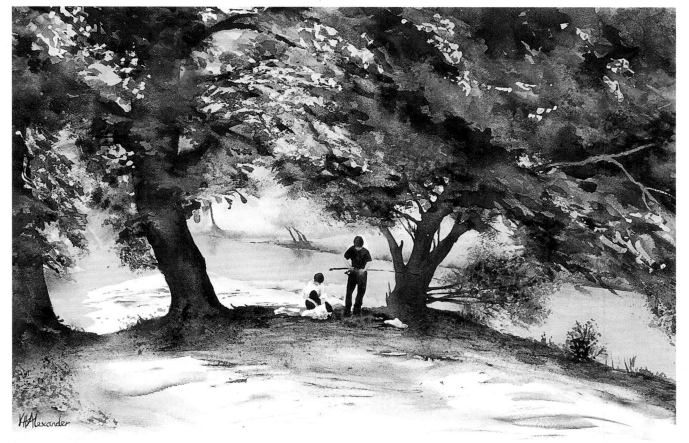

inspired by light

I have always loved the dramatic effect of strong sunlight on a scene, particularly when it is "contre jour", or streaming through from behind the subject. In this scene, the light was particularly fascinating. Great pools of light flooded the foreground, then the trees created a cave of sudden, intense darkness, perfectly enclosing the two figures. Behind them the sunlight lit up the river in a mysterious green glow. The poses of the two boys, completely absorbed in their task, perfectly summed up a lazy summer day.

my design strategy

The eye is drawn to the main focal point, the two figures, by the use of the strongest tonal counter-change in this area and by the series of directional lines in the foreground. Then the lines of the bank and tilt of the trees lead the eye gently through to the intense, sun-filled green of the water beyond.

my working process

- Surrounded by my sketches and photos, I began with a tiny thumbnail drawing — only 2 x 3" — to decide on my composition. I then drew out the main lines on my paper with a 2B pencil.

- Wherever there was a complex or small area of light surrounded by dark tones, I saved it with masking fluid. (Large areas of light were not a problem and were simply left as untouched paper).

- I then prepared four big washes and dampened most of the sheet with clean water. Then it was hold the breath and straight in, using a clean brush for each color to create the first, soft underpainting.

- After waiting for the painting to half dry, I used some stronger mixes to intensify color and add soft detail. I dried the whole completely with the aid of a hair-drier.

- Switching to my large, fine-pointed round sables, I painted in the dark masses of foliage, the tree trunks and branches and some shadows. I worked wet-on-dry but freely.

- When this was all dry, I removed the masking fluid and dropped in some pale colors, using a sponge to soften edges.

- Using my big flat brushes with great freedom and rapid strokes, I applied several washes to the foreground.

- Time for reflection, then the last finishing touches: adding texture, softening lines, defining the focal area.

something you could try

Create vibrant color by allowing different pigments to mix and merge on the paper's surface.

what I used

support
140lb cold-pressed watercolor paper

brushes
2" and 1½" flat brushes with mixed hair; round Kolinsky sables Nos. 16, 12, 8 and 6

other material
2B pencil
Masking fluid
Natural sponge
Water spray
Hair-drier

watercolors
French Ultramarine
Cobalt Blue
New Gamboge
Cadmium Lemon
Alizarin Crimson
Permanent Rose

Valerie H Alexander lives in Shropshire, UK → vhalex@tiscali.co.uk

I wanted to achieve a handmade quality compatible with the historic, traditional nature of my subject.

Wintering Herdwicks, Cumbria, oil, 32 x 42" (81 x 107cm)

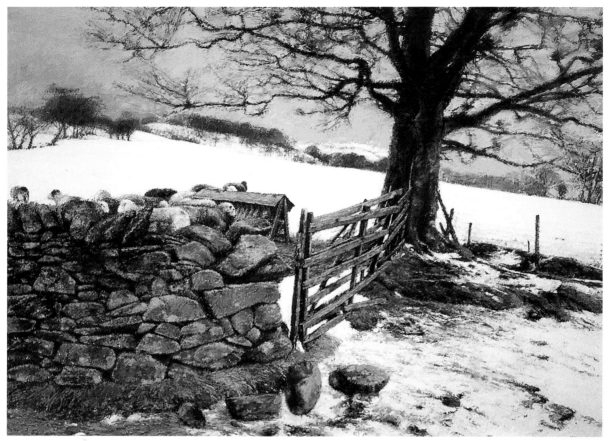

my inspiration

In Cumbria, the sheep that live upon the Fells have an inbred sense of attachment to their particular surroundings so that they do not stray. This concept can also be applied to the people who live and work within such unchanging landscape and steadfast traditions. I had spent time on a hill farm over a period of a year, watching and recording the cycle of work and life that is at the very core of the Lake District area of England. It is a culture and social fabric synonymous with the landscape that forms the framework of the great traditions of sheep farming on the Cumbrian Fells.

my design strategy

The subject and focus of the picture is the Herdwick sheep, yet the most dominant elements in the picture are the stone wall in the foreground and the wooden fence leading away to the beech tree in the middle ground. Your eye is drawn to the sheep by the high contrast there and by a dark triangular shape and the vertical fence post, which makes strong positive and negative contrasts. Accented with the addition of the warm ochre color, the sheep are clearly the focus.

my color philosophy

The color scheme is fairly restrictive within a range of cold earth colors. But the grays and blacks are achieved through different color mixes, some colder, others slightly warmer. There is no pure black. The ultimate warm color is the dye mark on the sheep's fleece. That is Alizarin Crimson, and only found at the focus of the composition.

my working process

- I worked on a lightweight smooth board, which I primed and sealed with a PVA and water solution. Such a smooth surface allowed me to easily draw with sable brushes.
- I started broadly, blocking in with large brushes (hog hair, household, sable, French polishing mops, and sometimes palette knives) to create a wide variety of marks.
- Once the overall composition was established, I began to work on specific areas.

try these tactics yourself

I use many tools to draw, take out, adjust and redraw until I achieve the right feel. The first mark is never, or hardly ever, the correct mark. The picture is an amalgam of marks, a sum of adjustments, that for me makes the very surface of the picture alive. All of this takes time, and provides the essential handmade quality of painting.

what I used

support
Eskaprint board with a PVA water primer 1:5

other materials
Metal baking trays for palettes

Small buckets with white spirit for cleaning

Masses of torn up rags

brushes
Sable and acrylic brushes: rounds, brights, filberts; filbert and flat hog hairs; household brushes; badger softeners; French polishing mops; hog and badger fans; sword liners; riggers; palette knives

medium
5 parts pure turpentine, 1 part stand oil, 1 part damar varnish, 1 part oil of spike lavender

oil colors
Titanium White

Cobalt Blue

Yellow Ochre

Raw Sienna

Raw Umber

Burnt Umber

Olive Green

Alizarin Crimson

Paynes Gray

Ivory Black

Keith Bowen lives in Scotland, UK

I wanted to create a tremendous sense of distance.

California Coast, oil, 6 x 8" (15 x 20cm)

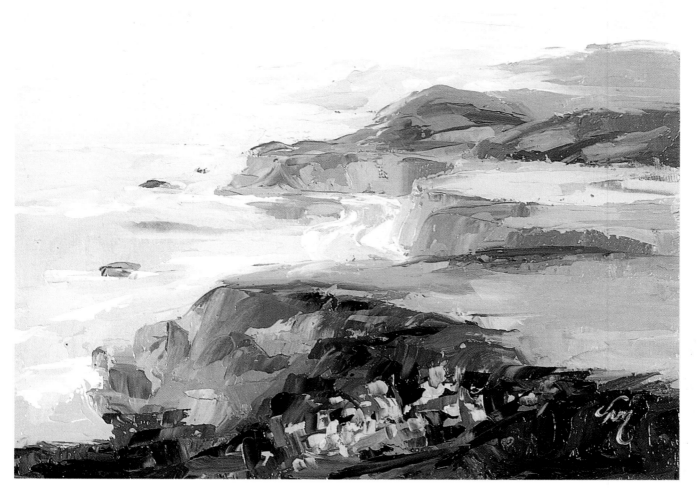

what I wanted to say

The mystique, the beauty and the expansiveness of this stretch of the Pacific Coast in California took my breath away when I first saw it several years ago. It has always stayed in my memory and, having photographed it at that time, I was later able to recapture what I had experienced through painting it. The scene still speaks to me of the sense of timelessness I felt in viewing such a powerful and pristine landscape.

my design strategy

Composition of this painting began with the camera, capturing the interlocking shapes of land and sea. When drawing in a rough sketch on my canvas board, these strong shapes were my primary focus. I also concentrated on being able to capture the tremendous sense of distance in such a small space. I wanted the eye to move naturally into the distance and back to the foreground. Using a simple palette of a few colors allowed me to create color harmony and subtle grays as they receded into the distance.

my working process

• I began with a 6 x 8" canvas board toned with a thin layer of Magenta. Since green tones would dominate the painting, I wanted the complementary Magenta to peek through the finished painting, creating notes of color vibration.

• I had two challenges in painting this scene. The size of the panel forced me to concentrate on what elements of this landscape were most important, which for me were the contrast of rocky shore and moving water and their movement into the distance. I accomplished this by working slowly from top to bottom, carefully transitioning values and detail.

• I painted with a palette knife, using the knife to create hard and soft edges and passages of thick and thin paint, which help move the eye through the painting.

my advice to you

Try mixing all your colors for a painting from just a few. Do not use black, but get your darkest darks by mixing pure color. You will find you can achieve wonderfully subtle values and harmony while keeping colors vibrant.

Once you have worked an area with a palette knife, rarely go back into it. The first strokes with the knife are usually technically the best and often present the best paint quality.

what I used

support
Canvas panel toned with magenta

brushes
Palette knife

medium
Turpenoid

oil colors
Cadmium Yellow Medium
Magenta
Raw Sienna
French Ultramarine Blue
Sap Green
Titanium White

Diane Van Noord lives in Michigan, USA → www.dianevannoord.com

The strong diagonal rock form united these two panels.

Anthony J Batten

Glory Days, oil, 36 x 48" (91 x 122cm) each panel

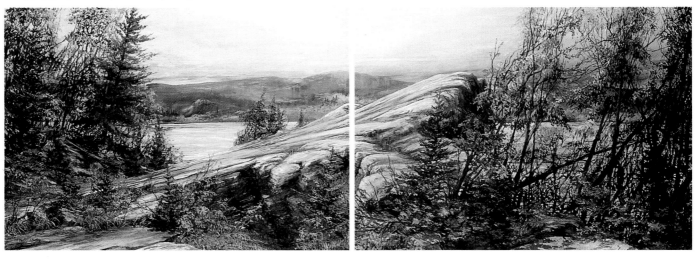

my inspiration

The painting was inspired by a rock ledge lookout overlooking an inlet on Georgian Bay. It was neither a particularly high rock, nor was the scene truly exceptional for the area. But with its combination of rugged landforms and water, it symbolized the ancient landmass that is central and eastern Canada.

my design strategy

I chose to eliminate a few man-made forms and focus on the primordial mass of the rock that unites the two canvases. The original sketches for this composition focused on the cliff-face and the silhouetted tree forms that make up the right-hand panel. The organic nature of the rock led me to expand the scene around the strong diagonal of the rock form itself. Still liking the original right-hand composition, I developed the sketch into two separate compositions that would be inherently united by the strong horizontal line of the far shore and the sweeping diagonal of the rock surface. The appeal of working on a diptych was the challenge of uniting two images.

about color

Beyond its two-panel format, this work was a personal challenge. The legendary colors of a Canadian autumn were something I rarely work with, and I saw this as an ideal opportunity to play with color and atmospheric effects. For me, the dark greens, Burnt Umber and blacks of the coniferous trees, as well as the purple-gray shadows, created a visual contrast against the vibrant reds and yellows of the deciduous forest.

my working process

- Two matching canvases were primed and then coated with ochre-colored oil paint to unify the work. I then sketched in the major forms in Burnt Umber, and developed the pattern of lights and darks by using a White/Naples Yellow mix to block in highlighted areas.

- Satisfied with the composition, I put in the sky, water and far shore with a palette knife, and blended the colors with brushes or rags. After these areas had initially dried, I applied some glazes to give the required translucency to the sky areas.

- Next, I painted the foreground, blending with brushes and, particularly on the rock, with rags. To add details, I used small, fine brushes.

- Some time after completion, I coated the surface with a matte varnish to eliminate the "spotty" surface that developed from using varying quantities of paint and thinner.

what I used

support
Gesso coated stretched canvas

brushes
Rounds and flats in a variety of sizes; palette knives

medium
Turpentine

oil colors

LEMON YELLOW · CADMIUM YELLOW PALE · NAPLES YELLOW · CADMIUM RED DEEP HUE · IVORY BLACK · BURNT UMBER · CERULEAN BLUE · ULTRAMARINE BLUE · COBALT VIOLET · CADMIUM ORANGE HUE

Transparent glazes of egg tempera brought out the luminous light and brilliant color in my summer scene.

Longstock, Hampshire, oil/egg tempera, 14 x 10" (36 x 26cm)

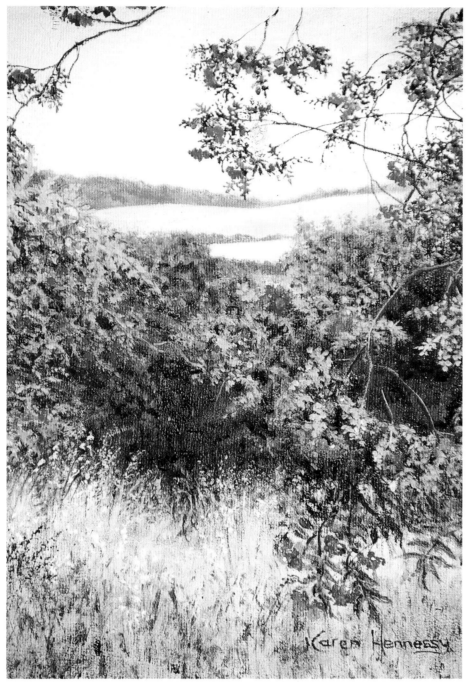

my inspiration

Having been brought up in the countryside, I feel this is the area closest to my heart. I have a deep affinity for our environment and the beauty of nature. Here, I wanted to capture the ambience of a perfect summer afternoon.

my design strategy

The size of this painting had to be governed vertically in order to create the depth between the sky and the ground. The warm color of the berries contrasted tonally against the mellow sky and deep green background. Grasses in the foreground balance with the sky. The overall framing of the rowan tree allows the viewer's eye to be drawn to all areas of the picture, finally resting on the focal point in the center.

my working process

- I used a skeletal sketch to get ideas of proportion, and I took photographs of the scene with a zoom lens to capture details of the grasses, foliage and berries.

- After roughly sectioning the board into thirds, I used a flat sable brush to put in the skyline and fields with a light crimson egg tempera wash. Green and yellow washes followed for the berries and main clusters of foliage.

- After allowing the surface to dry thoroughly, I painted the sky, then horizon and foreground with pale blue and pale yellow. I painted the middle ground and branches with a mixture of five parts turpentine to one part linseed oil and green, blue and brown paint, using a flat hog brush and a pointed sable for small areas.

- When dry, I again worked on the middle area with lighter colors, followed by yellow-green shrubbery at the front, this time using a little more linseed oil.

- The grasses were painted next with Naples Yellow and a round brush. To create the berries, I used about three successive glazes of red and yellow paints applied with a fine pointed brush.

special technique

I painted this picture in stages to create depth and brilliance of color through glazes, allowing each to dry first so as to prevent muddying the true colors. Choosing oil paint was crucial to the success of this process.

the main challenge in painting this picture

I found the main challenge was keeping the background foliage less detailed and distinct than the shrubbery at the front, which was more intense in color and texture.

what I used

support
Primed canvas board

medium
Turpentine and linseed oil

brushes
Flat sable; round sable Nos. 1, 2 and 4; a rigger; flat bristle Nos. 2 and 5; filberts Nos. 4, 8 and 10; palette knife

egg tempera colors
Titanium White
Permanent Rose
Naples Yellow
Viridian
Cadmium Yellow

Ultramarine Blue
Vermilion
Burnt Umber
Alizarin Crimson
Prussian Blue

Karen Hennessy lives in Hampshire, UK → karenhennessy@btinternet.com

By carefully rendering each texture, I accentuated the contrast between the hard stone and the soft snow.

The Hikers — Abbot Hut, watercolor, 20 x 28" (51 x 71cm)

my inspiration

I am currently working on a series of paintings of Heritage Buildings in the Rocky Mountains of Alberta. I was especially inspired by Abbot Hut because of its isolation high above Lake Louise, situated adjacent to Victoria Glacier. I hope my viewers are drawn into the unique mood and drama of this environment and experience the feeling of the stark and rugged stone in contrast with the peaceful feeling of the snow.

my design

The hut is the dominant feature in my composition. The snow ridge and scree (rock debris) edge leads the eye from the foreground up to the front of the hut. The brightly lit roof and the middle tones of the front of the hut contrast against the dark bluish tones of the rock face behind it. Also, the snow edge against the dark stone and the stone in the glacier all direct the eye to the hut.

my working process

- I gathered my photo references and did a number of pencil and tonal sketches. On stretched 300lb paper, I drew in the lines of my composition with an H pencil.

- After masking out the edge of the mountain on the right-hand side of the composition with liquid mask, I proceeded to paint the sky in a loose, wet-into-wet technique.

- After removing this first mask, I then masked out the hut edges and some of the snow areas and ran a warm, light wash of Burnt Sienna, Raw Sienna, Ultramarine Blue and Paynes Gray into the scree areas and rock faces.

- I removed the liquid mask from the hut before proceeding to the next step. After refining my perspective drawing with a pencil, I then rendered the hut, keeping in mind the light source from the upper left-hand side. I chose the lightest stone color and underpainted the whole front face with that tone and color.

- I included some detailing of the hut, although I did not complete it at this time. I preferred to go back to it after I was satisfied with how the other tones and textures in the composition worked out.

- At this point, I painted the rock face behind the hut. This now showed me, basically, the darkest areas against some of the lightest areas, which set my tonal range.

- From there on, it was a matter of rendering the surfaces to be true to their forms and colors.

what I used

support
300lb stretched rough watercolor paper

brushes
Nos. 16, 8, 6 and 2 sable rounds; 1" flat brush

other materials
Rubber masking material

watercolors
Cerulean Blue
Paynes Gray
Ultramarine Blue
Winsor Blue
Prussian Blue

Raw Sienna
Cadmium Red Light
Alizarin Crimson
Burnt Sienna
Raw Umber

Ken Samuelson lives in Alberta, Canada → mjsamuel@telusplanet.net

I made sure I created a strong focal point.

Winding Stairs, oil, 36 x 48" (92 x 122cm)

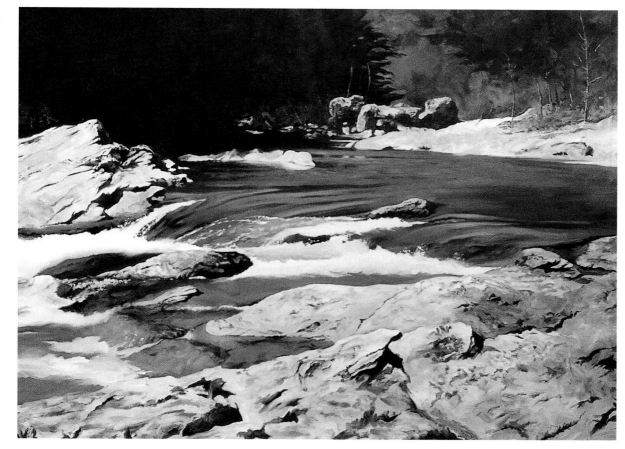

my inspiration

Arkansas is home to many beautiful mountain streams, such as this section of the Little Missouri River known as Winding Stairs. Searching for great subject matter sometimes requires great effort, and experiencing the beauty of creation in a remote setting such as this fuels my desire to somehow share the experience with others.

my design strategy

When shooting a landscape with a camera, I try to compose the image as if it were a painting. Wanting to place the focal point in one of the four quadrants, I framed the image so that the main area of interest — the shallow rapids — was found in the lower left quadrant.

achieving a sense of movement

The strong diagonal shapes from the scene, particularly in the water, create a powerful movement and excitement. They also help move the eye upstream in a zigzag direction. The juxtaposition of the large dark shape of the background at the upper left with the large lighter shape of the rocks at the lower right with the diagonal shape of the water dividing them also helps to create balance and movement at the same time.

my working process

- Because locating this setting required a 40-minute hike as well as crossing two rivers, I had to work from a photograph. Using a grid to transfer the image to a canvas enabled me to gain accurate proportions when drawing the basic shapes and values.

- After completing the drawing, I painted the basic shapes with oil paint thinned with turpentine. I used various values of subdued earth tones.

- When the value painting was dry, I began painting in the dark areas in the upper part of the painting, followed by the foreground and water. I added medium as necessary for fluidity. I tried to complete one area at a time, knowing that I would come back later to paint what I call the "tweak layer".

- At this stage, I tried to evaluate exactly what was needed to complete the painting.

please notice

Sometimes I work in a more painterly fashion, but in this case I let the subject matter dictate the brushwork. Because of the complexity, particularly in the rocks, I found the greatest challenge to be finding the right compromise between indicating too much or too little detail. I felt it was important to maintain as much texture as possible without losing sight of the main shapes.

what I used

support
Cotton duck canvas

brushes
Assortment of filbert and flat bristle brushes with some round bristle and sable brushes

medium
2/3 part turpentine with 1/3 part stand oil

oil colors
Yellow Ochre
Cadmium Red
Alizarin Crimson
Burnt Sienna
Cerulean Blue
Ultramarine Blue
Sap Green
Van Dyke Brown
Paynes Gray
Titanium White

Darrell Berry lives in Arkansas, USA → darrellberry@aristotle.net

To create the illusion of shimmering light, I applied short strokes of color from the same color families.

Plowed Field, acrylic, 19½ x 23½" (50 x 60cm)

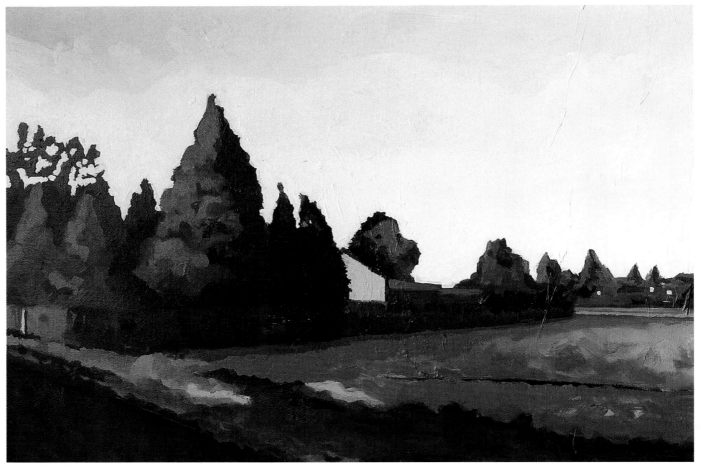

my inspiration

It was August and I was driving through the countryside of Norfolk, looking at all the wonderful variations in color that spread across the landscape. I was amazed to find this freshly plowed field that glowed in the setting sun.

my design strategy

By sheer luck, I found the subject already perfectly composed. All that was needed was to crop into the composition quite hard to position the focal point of the white farmhouse just off center. The curve of the road and verge naturally carried the eye into the hedge row and along to the building and beyond. I quickly produced thumbnail sketches and took photographs before the sunset.

my working process

- Using photographs and the sketches as reference, I redrew the scene onto a canvas board in pencil.

- Using quite a large brush, I quickly and loosely painted in the basic color structure of the picture.

- Next, I established where the light from the setting sun touched the trees and field, leaving the dark shadows behind. I applied the acrylic paint quite thickly to achieve a more rounded impression of a glowing sunset.

- From a range of pure colors, I rapidly mixed colors, even allowing some colors to mix on the canvas itself to maintain their vibrancy. I used the tips of several flat No. 10 brushes to lay down strokes of lighter and darker greens in the fir trees, as well as dabs of earth colors where the sun catches both trees and hedgerow. This technique was then used for the plowed field.

from site to studio

When weather and light permit, there is nothing more enjoyable than working directly outside. However, circumstances often require me to photograph my subject, download the shots into my computer and use those as reference. I find that preliminary sketches, color notes and even written notes on things like the weather conditions, smells, sounds and so forth are always helpful back in the studio.

what I used

support
Canvas board

brushes
Flats Nos. 8, 10, 12; round No. 4

acrylic colors

I warmed up the color and created strong contrast in the focal area.

St Pierre Le Viger, acrylic, 16 x 20" (41 x 51cm)

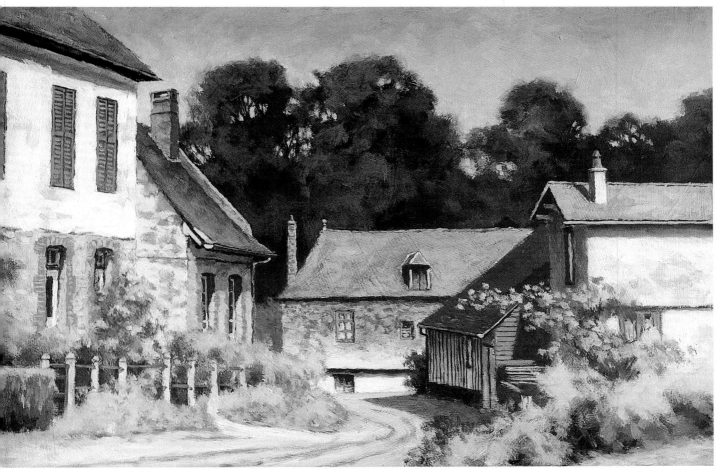

my inspiration

I found this quiet picturesque lane in a small French village in Piccardy while on a painting research trip. The light from the strong midday sun was bouncing up the sides of buildings even in the shade, gardens were in full bloom and a wide range of house structures accented the hill. A good composition was assured, so I just had to paint the scene.

my design strategy

The scene already had a strong composition of great shapes, needing only a little remodeling. I decided to establish the focal area in the lower left off center so that the buildings' shapes, meandering road and garden plants would all flow toward that area where the brightest colors contrasted with the darkest shadows, provided by the block of background trees. However,

I recognized that I would need to enhance some colors to warm up the focal area and create a strong tonal contrast there.

my working process

- First, I toned a prepared board with a thin wash of Burnt Sienna acrylic paint, creating a warm background. With a smaller round brush, I used thinned Burnt Umber to draw in the scene from a photograph, although I used a degree of artistic license to enhance the design. Good design is more important than realism.

- Next, I established the darks throughout the whole painting with Mars Black.

- Working from dark to light, I blocked in the whole painting to establish tone in a quick and loose style. This was completed in about 20 minutes. Before continuing, I adjusted the drawing wherever necessary

to create interesting shapes.

- I then began to put in the dark and darker mid-tones, freely allowing the paint to spill over to soften edges, except in the main areas around the focal point where I wanted harder edges.

- For a rich blue sky, I used Azure Blue at the horizon running into Cobalt Blue higher up. The shapes of the trees were cut out by the painting of the sky.

- Finally, I put in the rest of the

light tones and reflected lights to bring the painting to life. I enhanced the main focal area with bright highlights on flowers, fences and buildings and a few colored dark spots in the shadows.

HOT TIP!

Give your creative processes food for thought by creating at least six or more totally different paintings from one good photograph.

what I used

support
Prepared panel
(mdf board sanded with 2 coats of acrylic gesso)

brushes
Flat hog hair brushes Nos. 2, 5 and 14; round hog hair brush No. 2

acrylic colors
Lemon Yellow
Cadmium Yellow
Cadmium Red
Crimson
Azure Blue
Cobalt Blue

Phthalo Green
Burnt Sienna
Burnt Umber
Mars Black
Titanium White

John Stoa lives in Scotland → www.johnstoa.com

Susan Flanagan

To keep all these greens feeling tranquil — but not boring! — I varied tone and temperature.

Take the Path, pastel, 9 x 12" (23 x 31cm)

my inspiration

I frequently have my camera with me. My inspiration for this painting was a photograph I had taken on a walk. The lush growth of summer spoke of peace and tranquility. There were places of stillness as well as movement. The scene made me curious. Where would the stream or the distant natural path lead?

my design strategy

There is a natural, interesting design to this scene. The strong value changes, the dramatic lighting and the arrangement of the rocks and shoreline lead the viewer's eye from the foreground to the background, where there is a suggestion of a path. The trees are strong vertical elements that keep the interest inside the painting.

try these tactics yourself

- Working from the photograph, I sketched the large shapes on white sanded paper with a pastel pencil to be sure of placement and perspective.
- I then blocked in the shapes with generous amounts of soft pastel in colors similar to the final tones. Using an inexpensive brush, I applied odorless Turpenoid over the pastel so that the white of the paper was completely covered with pigment as I established my value pattern.
- When this was dry, I layered more pastel on top for detail. I generally work from the background to the foreground and from dark to light.

- For fine lines, I rolled the rounded edge of the flat end of the pastel stick. To soften some edges, as in the foreground bushes and the reflections, I blended with my finger.

the main challenge in painting this picture

A challenge for me in creating this painting was the dominance of the color green. I had to look carefully for variations in value and temperature of the greens and for other colors in the rocks, water and shadows.

what I used

support
Sanded paper

other materials
Medium soft pastels of several brands

Odorless Turpenoid

Brush from hardware store

Susan Flanagan lives in Illinois, USA → www.sueflanagan.com

The composition is what makes this whole painting interesting.

California, oil, 20 x 30" (51 x 76cm)

taking a break

I mostly paint figures, so doing a landscape painting is a good exercise to refresh my eyes. I always feel free and relaxed while doing landscapes. Not only do I get to enjoy the beauty of nature, I feel my spirit is all in there, too.

my design strategy

The composition is what makes this whole painting interesting, especially that huge area of filled-in shadow. The foreground, which is about ²/₃ of the painting, shows how wide the field is. In looking at this more closely before starting to paint, I realized that about 65 per cent of this shape is cool and the rest is warm, although these tones dominate. This analysis helped me to clearly know what colors I should use to make the whole painting look harmonious.

my working process

- First, I did a small quick study in oil on the side and played with the composition.
- For the actual painting, I started with a white canvas and quickly sketched down the big shapes by using a No. 2 flat brush and Burnt Umber mixed with turpentine. I kept the line drawing as simple as I could.
- Next, I blocked in values for the mid-ground and background only.
- Because I was afraid that the big shadow area would disturb my eye when I was working on the mid-ground, I left the foreground white.
- When finished with the block-in, I painted directly, trying to be sensitive to putting down the exact colors and tonal values. I started from the mid-ground, moved up to the background and sky, then down to the foreground.
- For the foreground, I painted a Viridian color first. When it dried, I painted Burnt Umber on top of it. Then I used sandpaper to slightly lift off some of the Burnt Umber to let the Viridian show through. This way, the foreground wouldn't look dim.
- After this, I painted a thin layer of Alizarin Crimson on it to make the painting harmonious.
- In my last step, I used a palette knife to apply heavy paint on these houses to contrast against the generally smooth surface, which makes the viewer's eye go there directly. I then used a No. 2 flat brush to define detail.

HOT TIP!

Do small, quick color studies before starting new paintings. They help a lot with composition and color.

what I used

support
Stretched canvas

oil colors
Cadmium Yellow
Yellow Ochre
Alizarin Crimson
Burnt Sienna

Burnt Umber
Viridian
Ultramarine Blue
Titanium White

brushes
Flat and filbert brushes Nos. 2 to 16; palette knife

medium
Half turpentine and half linseed oil

Shu-Ping Hsieh lives in California, USA → shuhsieh@hotmail.com

Painting on location helped me get the mood and colors right.

Fall in the Fish Hatchery, oil, 10 x 12" (26 x 31cm)

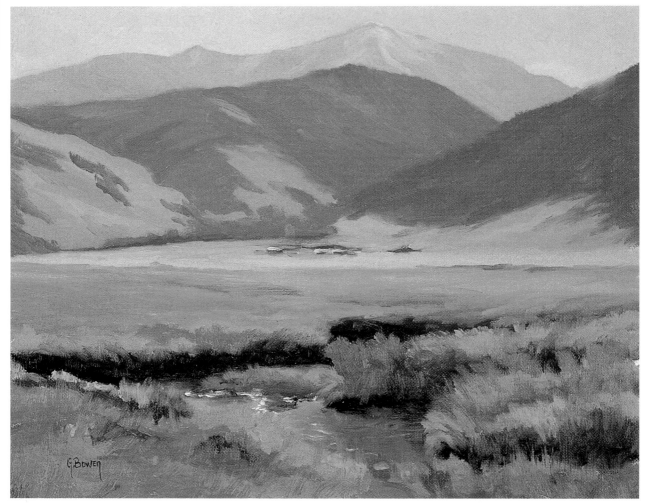

my inspiration

I painted this picture at the fish hatchery just north of Jackson Hole, Wyoming. It was a beautiful, crisp autumn morning in this wonderful grassy valley, where the elk come to graze in the winter. I wanted the viewer to see the beauty of this remote spot and feel how peaceful it was to be there.

my design strategy

Mother Nature provided a pretty great design without my having to change much. By omitting a small fence in the foreground, I allowed the viewer's eye to follow the creek and color changes back to the little village.

my working process

- Because I was traveling and painting outdoors, I packed a small, lightweight museum board with linen glued on top.
- I toned it with a thin wash of Burnt Sienna, then rubbed most of it off with a paper towel. I then did a light sketch of the creek and mountain placement with a Burnt Sienna colored pencil.
- When I started painting, I worked from dark to light, which meant I pretty much went from the bottom of the canvas up. I did put in the sky pretty early to make sure that I got my values right on the distant mountains.
- I wanted to show the atmosphere so I put the strongest colors up front and softened them as they receded. Cooler colors on the distant mountains created depth in the painting.

why I paint onsite

I painted this on location mainly because it's so darn much fun. I also find that my colors are more correct if I paint on location than from a photo. If I want to bring the painting back to the studio and do a larger version, I have the right color notes. I can then add photos to the mix for more drawing information if I need to. Also, painting from life helps me get to know my subject much better than a photograph so I can more easily convey the emotional aspect that I want.

HOT TIP!

The biggest challenge when you paint outdoors is always the speed with which you have to work. The light moves so swiftly and everything changes with it. It's quite important to have your gear properly organized so that when you find that great spot, you can get set up and painting very quickly.

what I used

support
Linen glued to museum panels with "Miracle Muck"

brushes
Filberts and flats Nos. 4, 6 and 8; No. 4 soft sable synthetic

oil colors
Titanium White
Cadmium Lemon Yellow
Cadmium Yellow Light
Cadmium Orange
Permanent Alizarin Crimson

Cadmium Red Light
Cerulean Blue
Prussian Blue
Winsor Violet
Indian Yellow

Ginger Bowen lives in Arizona, USA ➔ www.gingerbowen.com

Working with the painting upside down allowed me to focus on the shapes.

Dragons Mountain, oil, 24 x 36" (61 x 92cm)

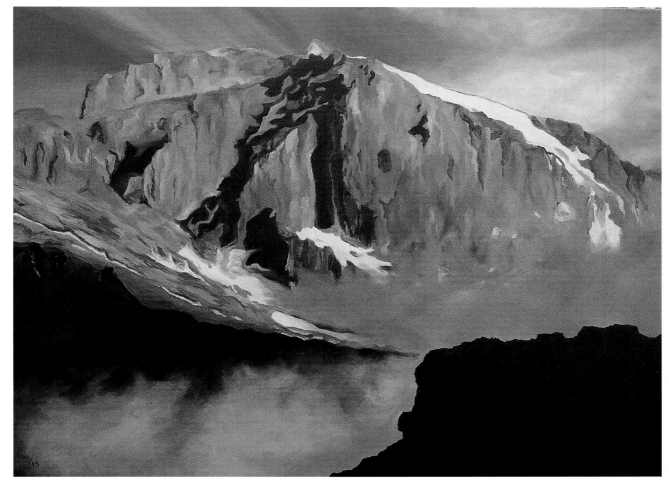

my inspiration

My inspiration came from looking at some images that a friend had sent me through e-mail. They were images from his trip to Africa, a climb to the top of Mount Kilimanjaro. He had captured, with his camera, the depth and wonder of that mountain and terrain. I wanted to see if I could also do the same on a canvas.

my design strategy

I did not have to do any of the typical design work to create this painting. The photograph already had all the right elements in place. What I wanted to capture was the depth of the atmosphere and the striking contrast of the light and shadow, while downplaying the mountain itself so that all the features became equal. I wanted all of the elements to accentuate one thing — the depth of the overall atmosphere.

thoughtful preparation

First, I printed out a black-and-white copy of the image, and also placed the picture on my computer desktop. Then I turned them upside down. I looked at these for a few weeks until it was no longer a picture of a mountain, but rather shapes, light, shadow and color. Throughout, I considered how to capture the mist and atmospheric depth.

my working process

- When I was ready to start, I used mostly complementary colors (yellows/purples) to block in the shapes. I used paint straight from the tube, with little mixing of other colors. I added painting medium for just a bit of smoothness and applied it with a large brush.

- I then began to build up thin layers of varied color, again using painting medium. I kept the image upside down during the whole process, and worked from the top down.

- I blended and feathered with a fan brush where necessary, in the sky and around the mists. I kept other areas chunky, but thinly layered, to build the sharp contrast between the shadows and lighted areas.

something you could try

By painting an image upside down, you force all normal parts of a landscape to become equal in strength and importance. For me, it helped me capture that sense of awe we feel when trying to take in a glorious sky, a beautiful mountain and a misty landscape all at once.

what I used

support
Prepared canvas

brushes
1 wide bristle and
1 fan brush

medium
Liquin

oil colors
Cadmium Yellow Light
Yellow Ochre
Alizarin Crimson
Cadmium Red Medium
Cerulean Blue

Ultramarine Blue
Burnt Sienna
Burnt Umber
Titanium White
Ivory Black

Cheryl Lynch lives in Virginia, USA → http://hometown.aol.com/mystymntntop/index.html

I played with my colors to get texture and mood.

Quiet Lane on Hollister Ranch, oil, 9 x 12" (23 x 31cm)

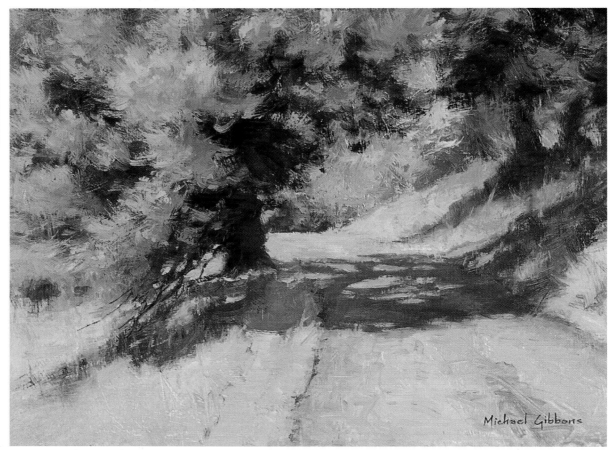

what I wanted to say

Solitude and quiet — I was alone with nature, late in the afternoon, under a tree for shade from the stultifying heat, in a narrow valley protected from the incessant wind. I was struck by the beauty of the tree on the left, especially the patterns and the variety of subtle colors. What I wished to say had more to do with how I envisioned my muse (the materials) being used to convey a feeling inspired by the particular patterns and colors before me.

my design strategy

Designing a painting is not a conscious activity at first. I will look for a contrasting area I wish to focus on, usually in the middle ground, and use elements around the focal point to assemble a simplified and hopefully a little more dramatic painting. In this case, I used contrast and delicious, subtle gourmet colors. The eye path begins in the

cooling shade of the tree before continuing on an inviting journey to an unseen destination.

my working process

- I quickly laid in the composition with a thin wash of distilled turpentine and Transparent Red Oxide, using a No. 12 flat and a ½" French sash brush, adding a touch of Ultramarine in the darker areas.

- Once satisfied, I sparingly added a medium to the dark and mid-value colors, using only enough paint to achieve the values desired.

- Next, I concentrated on the general colors and values before switching completely to my "auto-pilot" mode to bring the painting to the "it says what I want to say" stage.

- During the finishing process, I used three flats plus my favorite, a ½" "el cheapo" hog bristle brush. I also used a palette

knife to both add and remove colors. When to stop is the single most important concept to learn. Here, I stopped when the surface was rich and delicious.

something you could try

Use mixtures of transparent or translucent colors in the dark and mid-value areas. Light will pass through these paint mixtures and reflected back from the white

ground, appearing much like deeply colored glass.

my advice to you

Working directly from life is where the nuances and experiences of "being there" are perceived and translated by the artist through the medium of expression. A camera has no soul, no brain, is color impaired; deaf, and has but one eye. Enough said.

what I used

support
Masonite hardboard panel sealed on both sides and primed

oil colors
Vermilion
Cadmium Orange
Transparent Orange
Indian Yellow
Jaune Brilliante
Yellow Ochre

brushes
Flats Nos. 6, 8, 10 and 12; ½" French sash brush; inexpensive ½" hog bristle brush; palette knife

Yellow Deep
Cadmium Yellow Medium
Cadmium Yellow Lemon
Cadmium Green
Cobalt Teal

medium
Sun-thickened walnut oil, copal resin and distilled turpentine mix

Ultramarine Blue
Cobalt Violet
Transparent Red Oxide
Titanium White

Michael Gibbons lives in Oregon, USA → www.michaelgibbons.net

Variation and repetition of shape, rather than a specific focal point, is what makes my painting interesting.

Rammed Earth Houses, Yunnan Province, oil, 11 x 14" (28 x 36cm)

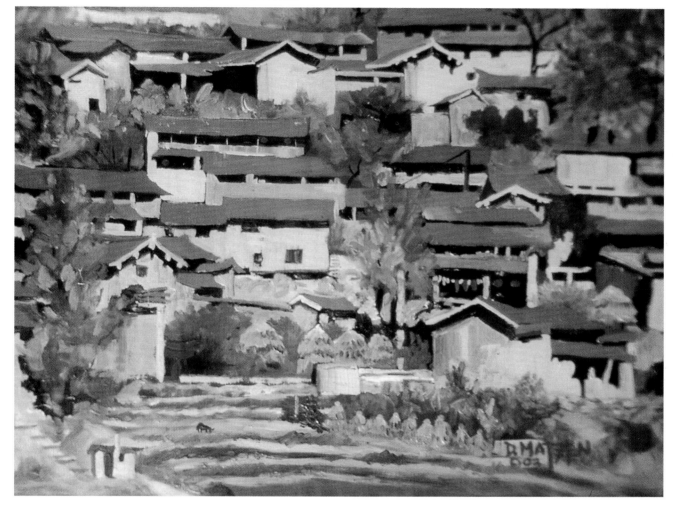

my inspiration

While living in China in 2002, I saw many instances of buildings cobbled together. There, they place the homes in clusters to preserve space for growing crops. This was my inspiration for this painting, part of an entire series about my memories of China.

my design strategy

When I saw this scene, the repetitive rectangular shapes "rubberstamped" on the landscape attracted me and became the focus of this painting. Variation and repetition of shapes, rather than a specific focal point, make it interesting. Once these preliminary shapes were in place, the values of the composition came into play. Values are often the feature that attracts and holds the viewer, thus they can make or

break a painting. Here, I divided the values into three distinct groups — light, medium and dark.

my working process

I used brushes for the entire painting, working to place the dark values, then the lights, with the medium values last. By painting the mid-range values last, I was able to adjust the hues of the buildings, giving each some variation. Sometimes I applied Vermilion to make the reflected light seem hotter. Trees and foliage were added after the buildings were in place and pretty much completed. I added touches of Cobalt Turquoise, Vermilion and yellows to the trees. This gave the painting a little more color and provided interest to the rather monochromatic buildings. For the most part, the paint was applied

and left without further adjustment. Seldom did I go back and glaze over any of the passages — I prefer the direct method.

my advice to you

Many times paintings seem "blah" because they fail to have the necessary punch that good darks can give. I am one of those firm believers that tubed Black will kill a painting, but some wonderful rich darks can be mixed from pure

colors. For instance, try mixing Quinacridone Rose and Phthalo Green or Burnt Sienna with Ultramarine Blue.

However, guard against homogenization! Don't overmix your colors — on the palette or on the painting — into mud or you will kill the light. Instead, dip one side of the brush in one color and the other side in another color and paint the stroke. The eye will blend the colors.

what I used

support
Board with three coats of Venetian red gesso

oil colors
Hansa Yellow Deep
Organic Vermilion
Quinacridone Rose
Burnt Sienna Deep

Cobalt Turquoise
Rich Green Gold
Phthalo Green
Zinc White

brushes
Mostly small flats

medium
Walnut oil

D Matzen lives in Washington, USA → debobon2001@yahoo.com

Despite my fast-and-furious painting technique, I was able to organize this complex scene.

Botanica, watercolor, 20 x 28" (51 x 71cm)

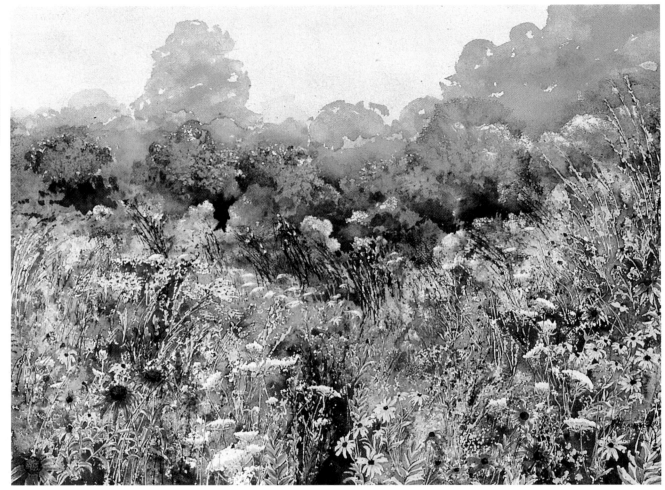

my inspiration

The idea for this painting came from a wildflower meadow I saw at a well-known garden in Pennsylvania. I believe that Americans have come to appreciate wildflowers more since Ladybird Johnson arranged to have them planted along our highways.

follow my eye-path

In the studio, I worked from sketches and photos so that I could create my own response to this meadow by arranging the flowers and colors to suit me. Through small thumbnail sketches, I worked out patterns and repetitive elements of colors and value shapes that would create a path for the eye to follow. This path allows viewers to enter the painting, relax and feel as if they are in there, a part of it. Contrast is a useful design principle that I employed to divide the space, thus giving depth to the painting.

my "wild" working process

- I started with a very detailed drawing of the flowers. I then masked out those elements that I knew I would not be able to save with my all-encompassing main glaze.

- In my first glaze, I put in the sky.

- Once that first glaze was completely dry about two or three days later, I went back in with the main glaze, which is a wild painting session that puts all the colors and values down all at once. As I worked, I washed out parts that were too dark, darkened areas that were too light, spattered, threw paint, gouged with a credit card edge or palette knife, sprayed on water and threw salt. At this point, I was frantic because this is the "make or break" of the painting, but everything had a purpose. The whole thing took about 20 minutes, but it was essential to work continuously or the paint would become too dry.

- Later I returned to add some details, darken areas and use a sharp knife to gouge out a few light points.

- Finally, I painted in the background trees.

something you could try

My lively one-glaze method is perhaps better suited to the studio although I use it in the field as well, much to the amusement and consternation of the bystanders!

what I used

support
Watercolor paper

brushes
Large squirrel mop; No. 10 sable round; small scrubber brush; rigger; palette knife

other materials
Spray bottle
Facial tissue
Cut-up credit card
Electric eraser
Coarse salt
Paper towels
Sponges
Stamps

watercolors
Hansa Yellow Light
Aureolin
Cadmium Scarlet
Winsor Red
Cerulean
Cobalt
Antwerp Blue
Ultramarine
Brown Madder
Paynes Gray

Rosemary Nothwanger lives in Virginia, USA → rnothwanger@rivnet.net

Diagonal edges and lines of dark accents were my keys to keeping the eye moving around this simple subject.

Long Lane, Devon, watercolor, 22 x 16" (56 x 41cm)

my inspiration

I have always loved to draw and paint trees, and this lane gave me the perfect excuse to show them in near winter mode, some bare of leaves, others still clinging on. Devon is full of interesting single track roads similar to this one.

my design strategy

This one was a "natural". The line of trees and hedges, the fall of the road and the line of telegraph poles all take the eye to the middle distance and then through to the horizon. Low winter sunshine added interesting and intriguing shadows, contributing to the overall painting.

my working process

- I started with a fairly detailed sketch of the fall and line of the road and hedges. I spent longer on the telegraph poles in order to make sure of the perspective. The main bulk of trees were drawn with reasonable attention to detail, with just the trunks drawn as I worked towards the distance. Distant buildings and fields were barely indicated.

- I washed in the sky using Ultramarine and Cobalt Blue. I carried this down the length of the painting, weakening the color across the distant fields and leaving patches of light, then strengthening the color along the stretch of road.

- Next, working back from the horizon, I suggested tree lines, buildings and fields. I added slight details to the nearer middle ground buildings and the main body of trees and hedges.

- The painting was completed in the studio, as I needed a steady hand to put in the final details of the trees, hedges and telegraph poles, as well as the strongest darks along the right hand hedge. These accents were used to connect the two sides of the picture.

what I used

support
300lb (640gsm) paper

brushes
7/8 goat hair; Nos. 2, 3 and 4 sable round; Nos. 1 and 2 riggers for detail

watercolors
Cadmium Lemon
Cadmium Yellow
Yellow Ochre
Burnt Sienna
Yellow Green
Cobalt Blue

Ultramarine Blue
Russian Blue
Madder Lake
Mars Brown
Russian Green

Peter Haynes lives in Doncaster, UK

I used value contrast and aerial perspective to draw the viewer into this fascinating street.

Humboldt & North, gouache, 22 x 30" (56 x 76cm)

my inspiration

In my mind's eye, there are certain places that take on a life of their own. This corner at Humboldt and North is one of those places. In the past several years, while I was very, very busy teaching, I'd drive through this intersection many times, longing to put aside my schedule and my work so I could paint it. Now I have. It was something I was actually desperate to do. Light, shadows and colors give the objects on the corner of Humboldt and North an animated quality.

my design strategy

In this painting, the viewer's eye is drawn through the intersection, over the hill and on up the shaded street in the center of the picture. The dominance of the tall poles and building on the right side of the street, along with the remaining buildings, poles and trees, serve to reassure the viewer that the center path of the picture is indeed the one to follow. I want the viewer to not only appreciate the colors and light offered by the objects visible within the picture, but also to wonder what lies beyond that pleasantly shaded street that draws you into the distance.

my working process

- Using my memory and several photographs I had taken of the area as references, I sketched the composition on illustration board with a soft lead art pencil.
- I painted the sky first with a flat No. 20 brush. Then, beginning on the left side of the picture, I painted the basic colors in all

the buildings. Following this, I painted the poles and streetlights on the right side of the picture.

- After these were dry, I again started on the left side of the picture, painting in details and defining the forms of the various objects.
- I completed the painting by putting clouds in the sky and adding any poles or signs I felt

would enhance the composition. The fire hydrant and grass in the right lower corner of the painting were a final touch.

why I chose this medium

I decided to use gouache as my painting medium because of its fast drying ability. I enjoy using gouache for certain paintings because it creates brilliant, flawless areas of flat color.

what I used

support
Illustration board

brushes
Flat brushes Nos. 20, 6; round brushes Nos. 4, 2, 1

gouache colors

Zinc White	Magenta	Olive Green	Vandyke Brown
Primary Yellow	Brilliant Violet	Gold Ochre	Lamp Black
Flesh Tint	Cerulean Blue	Permanent Green Light	
Primary Red	Primary Blue	Burnt Umber	

Kathleen Bergstrom lives in Wisconsin, USA

I wanted background with foreground to balance this subject.

Summer Solstice, oil, 16 x 20" (41 x 51cm)

my inspiration

I am fascinated with the abstract shapes and forms found within nature, particularly shadows and cloud formations. While these are often used as incidental elements within a composition, my intention was to bring these background aspects forward to make them equal in importance to any solid object. In doing so, I made the solid objects within the painting appear almost camouflaged against the background. This ensures that the viewer takes notice of things that are often overlooked or perceived as invisible.

my design strategy

Because the background was important, I sought out ways to unite it with the foreground, merging the two so that there was no way of knowing where the sky ends and the land begins. In this way, the eye would not be guided by straight lines, for I did not want any one part of the painting to dominate. Instead, I let the patterns and strong contrasts in tone and color guide the eye evenly throughout the painting. This applied to the light and shadows as well. I chose the time of day when the sun would appear near the zenith (hence the title "Summer Solstice"), so that the shadows would fall directly below the objects and therefore contribute to the abstract shapes that comprise the background.

my working process

- Initially, I completed several oil sketches in the garden. I then enlarged a selected composition onto primed, medium density fiberboard.

- Using my oil sketches as reference, I blocked in the colors with oil paint thinned with artists' solvent. I allowed the paint to dry before I worked in more detail on top, using thin sable brushes. Rags were employed to soften the edges of the outlines of the shadows and clouds.

- A little linseed oil was introduced into each subsequent layer of paint. In all, the painting was completed in four glazes to achieve the desired depth of colors and sharpness of detail.

the main challenge in painting this picture

Emphasizing the background meant heightening the colors and contrasts in tone and temperature as much as possible, yet I still had to make it look convincing. There was a danger of going too far — the colors in the background could have looked gaudy and the shadows too harsh. I wanted to see how far I could go without ruining the effect. I had to get the balance just right.

what I used

support
Medium density fiberboard prepared with acrylic polymer primer

brushes
Bristle and sable brushes

oil colors
Lemon Yellow
Cadmium Yellow
Cadmium Red
Permanent Rose
Ultramarine Blue
Phthalo Blue
Burnt Sienna
Burnt Umber
Titanium White

Rachel Shirley lives in West Midlands, UK → www.rachelsgallery.fsnet.co.uk

My limited color palette reflects the warm atmosphere and quiet pace of this rural scene.

Uxbridge Chickens, oil, 24 x 30" (61 x 76cm)

Mostafa Keyhani

what I wanted to say

On a visit to Uxbridge farm, I was taken aback by an old house and how simple and peaceful it felt. To me it personified rural life and its isolation from the complexities and fast pace of cities. The structure of the barn is beautifully simple. The nature of the village was very natural and self-sustaining. The healthy lifestyle these people led came through vividly. Observing the pace and life of this village was inspiring and extremely cathartic for me, and I wanted this feeling to come through in my painting.

my design strategy

It was crucial for me to paint from life so I could become part of this scene and understand the pace and nature of everyday life here. I wanted the sense of motion and the pace of this scene to come across. I made quick sketches and gave the right feel to the painting, not only by depicting a scene but also by using my brushwork to depict the sense of immediacy.

my working process

- On a canvas toned with Transparent Oxide Brown and Ultramarine Blue, I began this piece by first building the composition and the structure of the barn.
- Once I had built a solid foundation of the shapes, I started to fill in the darker areas, using transparent colors with a No. 2 brush. I continued this process, working with darker shades first and moving to softer, medium tones.
- For the finishing touches, I added highlights to bring out details in the painting.

try these tactics yourself

- Try to paint from life whenever possible. This way, you get a sense of the natural colors much better and a deeper understanding of the mood and pace of your scenery.
- Choose the best composition that is also pleasing and delightful to the eye. This gives you a solid structure for your painting.
- Try to paint a wide range of subject matters to get more experience. You'll find this will also give you different inspirations.

what I used

support
Canvas

brushes
Nos. 2, 4, 6 and 8 brushes

oil colors
Cadmium Lemon Yellow
Cadmium Yellow Light
Cadmium Yellow Deep
Cadmium Orange
Grumbacher Red

Alizarin Crimson
Transparent Brown Oxide
Rembrandt Green
Cobalt Blue
Ultramarine Blue

Mostafa Keyhani lives in Ontario, Canada → www.mkeyhani.com

I hid rich colors in unexpected places to surprise and delight the viewer's eye.

French Village, watercolor, 13 x 18¾" (33 x 48cm)

my inspiration

The inspiration for the painting was a small and remote village in the south of France, not far from Avignon. It was colorful in its first impressions, though otherwise a little forlorn, a broken section of fence marking its entry. A small group of locals was gathered, gossiping, in the distance. The village itself has a strange atmosphere and a pervasive sense of suspended time. It was for its atmosphere that I decided to make this into a painting.

my design strategy

Of primary importance in the composition was the roadway and its rough patterns offsetting the blocking in and solidity of the houses alongside. Vertical emphasis was, I felt, important for added dramatic effect. This was arrived at by means of the gap in the broken fence lining up with the corners of the two gable ends,

emphasized also by the attached telegraph lattice on the second house. The distant church and trees formed a useful background.

my working process

Most initial washes were carried out in watercolor, using a well-loaded 2" flat brush, which is excellent for covering a large surface quickly. More colors were added soon after, while the first swatches of pigment were still wet. Some of the outlined elements were arrived at more slowly and methodically once the first general areas were dry. Subsequent adjustments to this were made using gouache and acrylic, the latter to a minimal extent but with good effect in intensifying contrasts. It is, after all, important to avoid a painting looking rather lifeless due to lack of contrast, lack of color or both. Here, the ochre patches in the ground and touches of fairly intense blue

were added in order to liven up the image. Finally, the cool effects arrived at in this painting.

avoiding details

Try to distance yourself from needless detail that adds little to the main effect. Look rather to the original idea of the painting — does it have an impact? Whatever

the subject, the artist can perhaps emphasize some features he or she feels are important, or make a few adjustments that could result in more dramatic treatment. If it lacks interest, no one will give it a second glance. Better, surely, to bring the painting to life by communicating to the viewer what attracted the artist in the first place.

what I used

support
190lb not handmade watercolor paper

watercolors

	Raw Sienna	Cadmium Yellow	Cadmium Red	Burnt Umber	
Naples Yellow					Cerulean Blue
Cobalt Green					Cobalt Blue
Oxide of Chromium					Ultramarine Blue
Viridian					Mauve

J Richard Plincke lives in Hamshire, UK

I applied layers of color to build up the bewitching light in my painting.

Overy Beach Sunset, watercolor, 21 x 29" (54 x 74cm)

Andrew Dibben

my inspiration

I have painted numerous pictures of dusk and night scenes, because they are particularly evocative, atmospheric and romantic. I came across this scene after sunset but before darkness descended, following a very long walk along a raised bank, through salt marshes, a tidal creek and sand dunes. The light was quite bewitching and the cloudscape very striking, and there was a sensation of vast, open space enhanced by the complete absence of any living thing. I wanted to try to recreate that feeling of distance and calm.

my design strategy

Though the sky in itself was vast and striking, the feeling of space was magnified when this was reflected in the flat pools left at low tide. I chose to include areas of ridged sand scoured by the tide, as these give perspective, helping to define the depth in the scene. The strong contrast between areas of sand and water were very satisfying. Because of time and safety constraints (with the failing light), the picture was based on photographs taken on the spot.

my working process

- After drawing the basic shapes very lightly, I thoroughly dampened the paper and applied a graduated wash of Cerulean Blue for the sky and foreground water. (When dry, this becomes virtually insoluble, so it's the best wash to begin with.)

- Once dry, I dampened the whole sheet again for a graduated wash of Pale Yellow Ochre with a little Cadmium Yellow in the foreground water and lower sky.

- When dry, I put in the sand areas with a strong mixture of Paynes Gray and Light Red. To paint some of the ridged sand area in the foreground, I drybrushed a weaker mixture of the same colors with the side of a bigger brush to catch the texture.

- After wetting the paper yet again, I used a wet-into-wet technique for the clouds, repeating until the right tone was achieved. Streaky clouds were applied when dry.

- Lastly, I wet the paper again to apply my final washes, using a mixture of Cobalt Blue and Paynes Gray to bring out the glow of light in the sky.

please notice

Achieving the right tonal balance was the key here. It turned out that the strong contrast was essential in making a satisfying image, while the foreground sand ridges and the gradually receding clouds all helped give the feeling of depth.

what I used

support
300lb rough
watercolor paper

brushes
Synthetic brushes
Nos. 2, 4, 7, 8, 10 and 16; a few mixed synthetic and sable; a 2" flat synthetic

watercolors
Cadmium Yellow Pale
Yellow Ochre
Light Red
Bright Red
Cobalt Blue
Paynes Gray

Andrew Dibben lives in Norwich, UK → www.andrewdibben.com

Diagonals bring movement to this moody painting.

Stream by Kanis Road, oil, 24 x 36" (61 x 92cm)

my inspiration

Fall is my favorite season of the year. I love the vibrancy and the varieties of the fall colors. One morning, the backlight falling on this stream near my house seemed to cast just the right glow of light over the landscape, causing the fallen leaves to shimmer. These active elements contrasted with the tranquil, clear sky and tree trunk reflection in the water. It was a beautiful place at a magical moment.

my design strategy

The diagonals of the bright reflection at the water's edge echoed by the diagonals of the banks bring movement to this image. Likewise, the convergence point of the reflection in the right stream corner is echoed by the sloping point of the bank.

about light and color

The morning backlighting enhances an interesting silhouette of trees in the distance and creates a shimmering pattern on the water and the leaves on the ground. The warm tone of the foreground is in harmony with the warm backlighting at the horizon. The cool color of the focal point, the stream, was accentuated by the surrounding warm ground and was echoed distantly by the trees in the background.

my working process

- I selected the best photographs taken at somewhat different angles, then sketched the composition on canvas with Burnt Umber.
- After putting in a gradated blue/gray tone in the sky, I added a touch of Yellow Ochre

to represent morning light on the far right side. I also used Alizarin Crimson with a touch of Cadmium Red in the sky just above the silhouette of the trees.

- I used dark tones for the trees in the distant background, again gradating from darker to lighter in the left-to-right direction. Light strokes suggested bare branches.
- I then painted in the various shapes of the land masses and the stream, highlighting the top

parts glanced by the morning sun. I laid in some details, such as the cast shadows and horizontal strokes to represent leaves floating on the surface of the water, as I went along.

- Plenty of bright colors, as well as some neutrals, were required to suggest all the leaves and tree branches. The tonal values of tree branches and tree trunks were gradated similarly to the sky.
- To complete the image, I put in the curving road and fences.

what I used

support
Medium cotton duck canvas

brushes
Mostly filbert bristle brushes with a few small synthetic brushes

oil colors

Cadmium Yellow	Brown Madder Alizarin
Yellow Ochre	Van Dyke Brown
Alizarin Crimson	Cerulean Blue
Cadmium Green	Indigo
Burnt Sienna	Titanium White

Vaneerat Ratanatharathorn lives in Arkansas, USA → Vaneerat@aol.com

The gradual graying and cooling of my colors suggest a grand sense of space and depth.

Afternoon Light, oil, 16 x 20" (41 x 51cm)

my inspiration

The warm glow of the western sun reflected on the Grand Canyon and the vastness of this beautiful natural phenomenon inspired me. This time of day presents a lot of contrasts with light and shadow, creating a peaceful quality.

my design strategy

I wanted to emphasize the depth and distance of the canyon, recreating something the viewer would certainly feel if he were standing on the same spot. This composition is basic, dividing the canvas into three shapes — a thin band at the top and two triangular shapes formed by a diagonal flowing from upper left to lower right.

The horizon line is very high to give the illusion of looking down into the canyon.

follow my eye-path

Gradually the eye moves from the sunlit shrubs on the rock outcropping on the left to the reflected light on the right side of those same formations. Then the eye moves on to the sunlit rock faces into the distance. By gradually graying and cooling the colors from foreground to background, I conveyed the distant feeling of the buttes and the horizon. The contrast of the shadowed foreground and the western-lit rock formations adds to the drama.

my working process

- On site, I took several photographs and painted a small watercolor to get a feel for the rock formations and their erosion patterns.
- Once in the studio, using these references, I drew the final composition on a canvas washed with thinned Raw Sienna oil paint to create a nice glow.
- Using a variety of filbert brushes, I blocked in the shapes from dark to light. As I moved to the background, I cooled and grayed my colors, making each section of rock formation appear to be farther away than the previous.
- I painted one section at a time, starting with the lower left foreground, moving to the lower right. Next, I painted the middle ground, the horizon and lastly the sky.
- Finally, I tweaked the image with dark and light accents here and there to push the contrast even further.

how to paint from photos

On-site observation is a valuable tool. Notice the obvious elements like sky, land, foliage and so on, then notice the subtle things like the way plants grow, the way rock erodes and the way the sunlight hits a textured surface. Observations like these will help you in the studio with your paintings.

what I used

support
Stretched, primed canvas pre-painted with Raw Sienna oil paint

brushes
Round and filbert Nos. 2, 4, 6

medium
Turpenoid

oil colors
Cadmium Yellow Light
Cadmium Orange
Cadmium Red
Burnt Sienna
Ultramarine Blue
Dioxazine Purple
Titanium White

Janet Broussard lives in Texas, USA → www.janetbroussard.com

Create large and intricate paintings on site by returning when the light is the same.

Trabuco Canyon, oil, 20 x 24" (51 x 61cm)

my inspiration

While hiking in an area known as Trabuco Canyon in search of a forest subject, I saw the light glowing through the leaves and streaming between the trees on the river bank. I knew immediately that I had to paint it.

my design strategy

I knew that the verticals and diagonals at the top of the painting would need some horizontals at the bottom to contain the eye. This is why I included a portion of the undercut bank with its exposed roots and driftwood tangles. These elements break up the dark horizontal band, keeping it from becoming dominant and also making it consistent with the patterning of leaves and branches above.

site, studio, site

- I had come prepared for sketching, and did an 11 x 14" sketch on a panel while on site.

- Even as I was sketching, I decided to do the work in a larger scale. Back in my studio, I began to develop the larger canvas by laying in the basic color masses on a white surface with large brushes. I used my on-site sketch as reference.

- A week later, I returned to the site to complete the larger canvas. Having done the block-in already, I moved immediately to doing some minor correcting of the linear elements that would carry the eye. I then dropped in my lightest lights and darkest darks to establish my value range, making sure it matched what was in front of me. Next, I did the same with the warmest and coolest hues.

- I returned to the site with the large canvas three more times for about two hours each session. In these later sessions, I used progressively smaller brushes to break up the large masses, such as leaves or shaded tree trunks. However, I spent more time on capturing the overall look — position and shapes of masses, positive and negative spaces, lights and darks — than on rendering details. I wanted whatever I put on the canvas to convey what had initially caught my eye.

my advice to you

Work on site, returning only under the same light and weather conditions to develop your painting beyond being only a start. Spend your time looking at the subject and painting it, rather than looking at your painting and fiddling with it. Compare what you have just done to Nature, and Nature will tell you if you did it right.

what I used

support
Oil-primed linen canvas

oil colors
Titanium/Zinc White
Cadmium Yellow Light
Cadmium Yellow Medium
Cadmium Orange

brushes
Bristle brushes and some fine sables

Yellow Ochre
Cadmium Red Light
Cadmium Red Deep
Alizarin Crimson

medium
Turpentine

Viridian
Cerulean Blue
Cobalt Blue
Ultramarine Blue

Richard H Probert lives in California, USA → rhprobert@sbcglobal.net

I wanted to make the empty areas the focus.

Wisconsin Field, oil, 22 x 60" (56 x 153cm)

Gilbert Gorski

my inspiration

During my late teen years I spent many happy hours exploring the rural areas of southern Wisconsin on a motorcycle. With this painting, I recalled my attraction to the flat prairies that create such startling compositions. During the long Chicago winters I painted this piece for myself to remind me of those pleasures.

my design strategy

My objective was to create a painting that would complement a minimalist interior design. I used a one-point perspective to flatten the image and reduce the composition to an arrangement of planes. I was interested in attempting to make the empty areas of the piece the focus. The surface has a variety of textures, from an eggshell smooth sky to thick impasto touches in the foreground.

my working process

- On a neutral gray ground, I started by defining the areas of the composition in flat areas of color.
- After this had dried, I worked up the painting one section at a time. For each area, I applied a dark, sticky glaze that would then set up, allowing me to brush paint strokes over it that would then fuse into the canvas. Some areas were more richly textured than others.

about photography

The field portrayed here does not exist except in my memories. In a way, I believe the success of this piece might have come about because I was freed from being influenced by a photograph and allowed myself to explore the possibilities of a composition that I sensed more than I had seen. The design was created through a number of pencil studies. I am only beginning to understand the difference between photography and painting. Photography is an act that is processed through a mechanical device; painting is an act that is processed through a human being.

what I used

support
Linen stretched over heavy duty wood bars, primed with a thick, smooth oil base

brushes
Hog hair filbert brushes of various sizes; palette knives

medium
Sun-thickened linseed oil and damar varnish

oil colors

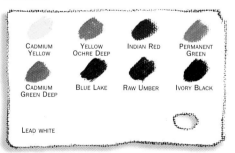

CADMIUM YELLOW · YELLOW OCHRE DEEP · INDIAN RED · PERMANENT GREEN · CADMIUM GREEN DEEP · BLUE LAKE · RAW UMBER · IVORY BLACK · LEAD WHITE

Gilbert Gorski lives in Illinois, USA → www.gilgorski.com

I used a warm palette of analogous color to create a restful atmosphere.

Sunlit Pathway, oil, 24 x 36" (61 x 92cm)

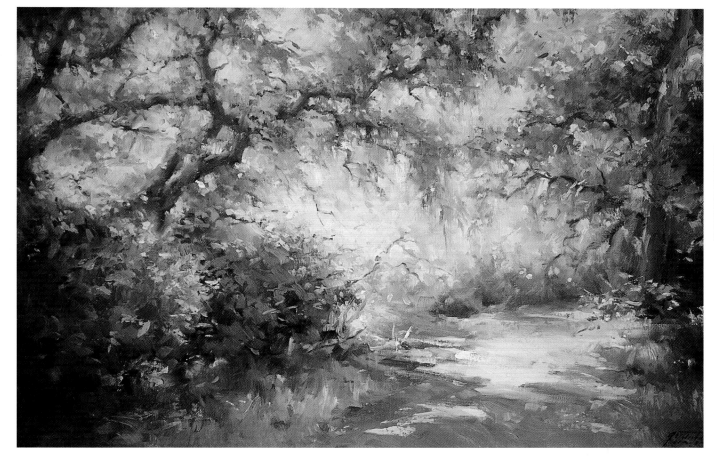

my inspiration

Dappled sunlight dancing through a forest onto a winding dirt pathway has always intrigued me, beckoning me to a peaceful place. I have hiked this trail a number of times, and finally took my pochade box back to make an oil study and take a photo. The result moved me. I decided to produce the painting all in one long day so as not to lose the impact of my emotion regarding this fleeting, exuberant moment.

my design strategy

In creating this painting, I composed a backwards "C", using the inner drama of light to attract the viewer's eye. The large oak branch on the upper left provides an anchor, a strong dark to contrast my focal point of light.

a color study

I initially worked up a small oil color study and took a few photos to document the scene. Oil studies are most useful, as photos taken in extremely contrasting light lose all of the detail that the eye can see. The nuances of color and value changes are also available only when working from life. Here, I used a warm palette of analogous color to create a restful atmosphere. Only a dash or two of red were added at the end for a bit of excitement.

my working process

- I knew I had to paint this in one long spurt of creative energy to get the magic of fleeting sunlight, so I laid out huge amounts of paint.
- I laid in my darkest washes first with a mix of Alizarin Crimson, Sap Green and Ultramarine Blue. As soon as I had established my main composition, I added some opaque Cadmium Yellow Deep to the same mixture and began applying thicker mid-tones. I then dashed in an area of light to confirm the overall value pattern.
- From there, I worked back and forth from darks to mid-tone darks and into the lighter areas, using very large brushes. I finished with bold strokes of a palette knife in the light areas only.

try these tactics yourself

Try painting a large painting with a surge of creative energy in one session, trusting your knowledge. Take a chance and make bold statements with large brushes. Make good compositional studies first and then "go for it". Move quickly and don't go over any brushstrokes you put down. Your art will radiate the energy and emotion you felt.

what I used

support
Oil-primed linen

brushes
Bristle brushes, Nos. 10 and 12 filberts and No. 8 flats; painting knife

medium
Walnut oil and a bit of bioshield thinner

oil colors

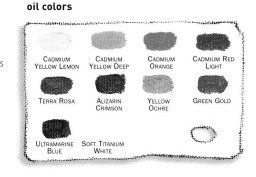

CADMIUM YELLOW LEMON CADMIUM YELLOW DEEP CADMIUM ORANGE CADMIUM RED LIGHT

TERRA ROSA ALIZARIN CRIMSON YELLOW OCHRE GREEN GOLD

ULTRAMARINE BLUE SOFT TITANIUM WHITE

Lynn Gertenbach lives in California, USA → www.lynngertenbach.com

Light and dark contrast and horizontal highlights make a strong, moody painting.

Reflections, pastel, 24 x 18" (61 x 46cm)

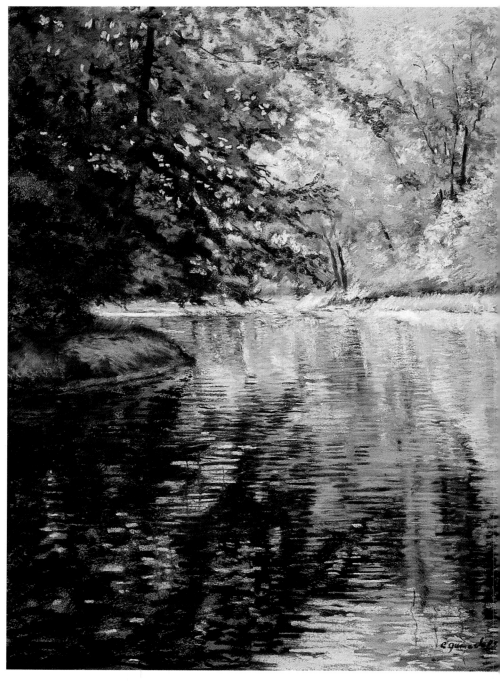

my inspiration

My interest is in nature and in experimenting with color and light. I look for places that bring me a sense of peace. The Cape Neddick River, close to where I live, is a spiritual place for me, a place where I find inspiration. The day I took this picture I was in a small boat. The light was right. The calmness of the day and the light created wonderful reflections. I wanted to capture this moment forever in a painting.

follow my eye-path

In this painting, I used the reflections to lead the viewer up the river and behind the left bank into the light. The horizontal bank and the diagonal tree branches in the upper left frame the lighted area, making it the center of interest. The contrast of the darks and lights with horizontal highlights gives this painting added strength and creates a mood.

my working process

- I sketched the composition with vine charcoal on a tan board from a photo I had taken. Although I often paint outdoors, capturing this particular scene was more easily done in my studio since light and reflections change so rapidly.

- After planning my light areas, I covered them with Cadmium Yellow. I then covered dark areas with a dark violet. Using rubbing alcohol and an inexpensive brush, I painted over the colors to create a fairly solid underpainting.

- I then started the sky and trees, marrying the colors of each as they met, leaving soft edges. I continued working from top to bottom, focusing on covering the entire painting in values (darks and lights).

- Again working from top to bottom, I applied many more layers of color, placing several values of my colors for variety in each area.

- I seldom blended with my finger. When blending was required, I used a hard pastel or pastel pencil. The marks created in the reflections thus remained clean and clear.

- Details and highlights were added last.

the main challenge in painting this picture

Painting these water reflections was difficult. I had to pay close attention to the shapes of lights and darks to show the flow of the water. However, I also had to control my marks, values and colors to reveal which objects the water was reflecting. In the end, the short, horizontal highlights of blue, yellow and orange brought it all together.

what I used

support
Tan pastel board

other materials
Soft pastels of various brands
Alcohol
Inexpensive brush

Claudette Gamache lives in Maine, USA → www.claudettegamache.com

Fine detail and texture produced with small brushes helped me recreate the sensation of being there.

Flying Home, acrylic, 16 x 20" (41 x 51cm)

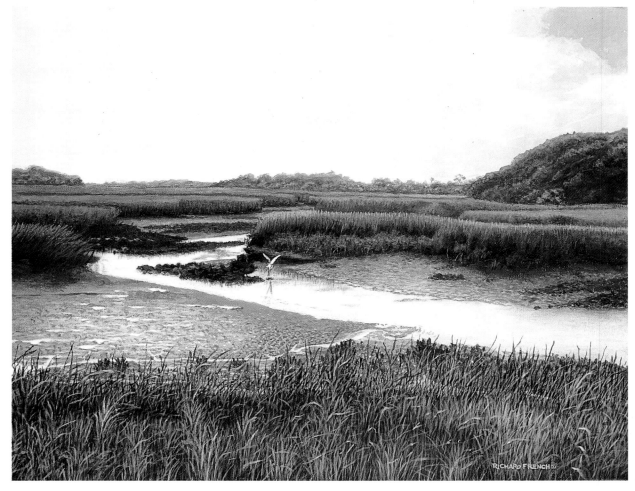

my inspiration

This painting depicts a moment in time when the light is beginning to fade and the gull takes flight for its roost. The serene marsh is at low tide. The backlight produces cool, soft shadows, emphasizing the peach of the setting. The varied textures of foliage, sand, water and oyster beds present an added challenge in realistically interpreting this scene.

my design strategy

The reflected light on the stream leads the viewer's eye to the point of greatest contrast and the focal point of the painting — the white gull against the near black of the oyster beds. The stream meanders on into the far ground, while the serpentine foliage directs your eye back into the painting to explore the details of the foreground.

my working process

- I primed the canvas with a coat of gesso that I had tinted with Ultramarine Blue so I could work on a colored field.

- I work from slides I've made, and I project them onto a screen next to my easel. With a soft pencil I drew a minimal sketch on the canvas for placement of the major elements, leaving out the man-made objects. Then it was time to turn the projector off and make a painting.

- I blocked in the sky and large areas of foliage with a ⅝" angular synthetic brush. I continued working from the top down, bringing each area to a rough finish. By adding acrylic glazing liquid, I was able to work over the entire painting, adjusting hue, intensity, temperature and value as necessary.

- At this point, I began to focus on the fore- and mid-ground by using sable brushes to put in detail and texture.

my valuable slide library

I always use pictures I have taken myself so I can rely on my memories while recreating the feeling of having been there. Over the years, I have taken many hundreds of slides, which I've sorted by subject matter into an extensive library.

However, I have never produced a painting from a single slide, nor would I want to. For instance, if I like an image except for the sky, I look in my sky file for an additional reference. In some cases, I have used as many as seven slides as sources, just so long as the lighting matches. In other words, I never try to literally copy a photographic source — I edit, simplify and refine.

what I used

support
Stretched canvas primed with colored gesso

brushes
Nos. 2 and 4 rounds;
⅝" angular;
½" flat;
2" synthetic brush

medium
Glazing liquid

acrylic colors
Turner's Yellow
Light Ultramarine Blue
Medium Magenta
Chromium Oxide Green
Viridian

Cobalt Blue
Ultramarine Blue
Burnt Sienna
Burnt Umber
Titanium White

Richard French lives in Florida, USA → www.richardfrenchfineart.com

Broad strokes and a warm palette allowed me to emphasize the dappled light.

Backlit Ridge, pastel, 13½ x 17" (35 x 44cm)

Barbara Benedetti Newton

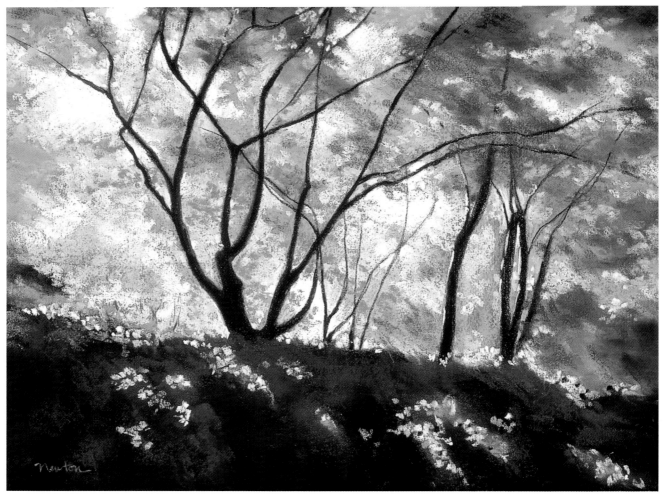

what I wanted to say

One sunny, spring day I spent several hours in Washington Park Arboretum in Seattle, a 230-acre collection of rare trees and shrubs. Of the many reference photos from that visit, the one that became "Backlit Ridge" stood out because of the sharp contrast between light and dark. In particular, the silhouetted tree branches and foreground dappled with light caught my eye. It created an unusually dramatic landscape.

my design strategy

I liked the unusual perspective of looking up onto the landscape. The composition of the scene was quite good just as I found it, requiring little design correction. I adjusted the color to a warmer palette, allowing the background of light to suggest a wall of fire, which added drama to the scene.

my working process

- I printed my digital reference photo at low resolution so I wouldn't get caught up in too much detail.

- With the reference photo in hand and my memories of the scene, I considered the palette of colors for the painting. I also selected a red paper to complement and support my color scheme.

- After attaching my paper to thick foam board and positioning my surface straight up and down so the excess pastel would fall into a paper trough below, I was ready to begin painting. I used vine charcoal to lightly sketch the scene on my paper.

- Next, I selected a soft white pastel to lay in areas of the lightest value, using my reference photo as a guide. Similarly, I lightly applied a dark pastel to the darkest areas. Wearing a latex glove, I rubbed the first layers of pastel into the tooth of the paper, using separate fingers to keep lights and darks apart.

- Once I had established both ends of the value scale, I used that to make additional decisions about value and color. Starting at the top, I began to build the landscape with layers and juxtaposed areas of various colors of soft pastel. My emphasis was on broad strokes of color, rather than detail, that captured the essence of the scene.

something you could try

When working with pastel, I find it interesting to use a colored paper surface. A paper in the same color as the overall color scheme will unify the scene, while a complementary color will intensify the pastel pigments.

what I used

support
Machine-made French cotton, acid-free paper

other materials
Both hard and soft pastels

Sweeping curves add up to a circular composition that brings your eye right to my focal point.

Afternoon on the Towpath, oil, 16 x 24" (41 x 61cm)

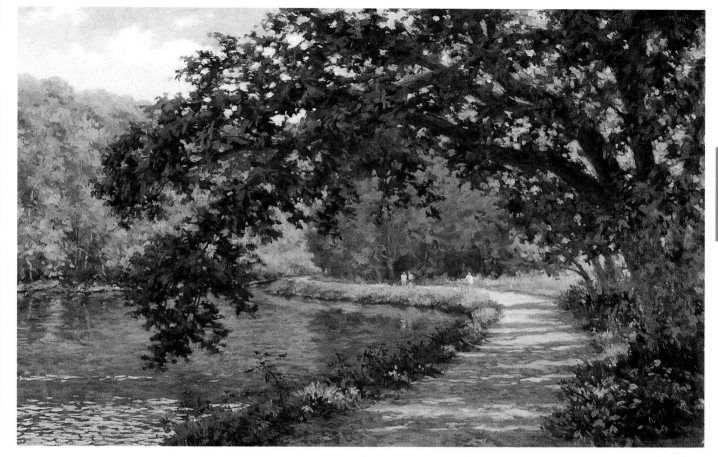

ARTIST
37

Barbara Nuss

my inspiration

The C&O Canal in Washington, DC, is one of my favorite painting sites. It's a cool oasis in the big, bustling city that attracts hikers, joggers, birders, kayakers, fishermen, and, of course, artists. When I saw this graceful old tree bending toward the water, I couldn't resist the way it framed the distant figures.

follow my eye-path

Fortunately for me, this is one of the few paintings that did not need much rearranging and redesigning, but I did curve the towpath so that it would lead in from the left. The powerful circular format was laid out in front of me and all I had to do was paint it. The viewer's eye follows the curved towpath into the scene and focuses on the distant figures.

my working process

- I began the painting on location with a 9 x 12" color field sketch.

I took photographs for reference, using the zoom lens for details. While I was painting, I took numerous shots of the water reflections and the figures for additional options.

- With some minor adjustments, I gridded my sketch to enlarge it. After my initial sketch with soft charcoal on the canvas, which I wiped off as I proceeded, I laid in appropriate lean, cool, dark colors for the shadow areas, the masses of tree foliage, the trunk and limbs. I roughed in the intricate shadow pattern on the towpath with a cool orange.

- With cool mid-tone greens, I massed the trees on the far bank. Then I painted the sky with a fluffy white cloud.

- I repeated these steps, working dark to light, refining the areas as I proceeded. With subtle touches of blue-violet, I increased the cool atmosphere in the areas of the far trees.

- The next-to-final steps included adding thin branches, sparkly sky reflections on the water, wildflowers and weeds along the towpath, and bright spots of sunlight peeking through the tree.

- The last step was painting the suggestion of figures. From my source photos, I selected one jogger by himself and two others nearby, apparently deep in conversation.

please notice

To paint convincing aerial perspective, I diluted the receding areas with gray and blue-violet.

my advice to you

If you like landscapes, I recommend learning to draw accurately and quickly and frequently working from life.

what I used

support
Stretched Belgian linen prepared with rabbit's skin glue and primed with white oil

brushes
Bristle filberts Nos. 2, 4, 6, 8; synthetic sable filbert No. 2; synthetic sable round No. 0

medium
Odorless turpentine, Liquin

other materials
Soft vine charcoal
Mahlstick
Cotton rags

oil colors
Cadmium Yellow Light
Cadmium Orange
Yellow Ochre
Cadmium Red Light
Quinacridone Red
Ultramarine Blue
Phthalo Blue
Phthalo Green
Titanium Zinc White

Barbara Nuss lives in Maryland, USA → www.barbaranuss.com

Notice how I used angled shapes, such as the triangle of snow, to direct your eye around the painting.

Sedona, Early Snow, oil, 30 x 40" (76 x 102cm)

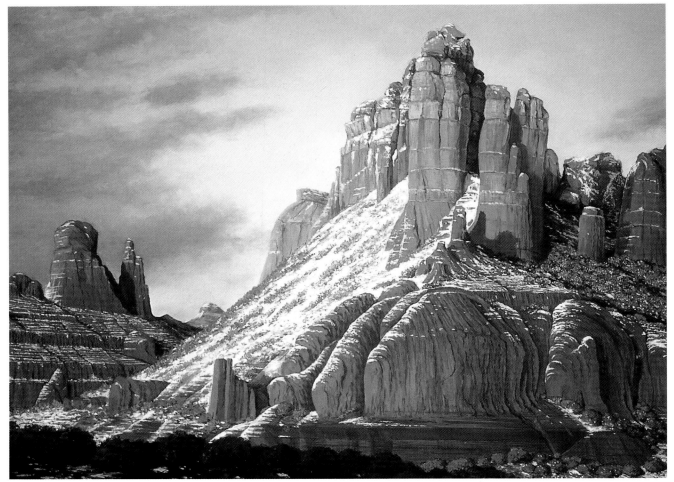

my inspiration

I painted as a young man, but for the past 28 years I have owned several art galleries throughout the Southwest so my focus has been on working with other artists. However, when I saw these rocks glowing against the clear winter sky, I felt the desire to capture the essence of that moment in a painting. This is my first painting in 30 years, and the start of my next career.

my design strategy

While the rock formations are quite complex, I planned the painting with an upward thrust based on the triangular shape of the snow-covered side of the formation. This key element ties the complexity together by drawing the eye up from left to right to the brilliant coloring of the red rock against the blue sky.

Just as the dark trees against the bottom anchor the movement and direct the eye back upward again, the echo of formations on the far left also block in the composition to direct the view back to the center.

my working process

- First, I took photographs to capture the unusual view and brief moment of light that would have been very difficult to paint during a long outdoor session.
- I drew the major formations in acrylic washes of Burnt Umber to create the basic composition of the painting. Still using acrylics, I quickly refined and adjusted the overall layout.
- I then proceeded with oil paint, using round sable brushes with Liquin and turpentine to build layers of color.

- The sky was painted with a flat sable brush, adding a slight amount of Lemon Yellow and white to the blue for a brilliant color. That brilliance was enhanced with a lighter blue around the edges of the rock formations to emphasize the color of the red rock.
- I softened the clouds by feathering and blending the colors with a finger.

special technique

I find it helpful to test a possible color, shape or detail on a piece of clear food wrap laid over the painting before committing it in oil on the canvas. This way, if it doesn't work, I can quickly take it off and try something else.

please notice

To make each painting uniquely your own, know your subject, be inspired, then present the painting in your own expression rather than following the influence of others you may admire.

what I used

support
Canvas

brushes
Round and flat sables

medium
Liquin

oil colors
Titanium White
Winsor Lemon
Cadmium Orange
Cadmium Red
Venetian Red

Burnt Sienna
Sap Green
Cobalt Blue
Cerulean Blue
Van Dyke Brown

Don Pierson lives in Arizona, USA → elprado@sedona.net

The contrast of shape, value, texture, edges and color make my focal point clear and engaging.

Autumn Leaves, oil, 16 x 24" (41 x 61cm)

John Pototschnik

what I wanted to say

The creation of "Autumn Leaves" had several motivations. Underlying everything was the desire to capture the feeling of autumn in New England with all of the nuances of color and texture. I also loved the surprise of discovering a residence behind all those fallen leaves.

follow my eye-path

The design of this piece is pretty straightforward. The focal point is framed by two large groupings of very dark tree trunks and the sunlit side of the house is the lightest shape in the painting. Therefore, contrast of shape, value, texture, edges and color play a significant role. The painting began from a color photograph, although I redesigned the house, changed the lighting and intensified the color.

my working process

- On a white canvas, I began organizing my subject by drawing directly with a round bristle brush and a warm hue. Once the necessary information was on the canvas, I double-checked the placement of all elements by placing the canvas in a frame.

- I began the block-in with the darkest tree trunks. Then all other color-values, thinned with mineral spirits, were laid in relative to those initial darks. I used the largest brush I could so I wouldn't be tempted with details at this early stage.

- Once the canvas was covered, I again checked everything with the canvas in the frame. This was certainly the easiest time to make changes before proceeding to the next layer.

- I began with the sky, the house, then the area surrounding the house, taking each area pretty much to finish. I concentrated on refining the drawing, color, value and edges of each element.

- Finally, I put in the finer details. A critical analysis of the piece as a whole helped identify slight adjustments to be made here and there.

why I chose oils

Oil painting really suits my temperament. I like to go slow at times and carefully consider my next move but I also appreciate how easily changes and adjustments can be made. It lends itself to everything from the scantiest of marks to the highest degree of refinement.

my advice to you

- Intently learn your subject by painting directly from nature. However, the development of your memory, imagination, patience and quality of finish also have value.

- Don't let your photographic reference determine the look of your painting but instead let your concept determine how the photo reference will be used.

what I used

support
Masonite panel, sanded and painted with several coats of acrylic gesso

brushes
Nos. 2-8 flat bristles; small, round, synthetics

oil colors

John Pototschnik lives in Texas, USA → www.pototschnik.com

Careful attention to value and color helped me capture the specific characteristics of weather and locale.

Windswept, oil, 20 x 30" (51 x 76cm)

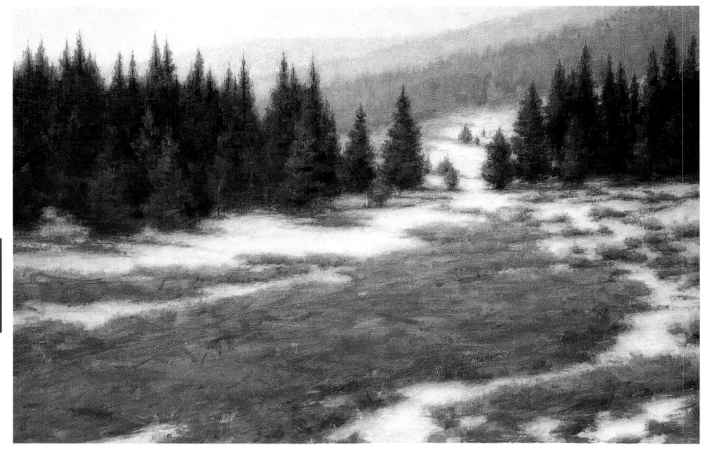

my inspiration

This scene made a strong impression on me with its cold wind, intermittent blizzards and expansive views. I wanted to see if it was possible to portray this excitement, even though the subject was quite dimly lit and presented a very limited range of subdued, neutral colors.

my design strategy

The major shapes in this piece all describe the same gentle incline. The strong directionality helps to evoke the windswept feel of the place. There are secondary vertical and curved elements that provide interest and help balance the strong oblique line. Pathways are included to invite the viewer to "travel" through the painting, engaging the imagination and providing a more complete sensory experience.

preliminary study

- Hiding from the wind in the front seat of my car, I did a small painting of this scene on site to help me understand color and value. Since I hadn't painted these exact conditions before, I didn't try to produce a piece of finished artwork. I just focused on gathering the information I would need later in the studio.

- I also took some digital photographs. The two types of reference material together provided enough information to complete the final painting.

my working process

- Back in my studio, I needed a few more sketches to explore compositional issues. I transferred the best of these to the canvas as a thin oil wash.

- I then used blue-gray paint at the top of the painting, progressing to a rust color at the bottom. I like to allow the underpainting to peek through the final painting, and these colors would help to create the illusion of relative distance.

- Using the oil paints without added medium, I started with the sky and worked my way down to the foreground. I made several passes over the whole painting, refining composition, values, colors and edges each time. I was careful at every step to ensure that all the parts of the painting appeared consistent and truthful relative to each other.

the main challenge in painting this picture

The dim, non-directional light and narrow color range in this subject could easily lead to a boring painting. To avoid this, I used lively brushwork and a variety of subtle but interesting colors. Most important, I knew that the success of the painting would depend on a strong design.

what I used

support
Stretched cotton canvas with an oil-based white primer

oil colors
Cadmium Yellow Pale
Cadmium Yellow
Yellow Ochre
Cadmium Orange

brushes
Medium to large flat bristle brushes; palette knife

Alizarin Permanent
Cadmium Red Light
Burnt Sienna

medium
Odorless mineral spirits

Ultramarine Deep
Manganese Blue
Titanium-Zinc White

Scott Leonard lives in Colorado, USA → sdleonardart@aol.com

Blending and layering color achieved this tranquil evening scene.

Still Waters, pastel, 10 x 10" (26 x 26cm)

my inspiration

I spend my summers on the beautiful coast of Maine. Each year, on the last evening before leaving, sadly knowing I will not be back until the following summer, I try to impress a picture on my mind that will last until I return to that lovely place again. This picture comes from an outdoor painting session on my last night there last summer.

my design strategy

The color of the evening sky and the reflection of it in the water drew me to paint this. I wanted all the elements and colors to complement each other and direct the eye to the highlight of the painting, the water and the sky. The last light of the day on the rocks reinforces the tranquil mood and time of the day. It also leads the eye to the horizon, then around the sky, and finally back to the land, a movement that makes a complete cycle. The blending and layering of pinks and blues surrounded by the warm earth tones turn the sky and the water into the focal points of the painting.

my working process

- For this painting, I began by making a drawing in charcoal on white museum-grade paper, letting my designer's eye guide the placement of trees, rocks and other elements. I then shaped all of these elements with lights and shadows, squinting my eyes to see if I was satisfied with the design. To set the drawing, I sprayed it with fixative.

- I then laid in color, using a combination of local and complementary colors while also trying to achieve the correct values. I used warmer tones in the foreground, getting bluer as I moved into the distance to suggest depth. I then used fast-drying alcohol applied with a brush to set the color tones.

- When the alcohol dried completely, I used my same selection of colors to redraw the scene, using the charcoal outline only as a guide. I applied the pastels on their sides, cross-hatching, scumbling and occasionally blending with the tips of my fingers. I started at the top of the painting and laid in color throughout before starting any detail work.

- At the completion of the painting, I removed it from the foam backing board and flicked the back of it with my fingers to remove as many loose particles of pastel as possible.

what I used

support
Museum grade paper

other materials
Various brands of pastel
Charcoal
Fixative
Alcohol
Synthetic brush
Foam backing board

Marge Levine lives in New Jersey, USA → www.mlevine.artspan.com

Once I had established the value drawing, I was free to add interest by using a wider variety of color.

Dawn Over Port Royal, pastel, 18 x 26" (46 x 66cm)

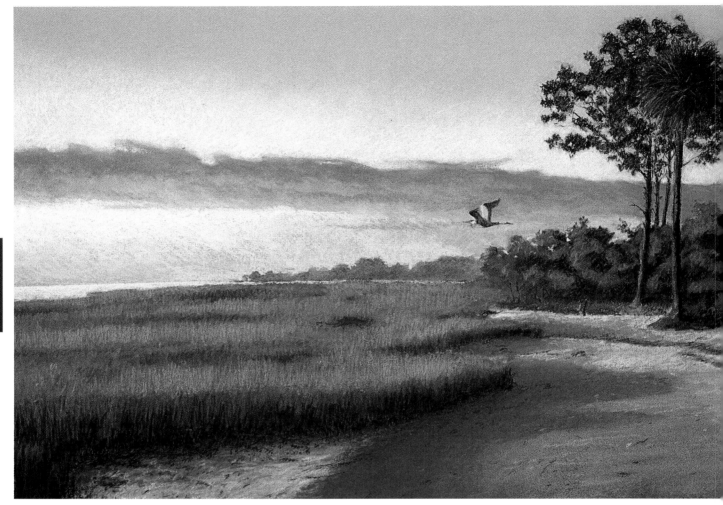

my inspiration

How could anyone resist a beautiful sunrise with all it has to promise? Most people think of marsh color as a dull gray-green, but when the sun's first light hits the dew moist grass, it turns the marsh to a blazing orange. This was my inspiration.

my design strategy

The sunrise light was changing very quickly, so I took 25 to 30 digital photos and made mental notes of the colors. Back in the studio, my computer helped me to find details in the shadows and bring color back into the lightest areas of the photos. Before I put pastel to paper, I spent a lot of time studying the photographs, planning how I would handle the light and dark patterns, color perspective and textures of various surfaces. What were the underlying colors in the shadows? What visual information was important? What needed to be subdued or deleted?

my working process

- On sanded paper, I started with a line drawing to determine proportions and value patterns.

- After a light coat of fixative, I began an underpainting by scribbling in the large, flat areas with hard pastels. I used colors that would enhance my final colors, such as an olive green under the orange grassy areas and purple under the dark green foliage. Next, I applied alcohol to the different colored areas with a flat ½" hog hair brush to work the color into the paper, being careful not to fill in the sanded texture. Again, I applied a light coat of fixative. In a matter of a few minutes, I'd covered the entire paper with an abstract value sketch, which was useful for checking my drawing and pattern shapes.

- To continue, I worked with hard pastels and built up the painting slowly, remembering to allow some of the underpainting colors to show through. I also used many colors within each color to provide added variety and interest.

- After putting in the finishing touches and highlights with soft pastel, I snapped the back of the paper to remove any excess pastel dust.

try this tactic yourself

If you accidentally get too heavy with your underpainting and fill in the tooth of the sanded paper, you can wash off the excess pastel with an old washcloth and alcohol.

what I used

support
180lb archival cotton paper, coated with a mixture pumice and gesso

other materials
Hard and soft pastels
Rubbing alcohol
½" flat hog hair brush

Don Nagel lives in South Carolina, USA → dfnagel@aol.com

It took two attempts, but I eventually nailed down the mood with interesting shapes and warm tones.

Enter by the Narrow Gate, oil, 14 x 18" (36 x 46cm)

what I wanted to say

How lovely the light seemed to me. It felt like an invitation for the viewer to enter and recall a time when summer was unhurried, neighbors knew each other, we shared lemonade or iced tea, and kids would swing in backyards, oblivious to the cares of the world.

follow my eye-path

My plan was for the viewer to enter the ovular structure and engage in the geometry of the neighborhood houses and the suggestion of flower patterns. The dominant geometrics are counterbalanced by smaller organic shapes that drift across the horizontal format. I wanted unequal, yet balanced, shapes and proportions.

lesson learned

While I usually make small preliminary sketches as to the design and placement of a painting, I did not do that on this painting. I sketched the image directly on the panel in one afternoon. When I came back the next day at the same time, to my disappointment, I saw that my design had problems. Onlookers were stunned to watch me wipe out everything with turpentine and start over. It would have saved a great deal of time and frustration if I had had a substantial plan-ahead sketch.

my working process

- Over a dry Burnt Sienna wash used to eliminate the white of the canvas, I began again, taking greater care with proportions, scale and shape placement.
- When I was satisfied with the design, I used a broader brush to lay in the half-tones, comparing similar color notes to each other. I kept the shapes quite simple and established the shadow patterns. I continued working on this abstract pattern until I had set up a color harmony, often consciously pitching color complements adjacent to each other.
- Switching to smaller brushes, I begin to refine the forms.
- Finally, I put in the lights with heavier pigment, as well as some dark accents. After about two hours, I felt I had caught what I wanted.

advice for the plein-air artist

For me, painting on location transmits an emotion and achieves breathtaking results. However, experience has taught me that in the field, my tendency is to paint too dark. The painting appears bright and light outside, but because oil paint absorbs the light, the painting drops in value and cools when it is brought indoors. I have learned to adjust for this phenomenon.

what I used

support
Gessoed Masonite

brushes
Filbert hog bristle brushes Nos. 8, 6 and 4; round No. 2

oil colors
Cadmium Yellow Light
Cadmium Orange
Golden Ochre
Cadmium Red Medium
Alizarin Crimson
Burnt Sienna
Phthalo Green
Cerulean Blue
Ultramarine Blue
Cobalt Blue
Titanium White

Deanne Lemley lives in Washington, USA

Like an unexpected surprise in life, backlighting always helps me — and my viewers — see things in new ways.

Sunlight on Rocky Slope, acrylic, 18 x 24" (46 x 61cm)

my inspiration

I have a very strong attachment to the mountains, especially in Yellowstone National Park, where I have drawn many colored sketches and taken many pictures to record the changes of lights and colors. These source materials always excite and inspire me to complete one painting after another. In this one, I vigorously tracked down the divine and wonderful spirit that each object shows in the various changes of light and my own love for nature.

follow my eye-path

Viewed from a slightly upward slant, the painting shows the relationship between the fresh air and the space, focusing viewers' attention on the areas of multi-colored blocks in the center of the painting and leading them to the scenes in the distance, and eventually leading their sights into imagination.

about the light

In my landscapes, I like to use backlighting. To me, frontal lighting is just like our normal daily lives, whereas backlighting is like a surprise event in life. Backlighting — with its theatrical colors, lights and shades — can help us uncover the essence and intelligence of nature.

my working process

- After sketching in my composition with 2B pencil, I used a medium-sized brush to underpaint in pale colors, except in the brightest part of the sky.

- First, I painted the darks and the transition colors, constantly comparing values and colors for accuracy.

- Since the focus of this painting is mainly the crushed stones and fallen trees on the slopes under the sunshine, I then paid close attention to these mid-tones in the center. I did not mix the colors well but rather lightly dipped my brushes into the colors on the palette to better express these textures through brush work.

- In painting the bright parts, I simplified the relationships between colors and weakened the contrast to keep the focus on the center of the painting.

- Finally, I made adjustments to bring the dark color-values into a coherent whole, strengthen the details and enhance the rhythm.

my advice to you

Don't be ambiguous in your handling of color. Try to accurately show their strengths and weaknesses, the relationships between neighboring colors and the various gradations as one color transitions to another. Doing these things will help to capture your feelings and those of the objects. Otherwise, the painting will be boring and tasteless.

what I used

support
Illustration Board

brushes
Flat brushes Nos. 2, 4, 6, 8; No. 2 round kolinsky

other materials
HB or 2B pencils

Sponge, acrylic paper and sprayer for keeping acrylic moist in palette

acrylic colors

White	Yellow Primrose	Yellow Medium	Cadmium Red
Burnt Umber	Dioxazine Purple	Permanent Green	Cerulean Blue
Ultramarine Blue	Black		

Xinlin Fan lives in Florida, USA → vickli19@yahoo.com

I eliminated all of the non-essential elements in order to keep the focus on the late-afternoon atmosphere.

Summer Afternoon, acrylic, 12 x 16" (31 x 41cm)

my inspiration

I came across this Canadian farm scene late on a summer day, when the light was just above the hilltop. It evoked a view into the past for me. It spoke of simpler times, of a certain lost tranquility in our lives. At that moment, I knew I would strive to capture the nostalgic mood of this beautiful rural setting.

why I worked in the studio

I photographed the view of the barn, using a lens shield that enabled me to capture the backlighting and subtleties of the shadow areas. Later in my studio, free from the distraction of the outdoors, I challenged myself to use a small format. I decided to work only from the photo, experimenting with the shapes and colors until I felt the story line emerging.

my design strategy

I sketched directly onto the canvas with a stick of willow charcoal, which allows for roughing in plans and revising at will. For instance, I experimented with the addition of such foreground elements as fences and driveways until I discovered the most dramatic solution — leaving the expanse of field uncluttered so that it could dominate. Other medium and small shapes, such as the telephone poles, balanced and played off each other to create interest. In this way, I stripped away all of the non-essential elements without fear of losing the magical, late-afternoon atmosphere that caught my attention in the first place.

my working process

- Over my sketch, I loosely blocked in my design of tonal values with Dioxazine Purple, Burnt Sienna, Azo Red Middle and Naples Yellow.

- I then applied the topcoat of color, working traditionally from dark to light. I took care to pre-mix my colors to keep the hues fresh. In addition, I varied my brushstrokes from the broad sweeping strokes in the foreground to the generous shorter strokes in the mid-zone to the choppy, short strokes in the background hills.

- I have discovered that Burnt Sienna is a great harmonizer in any painting. So in addition to the Burnt Sienna applied on the base coat, I also pulled my brush loaded with Burnt Sienna through the newly applied Yellow Ochre in a few spots. This gave the painting weight, unity and strength.

- After letting the painting dry overnight, I added the touch of red at top right to emphasize the barn and balance the blues and yellows.

what I used

support
Stretched canvas prepared with white gesso

brushes
No. 36 flat; Nos. 10 and 9 bristle brights

acrylic colors
Cadmium Yellow Medium
Naples Yellow
Yellow Ochre
Azo Red Middle
Burnt Sienna

Sap Green Hue
Anthraquinone Blue
Dioxazine Purple
Paynes Gray
Titanium White

Cynthia Eyton lives in British Columbia, Canada → moonprnt@islandnet.com

Very wet, loose washes of color provided the foundation for my misty, moody landscape.

Solitude, watercolor, 20 x 30" (51 x 76cm)

Pamela Erickson

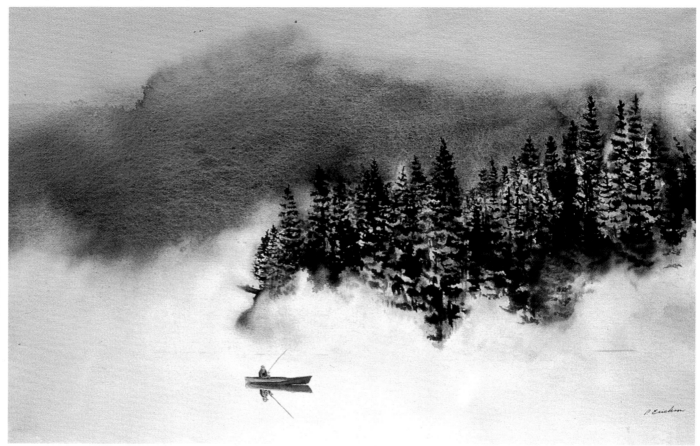

my inspiration

I was inspired by the sight of the sun's rays burning off the fog on Atlin Lake, near the Yukon border, early one morning. As our canoes sliced through the glassy surface of the lake, we listened to the loons cry and saw the splash of fish as they arced above the surface. In less than an hour, the sun had penetrated the fog enough to reveal the tips of trees on nearby islands. I quickly squeezed the shutter of my camera. Although the pictures turned out well, most of the magic remained in my mind's eye.

my color philosophy

In planning this painting, I strove to capture the contrast between the thick blanket of fog and brilliant colour of the sky as the sun burned through. I was also trying to convey a mood of quiet reverence for the power of nature. Before lifting my brush,

I experimented with various colour triads until I found the one that best captured the intense liquid colour of the sky — Aureolin Yellow, Alizarin Crimson and Ultramarine Blue.

my working process

• Working flat on a table, I wet the entire sheet with a generous amount of clear water. Coming in with broad strokes of first Aureolin Yellow, then Alizarin Crimson, then Ultramarine Blue, I filled the entire sky area. I allowed each color to absorb, overlap and mingle slightly before adding the next. Then I sprayed the bottom edge of the sky to ensure a soft edge, and left it to dry thoroughly.

• Later that evening, surprised and pleased with the initial pass, I decided to move ahead. First, I painted spruce trees, using my same blue-red-yellow triad plus some touches of Phthalo Blue

mixed with Burnt Sienna for emphasis. By painting some trees in a darker mixture of paint, I hoped to create a feeling of distance while building in some contrast between the sky and the island.

• Finally, I drew the fisherman on a small piece of paper and tried him out in different positions. When satisfied, I painted him and his reflection into the scene.

I felt I had captured the essence of that splendid morning.

something you could try

Starting with a very loose wet-into-wet wash takes a leap of faith, but it's a fun challenge to work with whatever you get instead of trying to control every aspect of the painting.

what I used

support
300lb cold-pressed watercolor paper

brushes
A variety of sable flats and rounds

watercolors

Pamela Erickson lives in Ontario, Canada → pamelaerickson@rogers.com

By reducing the buildings to one silhouette, I was able to focus attention on the foreground.

Against the Light, watercolor, 13½ x 21" (35 x 54cm)

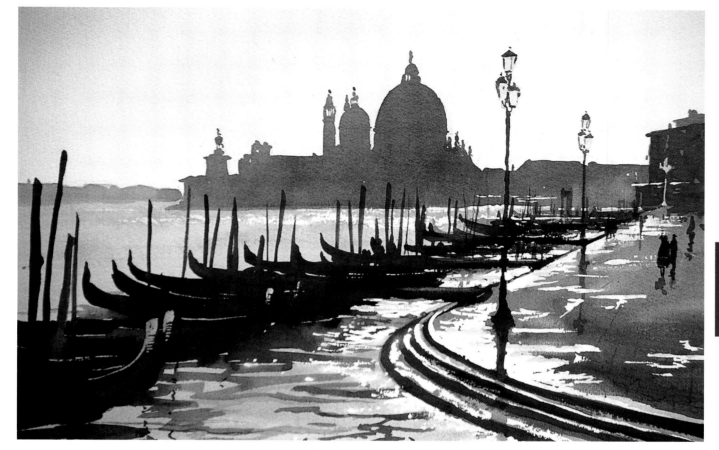

Kristina Jurick

my inspiration

When you enter Venice, it is like traveling back in time. There is a subject around every corner, which is why Venice has been an artist's heaven for centuries. In the two weeks I spent in this fascinating city, I did several on-location paintings, filled one sketchbook and shot 10 rolls of film. Sometimes I wasn't sure if Venice was real or a fairytale.

my design strategy

My aim was to capture the peaceful lagoon, so I couldn't let the Maria de la Salute overpower the painting. This is why I reduced it to a simple silhouette and used the gondolas to lead the eye into the painting and into the misty distance. For reference, I used my sketches and one photo of the lagoon.

my working process

- First, I covered the light reflections with masking fluid.
- Then, I laid an overall wash across the whole painting, graded down from warm to cool, light to dark. I filled in the distant hill and pulled down the same color into the water to make it slightly darker than the sky.
- For the silhouette of the church, I laid in a single wash, changing the colors with each brush stroke to add more interest. I used the same mix of colors in the sidewalk for continuity.
- I also painted the gondolas with one single wash, connecting them with their reflections and the poles.
- The lamp poles and people added a touch of lively detail to the painting, and their reflections gave the pavement a wet look.

- At last, I removed the masking fluid and softened edges with a bristle brush. A little scratching with a knife brought out sparkles in the water.

try these tactics yourself

- I prefer sketching on location, as it helps me to simplify complex scenes, leaving out all the unnecessary detail. Also, the camera can't catch my personal feeling about a subject, whereas a sketch will hold this feeling for many, many years.
- In order to determine what I am aiming for, I often do several color note sketches until I find the one I feel most comfortable with. In this case, my color notes revealed that a limited palette would allow me to emphasize contrast and atmosphere. It also helped me determine which colors I needed for the glowing sky and the brilliant darks.

what I used

support
140lb rough watercolor paper

brushes
3" and 1½" flats; No. 12 round; No. 4 rigger

other materials
Masking fluid
Craft knife

watercolors

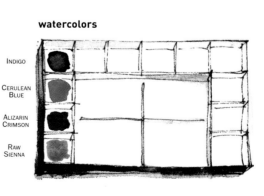

INDIGO
CERULEAN BLUE
ALIZARIN CRIMSON
RAW SIENNA

Kristina Jurick lives in Germany → www.mango-art.com

To suggest expansive depth, I arranged shapes and controlled my values.

Silverthorne, Colorado, oil, 16 x 20" (41 x 51cm)

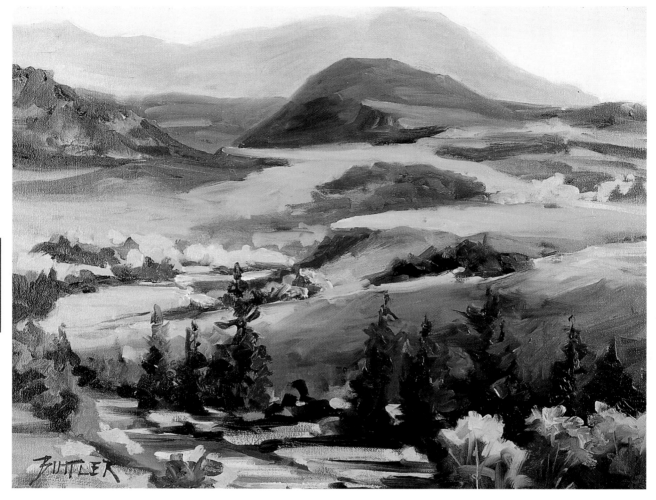

what I wanted to say

Clear air, the plays of light and shadow and the vibrancy and intensity of nature's colors are enough to make me put paint to canvas. This beautiful spot along the Blue River in Colorado had all the qualities I enjoy. In painting it, I wanted the viewer to feel the sense of distance, the expanse of the high plains against the large mountain backdrop and the complementary reds and greens without getting overly involved in detail.

my design strategy

As my time on site was limited, I worked at composing a good photo. When I got home, I used little cardboard "L"s to find the most attractive composition within my photo. To enhance this,

I viewed this composition abstractly, as a series of triangles composed of diagonal lines that carry your eye through the scene. I made sure I varied my shapes and took care not to line up any one element with that which was directly above or below it. As a relief from all the diagonals, I put in some vertical lines (such as the trees) and varied the colors and tonal values.

my working process

- To tone the canvas, I added a drying agent to a dull, mixed orange and applied this mixture thinly to the canvas with a paper towel. After letting it dry completely, I drew in my preliminary design with a hog bristle brush and the same orange mix.

- Next, I painted in the major areas of lights and darks, allowing the toned canvas to show through in a number of areas, including where the river would fall. This gave me an idea of the value pattern of the painting.

- After letting this dry overnight, I went back in to beef up the colors and adjust some values, adding the lights last but making no attempt at detail. I played cool greens against

warmer yellow-greens to create contrast wherever values were too close. If the greens were too intense, I added a little Venetian Red to gray them down.

- When I got to the foreground, I used my bristle brushes to quickly paint in the large pines. I then used a small rigger to add some calligraphy in the shrub areas.

- To complete the river, I added purple shadows and green highlights.

what I used

support
Stretched canvas

brushes
Hog bristle Nos. 2, 4 and 6; a synthetic bright; No. 0 rigger

oil colors
Cadmium Yellow Medium
Yellow Ochre
Cadmium Red Medium
Venetian Red
Alizarin Crimson
Manganese/Cerulean Blue
Cobalt Blue
Ultramarine Blue
Bright Violet
Sap Green
Titanium White

Pris Buttler lives in Georgia, USA → prisbuttler@charter.net

By using complementary color and varying my brush technique, I achieved some exciting effects.

Utah Fence Line, oil, 11 x 14" (28 x 36cm)

ARTIST
49

Bethanne K Cople

what I look for in a subject

I always look for interesting atmospheric qualities. The landscape must intrigue me, but it is exciting light and atmosphere that turn an ordinary scene into something extraordinary. This particular scene caught my eye because of the incredible yellow sun trying to burn its way through the pale violet, snow-laden clouds. The golden-hued trees were also a perfect complement to the fresh lavender snow.

my design strategy

This scene was perfect for using complementary colors and varied paint handling to create exciting effects. The receding fence line draws the eye to the focal point, the golden trees against a heavy sky. The glowing sun added a secondary interest, which keeps your eye moving around the painting. The vibration of complementary colors and warm and cool hues created mood. The scene also allowed me to incorporate many different oil techniques. I contrasted thick impasto with thin washes throughout, thereby producing textural interest.

my working process

- I began by toning my canvas with Burnt Sienna, using a paper towel to spread the paint. This became my medium value. Then I sketched in the big shapes of darks (still using Burnt Sienna) with a large, flat bristle brush and lifted out the light shapes with a solvent-saturated paper towel. I checked to be sure I had a solid, interesting design scheme.

- The real fun began when I started to lay in the dark colors. I wanted to keep them pure and very thin, just a stain. I blocked in the tree line with the sides of my No. 8 flat, bristle brush, scrubbing the paint so that the underlying canvas would shine through. This created a nice glow in the trees. I also blocked in the fence line as a mass.

- Then I began mixing my light colors. Using thick paint and a No. 8 flat, bristle brush, I rapidly painted in the snow and sky. I was able to weave the snow through the trees, creating interesting paths for the eye to follow. Likewise, I carved out the fence line with the snow color. I constantly worked across the entire painting.

- When the painting was about three-quarters of the way finished, I used my palette knife to add some very thick color notes in the foreground, which helped suggest depth.

what I used

support
Linen mounted on board

brushes
Bristle flats and filberts Nos. 6 through 12; palette knives

oil colors
Cadmium Lemon
Cadmium Yellow Pale
Cadmium Orange
Cadmium Red
Alizarin Crimson
Raw Sienna

Burnt Sienna
Viridian
Ultramarine Blue
Cerulean Blue
Titanium White

Bethanne K Cople lives in Virginia, USA → pleinair1@comcast.net

Preparing my own ground gave me a lot of control over my painting's surface texture.

Ancient Dwelling, pastel, 30 x 24" (76 x 61cm)

Howard Scherer

my inspiration

What inspired me was the texture and beautiful colors of the various layers of stucco. Although the building is very old and in poor condition, it still has value to the people who live there.

follow my eye-path

When I travel, I take many photographs and prefer to compose my paintings in the camera as much as possible, although I make changes as needed. I prefer slides to prints as they provide more color accuracy and brilliance.

This painting was done from a slide I took on a trip to the old section of Lisbon, Portugal. The cat in the upper right window was not in the photo. I added it to act as a pointer to the center of interest (the window with the clothing). I also set up the brightest area of stucco next to the center of interest. This was designed to bring attention to that window.

my working process

• I used illustration board that I coated with gesso and pumice to give me a surface that had some uneven texture. When applying the gesso and pumice mixture, I laid the strokes down in all directions and left them. This resulted in even more texture in the ground.

• I then painted the board with dark blue acrylic paint. I let this color show through various areas of the painting to help unify the color.

• I started with hard pastels and used them as long as I could. Simply by applying light pressure to the later layers laid over the base colors, I was able to create subtle color mixtures. I sprayed on workable fixative as needed to restore the tooth of my surface.

• Softer pastels were used for the lighter areas and the highlights as I worked from dark to light.

the main challenge in painting this picture

The painting was done with a limited palette, primarily various values and hues of red, in order to interpret the nuances of color of the layers of cement and stucco. Because of the use of mainly one color, I had to be careful not to let the painting become boring. I tried to mix passages of cool blue into the warm reds to lend more interest.

what I used

support
Illustration board coated with gesso and pumice, then acrylic color

other materials
Hard and soft pastels
Workable fixative

Howard Scherer lives in Florida, USA → howbetsy@hotmail.com

I used the waterway to link foreground to background and communicate a sense of distance.

Montana Forever, oil, 28 x 36" (71 x 92cm)

**ARTIST
51**

my inspiration

These cottonwoods in Wyoming and Montana stand so much straighter than their cousins to the south, like proud witnesses of another glorious day. The light bursting through the outer leaves, the golden fall grasses dancing in the wind and that wonderful reflection in the still water all added to my fascination with the subject, but the main inspiration was the expansiveness of the land.

my design strategy

I balanced strong verticals against the horizontals, and worked in an "S" composition as a secondary design.

my working process

• With thinned Cadmium Red and a No. 4 flat bristle brush, I first placed my horizon and sketched the composition.

• Using two small study paintings and several photo references to work from in my studio, I mixed my whole palette for this painting. I kept in mind my four main value groups: sky, ground, slanted elements and upright elements. Value relationships are key to a good painting.

• I then laid in my darkest darks in the foreground. As I moved to the tree lines, I swayed my grays toward the bluer gray to set the most distant tree line back in space.

• I continued covering the whole canvas, building the broad masses. Within those masses, I tried my best to watch my edges.

• After letting the painting dry, I brushed a coat of Liquin all over the canvas. This brought my darks back and let me paint wet-on-wet in a second session, in which I adjusted my value-color relationships throughout, refined edges and added detail as needed.

• I repeated this process four more times until I was satisfied with the painting.

my advice to you

Study the works of past masters, and look for good instruction from living artists as well. Then be willing to take in that good instruction and grow one painting at a time.

please note

This painting started as a 36 x 36" square, but a painter friend and mentor talked me into cutting off a few inches. I'm glad — he was right.

what I used

support
Stretched linen

brushes
Bristle flat brushes; palette knife

medium
Liquin

oil colors
Cadmium Lemon Yellow
Cadmium Red Medium
Ultramarine Blue
Cool Gray
Titanium White

Keith Alan Huey lives in Hawaii, USA → www.Hueyfineart.com

My aim was to reveal the hidden colors in the shimmering shadows.

The Sun Sets in the West, oil, 36 x 48" (91 x 122cm)

my inspiration

Taking a country walk in the south of France at the end of a glorious spring day, I was struck by the long shadows on a freshly plowed field, showing a thousand facets of gray, mauve, violet, ochre and so on. I made a sketch and took some pictures right away to use later in capturing on canvas that feeling of serenity.

designing as I sketched

- Back at the studio, I chose a canvas coated with yellow-tinted gesso. The large, human-scale size of the canvas — perfect for those long shadows — let me apply my oil sticks with my whole body, rather than just moving my hand.

- The midsection of the landscape exploded in an oval shape of light, rendered by a white mass and shades of chartreuse. The shadowy foreground provided a comfortable resting place for the shape, while the dark silhouette of the mountains and the village emphasized the roundness of the field in the distance.

- The cool colors of the shadows were soon "warmed up" by the yellows and touches of Cadmium Red.

my working process

- Confident in the oval eye-path of my design, I freely applied odorless solvent over the sketch and let it dry overnight.

- The next day, I prepared a full palette with different colors of oil paint to be mixed with painting medium. Using a clean brush for every color, I filled in the painting, saving the most vivid hues for the foreground.

- I added strokes of oil stick here and there to accent a line or deepen a color, melting and extending the color with my fingers.

- I then applied a variety of warm and cool grays in the shadows.

- After considering how I might pull the painting together while emphasizing the core interest, I added touches of blue, green and red to enliven the plowed fields. A few strokes of Prussian Blue accented the mysterious space in the bottom left corner.

- Once the painting was completely dry, I sealed it with varnish to protect the surface and allow for cleaning.

my advice to you

- Travel often. A change of scene is sure to ignite the curiosity and stimulate the imagination.

- Follow your intuition. When you see something that touches your heart, dare to express yourself with great delight and let your work show emotion.

what I used

support
Stretched canvas coated with pale yellow gesso

oil colors
Stil de Grain Yellow
Cadmium Yellow Light
Permanent Yellow Deep
Alizarin Crimson

Cadmium Red Light
Permanent Green Light
Turquoise Blue
Prussian Blue

brushes
All sizes of bristle rounds and flats; palette knife

other materials
Oil sticks
Medium
Odorless solvent
Varnish

Ultramarine Violet
Violet Gray
Titanium White

Madeleine Lemire lives in Quebec, Canada → www.madeleinelemire.com

Try my wet-in-wet wash, scumbling and finger painting techniques.

Low Tide, acrylic, 20 x 36" (51 x 92cm)

my inspiration

On a recent trip to Maine, I photographed this view of Southeast Harbor near Acadia National Park. The long shadows and the interaction of warm and cool colors were very inspiring.

my design strategy

I chose a classic landscape format to emphasize the quiet horizontal elements, then used the slight angles of the water's edge and shadows to create an "S"-shaped movement within the composition. There is repetition in this design, which solidifies it even further.

my working process

- Referring to photos, I worked out the composition in small thumbnail sketches. I then created a tight pencil drawing on the paper.
- Starting with the darkest values, I applied a thin mixture of Burnt Umber and Phthalo Blue. Establishing this detailed, dark

value pattern first allowed me to block in freely without losing my design.

- Using semi-transparent washes of color, I painted in the background elements and allowed them to dry almost completely.
- Next, I wet the edges of these areas with clear water, which I extended out over the sky and water areas. I then applied more washes in various semi-opaque mixtures of blues and other colors. This process allowed me to smooth out the transitions between the various elements of the painting.
- After drying completely, I again wet the sky and water areas with clear water, followed this time by a thin layer of gesso. While still wet, I added and blended more opaque and semi-opaque colors to refine the values and color intensity.
- Later, after realizing the trees, islands and shoreline were much too light in value,

I scumbled on layers of semi-opaque color, using worn round brushes.

- I also used the scumbling technique on the long shadows, blending the color with my fingers. On top of this scumbled color, I layered thin washes of transparent color to deepen values and adjust color.
- I added the final details with semi-opaque and opaque color mixtures.

what I used

support
Cold-pressed 140lb watercolor paper

brushes
Synthetic watercolor rounds Nos. 4, 6, 8, 10, 12, 32; Kolinsky watercolor round No. 2; synthetic watercolor flats in ½", 1" and 2"

try these tactics yourself

I've "borrowed" three classic techniques from other media to make blending acrylics easier:

- Layers of wet-in-wet washes, using either water or gesso, builds color intensity.
- Scumbling, best done with a worn brush, is a great way to move color around and soften edges.
- Finger painting seals the surface of the paper, which allows the paint to slide around more easily.

acrylic colors
Yellow Orange Azo
Cadmium Orange
Cadmium Red Light
Acra Crimson
Burnt Sienna
Burnt Umber
Permanent Green Light
Ultramarine Blue
Phthalo Blue
Dioxazine Purple
Titanium White

Christopher Leeper lives in Ohio, USA → www.christopherleeper.com

By simplifying the details, I accentuated the light on this majestic landscape.

American Farm, oil, 16 x 20" (41 x 51cm)

Lilianne Laurin

what I wanted to say

One late afternoon in December I went for a drive in the Blue Ridge Mountains of North Carolina and came upon this scene. The light was extraordinary and the landscape was simple, yet majestic. I spent considerable time photographing and enjoying the almost spiritual quality of that fleeting time of day when the setting sun turns everything to gold. I love to capture in paint these inspirational moments in time as my way of saying, "I wish you had been there to experience it with me".

my design strategy

I kept the foreground simple with little detail to let the viewer focus on the center of interest: the distant ground where the cows are grazing and the valley behind them. Here, the contrast from dark to light is greatest. The overall color scheme creates unity and conveys the feeling of a landscape bathed in the warm glow of late afternoon light.

my working process

• I began by painting the surface with a thin wash of Yellow Ochre. Since I was satisfied with the composition in my slide, I used the grid method to transfer the image to my canvas.

• After blocking in the sky, I then established a general impression of the trees and the snow-covered hill.

• I had originally painted more detail in the middle and foreground, but decided to simplify it before it dried. Simplifying the work let the drama of the composition and lighting convey the scene more clearly and directly to my viewers.

why I work from slides

I worked from a slide viewed through my rear-screen viewer that projects an image unto an 8" x 8" screen. A slide conveys the quality of light much closer to the original scene than a photograph does, so it does a better job in reminding me of what inspired me about the scene originally. Photographs, on the other hand, deaden color and overemphasize lights and darks, creating a challenge to overcome.

what I used

support
½" maple board prepared with three coats of acrylic gesso, carefully sanded smooth between each coat

brushes
Bristle flats and filberts Nos. 4, 6, 10 and 12; soft sables Nos. 2, 4 and 8

medium
3 parts turpentine to 1 part stand oil

my advice to you

• Go out in nature to paint from life as often as you can and, if possible, form a painting group with other artists.

• Get inspiration from other landscape artists by visiting galleries and art shows and reading good art books.

• Study landscape painting with artists whose work you admire.

oil colors
Cadmium Yellow Medium
Yellow Ochre Light
Cadmium Red Light
Alizarin Crimson
Transparent Oxide Red
Raw Umber
Cerulean Blue
Ultramarine Blue
Titanium White

Lilianne Laurin lives in New Jersey, USA → Laurinart.com

I used the design principles of dominance and repetition to organize my complex subject.

Swamp Reflections, oil, 48 x 24" (122 x 61cm)

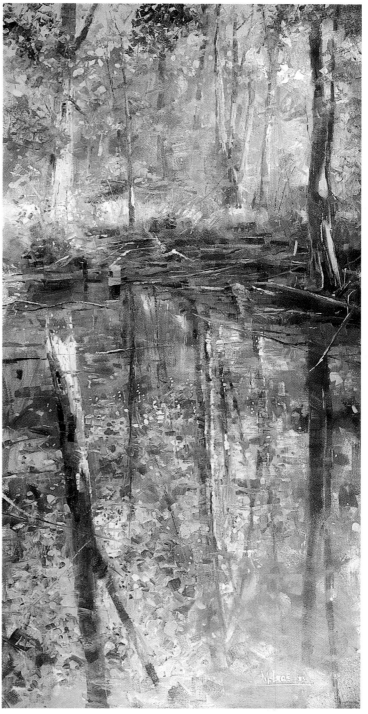

my inspiration

The reflections in the swamp, especially the way the irregularities in the water made them more interesting than just a mirror image, inspired me. What I wanted to get across with this painting was the humidity inherent in a swamp.

my design strategy

With the myriad of shapes in a busy subject like this, my main design strategy was to mass together shapes of similar value into a simplified design pattern. The two primary principles of design used here are dominance and repetition. I tried to incorporate just enough horizontal and oblique lines so as to avoid a static design. There is no real eye-path here, as much as a series of focal areas.

working out the design

- As it would be impossible to complete a canvas of this size on location, I began with some small, loose oil sketches on site, as well as a bunch of digital photos.
- In the studio, having chosen a photo to work from, I did a series of small thumbnail sketches in pencil.
- Once I'd settled on the best format, I did a slightly larger, more realized value study in pencil, using an electric eraser to pull out my lights. This allowed me to determine my focal areas and simplify my design without being concerned about color.
- Finally, I did a small oil sketch, primarily to key my color and to determine whether I'd found an exciting design or not.

my working process

- To prepare my canvas, I applied gesso with a housepainter's brush. Loose strokes helped to incorporate texture from the beginning.
- I then killed the white of the canvas with a thin wash of acrylic Burnt Sienna.
- Using flat bristle brushes and paint thinned with mineral spirits, I applied the transparent dark passages of the painting. I then switched to filberts and palette knives to build up the thicker lights. In addition to establishing form and dimension, I wanted to see a variety of paint applications in these layers.
- Finally, I used small, flat sables for detail around my focal areas. To refine the image, I used a palette knife to smooth out overly textured areas and to create thin branch-like shapes.

please notice

One thing about this painting I would particularly like viewers to appreciate is the variety of thickness and texture of the paint, ranging from thick impasto paint to virtually bare canvas.

what I used

support
Stretched canvas triple, gessoed with a housepainters brush

brushes
Bristle flats and filberts; palette knife

medium
Mineral spirits

oil colors
Cadmium Lemon
Cadmium Yellow
Yellow Ochre
Alizarin Crimson
Cadmium Red

Terra Rosa
Burnt Umber
Permanent Green
Manganese Blue
Ultramarine Blue

Mark Lagüe lives in Quebec, Canada → www.marklague.com

Mark Lagüe

ARTIST 55

Using strategic shadow and warm color I set the stage for my focal point.

Backwoods Road, oil, 24 x 30" (61 x 76cm)

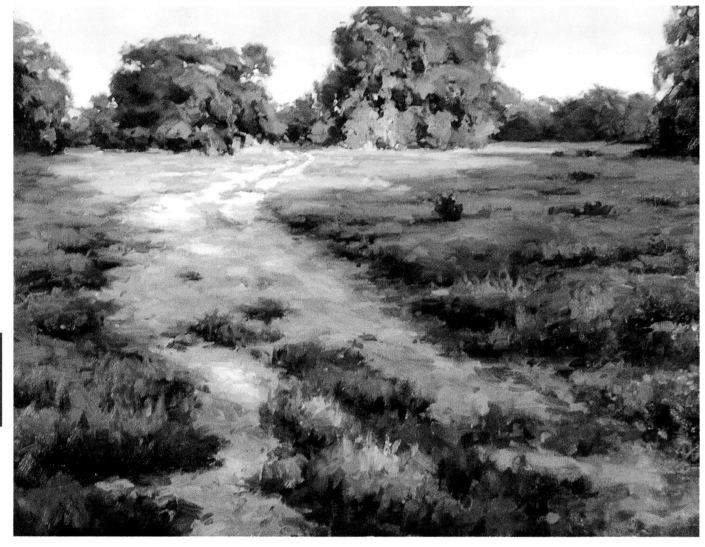

my message

I liked the mystery that the winding dirt road presented as it receded into space. You're not quite sure where it's going so you're left with your own interpretation.

my design strategy

I used the road's S-shape to help create depth and interest by providing the viewer with a path that leads into the scene and forces the perspective, with larger shapes in the foreground and smaller in the distance.

my color and tone plan

My color scheme was dictated by the warm early morning light in central Florida. Tonally, I wanted the painting to read as two-thirds shadow, to stage the focal point, which is at the vanishing point of the road between the oak trees.

my working process

I made a preliminary 8 x 10" color study on location to help me see the true color. Photos are great reference for drawing, but color and value can be very deceiving in a photo. Lights tend to wash out and darks tend to go black.

Back in the studio, I started with a thin, light reddish tone on a white canvas to establish my drawing and composition.

I then began blocking in general value and color shapes in the focal point to key in that area.

Subsequent colors and values related directly to the key.

the main challenge in painting this picture

The main challenge in this painting was executing the greens. A fellow painter once told me that if you can control green and its many variations, you can handle just about any color.

what I used

support
Medium weight, stretched canvas

brushes
Flats in various sizes

oil colors
Cadmium Yellow Light
Perylene Red
Alizarin Crimson
Phthalo Green
Ultramarine Blue
Titanium White

Barry Kooser lives in Florida, USA → www.koosergallery.com

Opaque highlights over thin washes of color enhanced the illusion of sunlit snow and watery reflections.

Willow Reflections by the Bridge, acrylic, 30 x 40" (76 x 102cm)

Virginia Jonynas

ARTIST
57

first in a series

Toronto's High Park has been a familiar place for me since childhood. One partially warm and sunny spring afternoon there, I came upon the willows by a small creek. Their dark majesty was mirrored in the water's surface, which was lit with late afternoon sun. This painting started me on a series called "Impressions of High Park".

my design strategy

I arranged this painting so that the viewer would first be attracted to the giant willows and their reflection and then to the melting snow and the warm water. This then leads them to the bridge and on to the hazy atmosphere beyond the willows.

my working process

- After making several study sketches done on site, I took reference photos. I prepared a Masonite board on the rough backside to get a tooth. I applied a mixture of gesso and Paynes Gray, let it dry and lightly sanded.
- I loosely sketched the scene in Burnt Umber with a small brush.
- Then, using a 1" flat sable brush, I applied my darkest areas. Using Burnt Umber, Paynes Gray and Burnt Sienna washes, I worked up the middle tones to light. With a 4" soft brush, I applied thin, transparent washes of yellow, blue and red in their appropriate areas.
- Using a range of hog hair and sable brushes, I brought up the details and finished with opaque acrylic wherever there was direct light.

what I used

support
Masonite board prepared with tinted gesso

brushes
Mostly flat hog hair and sable brushes in a range of sizes

the main challenges in painting this picture

Exploring the world in the reflection and applying the sunlit surface to the water were the main challenges. To help myself along, I would sometimes turn the painting upside down to view. I discovered a parallel world in the reflections.

oil colors

Yellow Ochre	Cerulean Blue
Burnt Sienna	Paynes Gray
Burnt Umber	Titanium White
Vermilion	

Virginia Jonynas lives in Ontario, Canada → www.irisfinearts.com

I used shape and color contrast to suggest this.

Path to the Shore, watercolor, 9³/₄ x 14" (25 x 36cm)

Nancy Davis Johnson

my inspiration

While walking through a friend's island meadow in Maine on a foggy late summer day, I looked behind me on the path and realized a painting had composed itself. The forms and color contrasts were wonderful. Standing there, I felt the heavy, ancient presence of the ledge, the stillness of the spruces, all waiting. I had to try to record my feelings about this image of light and subtle color changes in a misty atmosphere.

my design strategy

I was fortunate in that nature had created, for the most part, an interesting composition. The fractured ledges, grasses and trees merged in a rhythm that led back to the path I had just traveled. I only needed to accentuate shapes and values, intensify color

and eliminate non-essential detail to improve my photo's composition.

my working process

- In the studio, I transferred my pencil sketch to watercolor paper with graphite transfer paper.

- I began with a pale wash of Raw Sienna over all areas. While the sky area was still wet, I dropped in slight hints of Permanent Rose and Cobalt Blue.

- When the paper was dry, I blocked in the trees, the bushes and the meadow, generally working from top to bottom. Next, I shaped the ledges and rocks and added the grasses, then let the paper dry.

- Because I had used non-staining colors, I was able to refine the scene, lifting color by wetting an

area with my brush and blotting with a paper towel or damp brush, depending on how much pigment I wanted to remove.

- When the area had dried, I glazed color over it until the value and hue seemed right. I neutralized background greens and yellows with Cerulean to create the illusion of distance and fog.

- Then I started defining the details. I used small brushes to lift out pigment, drybrush and stipple the grasses and rocks.

Here the rough textured paper suited the subject. The ledge fractures were the final details added.

the main challenges in painting this picture

As there was no sunlight and no shadow for contrast, I had to rely on color to define mood and form. By using the energetic movement and color of the foreground grasses as a counterpoint to the background overcast, I felt the painting come together.

what I used

support
300lb rough cold-pressed watercolor paper

brushes
Synthetics in a wide range of sizes and types

watercolors
Permanent Rose
Raw Sienna
Burnt Sienna
Viridian

Cerulean Blue
Cobalt Blue
Ultramarine Blue
Brown Madder

Nancy Davis Johnson lives in New Hampshire, USA → nancy.d.johnson@comcast.net

In this rendition of a familiar subject, I decided to go for a more unusual composition and inventive color scheme.

Coughlin House, Fall, oil, 20 x 30" (51 x 76cm)

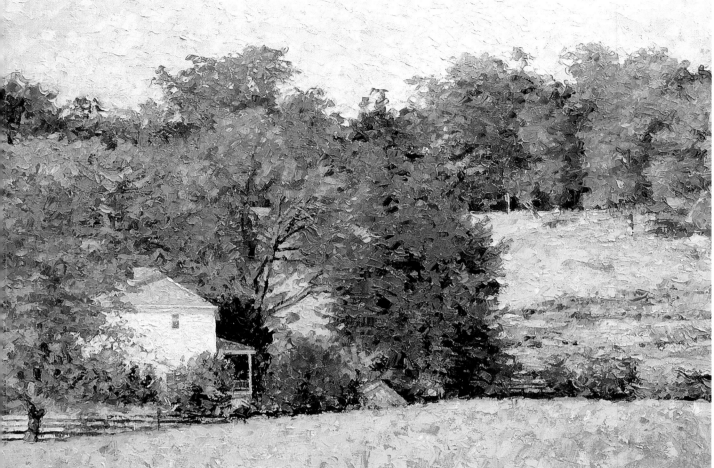

ARTIST 59

finding a fresh spin

This house and grouping of trees is one of my favorite scenes to paint in Virginia. I love the wonderful design potential of the house, hill and trees. Over the years, I've painted it many times both in oils and pastels, but each time I try to paint this familiar subject differently.

my design strategy

This time, I went around to the side of the house and noticed that there still was an interesting design created by the position of the trees in the landscape. I also liked the way the small hill in the foreground echoed the tree line. I felt that pushing the white house deep into the lower left-hand corner made the entire composition a little more interesting.

my color philosophy

Since I've often painted this subject in summer, I also decided to switch to a fall palette of warmer colors — harmonious shades of yellow, orange and pink. The cool blues and white of the house draw your eye there first.

my working process

- I first applied a veil of light color to the canvas to get rid of the white and to help harmonize the final colors.

- Next, I drew in all of the elements in the scene, using complementary colors to the colors selected. I did this very quickly as these lines will only serve as a guide.

- Using nothing but palette knives, I quickly applied foundation colors for each element in the scene. I tried to get the values and colors as accurate as possible since some of this layer will eventually show through and blend in. However, I was also very inventive and creative at this stage as I searched for an overall scheme that would tie the whole painting together.

- Finally, I put in the final layer, modifying a few values and colors as needed while paying strict attention to refining the drawing of each element in the scene.

try these tactics yourself

All of my paintings are always painted from photographs I have taken at various locations. However, I use them simply to indicate the correct appearance of each element in a particular scene. In my studio, I always create different and inventive color schemes and designs to make each painting more successful.

what I used

support
Stretched, toned canvas

tools
Palette knives

oil colors
Permanent Yellow Light
Diarylide Yellow
Cadmium Orange
Raw Sienna
Prussian Green
Cobalt Blue
Titanium White

Bill James lives in Florida, USA → billjames@bellsouth.net

Saturated color, especially in terms of complements, helped me recreate the emotional impact of this scene.

Cottonwoods II, watercolor, 30 x 40" (76 x 102cm)

John Hulsey

a don't-miss opportunity

It was late October and I was attending a housewarming party when I was stopped in my tracks by this marvelous and serendipitous scene. Because I had brought no art-making tools along, I studied the landscape for a while, making mental notes of the important details. I then began methodically composing and taking numerous digital photographs. I felt I could make a powerful large watercolor if only I could recreate the cathedral-like feeling of the arching bowers and the stained glass effect of the warm light through the yellow leaves. Fortunately, my companions were used to my distractions and waited patiently until I was finished!

my design strategy

I knew that I had to carefully balance three design elements for this painting to work: the bright light of the sun, the marching perspective of the line of trees, and the vast New Mexico background. The eye is drawn to the brightest areas and the largest dark shapes first, so those needed to be balanced by the remainder of the picture. The repeating forms of the trees would add rhythm and movement, and draw the viewer's eye along the diagonal of the road, but only if I created a very warm color at the terminus of the diagonal. The proportion and balance of the cool blue/violets of the sky would also be critical.

my working process

- As always, I started with a few smaller studies to become completely familiar with the needs of the large painting. I also visualized my finished work. These practices help me relax with the painting process instead of panic mixing in the middle of a large, drying wash.

- To begin, I drew my composition onto the sheet in light pencil. I painted the bright Indian Yellow leaves of the trees first, followed while still wet with the sky, then the big wet-on-wet ground surface and then the background. I paid close attention to my washes as they dried so I could adjust their all-important values as needed.

- I painted the dark tree trunks last, covering any previous washes that had spilled into their white spaces.

- Only at the very end did I add detail. I drybrushed just enough information to give the picture some snap — but not too much! The best paintings always allow the viewer to participate in adding the rest.

what I used

support
300lb watercolor paper

brushes
Large flats and Nos. 10, 18 and 20 rounds, all synthetic

watercolors

Indian Yellow	Prussian Blue
Naples Yellow	Cobalt Blue
Cadmium Orange	Cerulean Blue
Burnt Umber	Sepia
Winsor Violet	Brown Madder

John Hulsey lives in Kansas, USA → www.hulseytrustystudios.com

Lifting back my non-staining pigments allowed me to create glowing sunlight that entices the viewer into the painting.

Morning Has Broken, watercolor, 21 x 29" (54 x 74cm)

my inspiration

Walking through the woods and observing the way light filters through the trees and branches, I experienced a special moment that I wanted to capture with watercolor.

my design strategy

The emphasis was on the placement of the sun and how the shadows were cast from the trees. This composition draws the viewer into the painting.

my working process

- Using a photograph as a guide, I lightly sketched my image on my paper and applied a liquid mask to save all of the light areas.
- After the mask had dried, I wet the entire surface of the paper. Using non-staining pigments,

I applied a liberal amount of paint to the paper. I started in the center with warm colors and gradually progressed to cool colors towards the perimeter. I tipped the painting back and forth to fuse the colors together.

- I then accented the trees and branches with more concentrated pigments.
- After letting the painting dry completely, I carefully removed the dry mask. Then I took a stiff brush and, by scrubbing, removed pigment from the center of interest. This was possible because I used only non-staining pigment.
- Since a lot of white paper was left exposed, it had to be tinted. I used an airbrush to apply a light tint to the sky area, although I could have used a soft mop brush just as easily.

why I chose this medium

I chose this particular medium because of the wonderful subtle transitions that transparent watercolor gives from one color to the next. This gives the painting overall unity.

what I used

support
140lb rough paper

brushes
2" hake brush; No. 10 round brush; No. 4 rigger brush; old toothbrush; bristle oil brush; airbrush

other materials
Masking fluid

advice to landscape artists

- Don't paint what you don't know.
- Go to the source — walk among the trees, cross the meadows, watch the sun rise or set.
- Do some painting on site. Don't always rely on photos.

watercolors
Auerolin
Cadmium Scarlet
Scarlet Lake
Cobalt Blue
Cerulean Blue
Ultramarine Blue
Brown Madder Alizarin
Paynes Gray

Dick Green lives in Minnesota, USA

I created an interesting lead-in to a familiar Yosemite icon.

Linda R Abbott

ARTIST
62

Walk Toward the Rock, oil, 20 x 20" (51 x 51cm)

my inspiration

One winter morning, I decided to paint this view of the Yosemite Valley outside my front window. It was one of my favorite moments — the morning after a fresh snowfall. I wanted to record the exact feeling I had when I saw the still-pristine snow with only one set of footsteps across the meadow.

my field experience

I worked outdoors and a shadow quickly overtook me, bringing a 10-15 degree drop in temperature. Needless to say, I had to work fast! But that's exactly why I enjoy working outdoors. It's often a race to the finish — extreme painting! Making decisions and moving quickly can be stressful, but when it works, it is exhilarating. In the field, it's about what I'm seeing, feeling, experiencing and reacting to, which is why I often achieve a freshness and spontaneity that I just can't get in the studio.

my design

I believe a focal point, even a subtle one, and a way to guide the eye into the painting are important to the composition. In this case, Half Dome itself would have been a natural and awesome focal point, but I challenged myself to find a less obvious, more engaging focal point. I chose the little, unusually shaped group of snow-covered cottonwoods in the meadow, which put the magnificent granite structure in a secondary role. The lone set of steps leading to the trees, but also in the direction of Half Dome, serves to lead the eye into the picture.

my working process

- After laying out a basic palette, I began by drawing a quick, basic sketch on the canvas with a small brush and black paint. Satisfied with my composition, I got to work.
- I moved from dark to light, large shapes to small details and highlights, broad brushes to small brushes.

my advice to you

- When working in the field, it's important to know your color palette and equipment well. These things must work for you without you having to think too much about them.
- Painting is all about light and darks. Watch your values and make them work to describe form.

what I used

support
Canvas primed with light gray semi-gloss exterior enamel house paint for a slick surface

brushes
Filberts of all sizes

medium
Turpenoid

oil colors

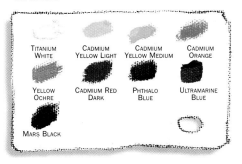

Titanium White Cadmium Yellow Light Cadmium Yellow Medium Cadmium Orange

Yellow Ochre Cadmium Red Dark Phthalo Blue Ultramarine Blue

Mars Black

Linda R Abbott lives in California, USA → www.yosemiteartists.org

I used backlighting and a strong diagonal composition to enhance the drama of my painting.

First Snow, oil, 22 x 28" (56 x 71cm)

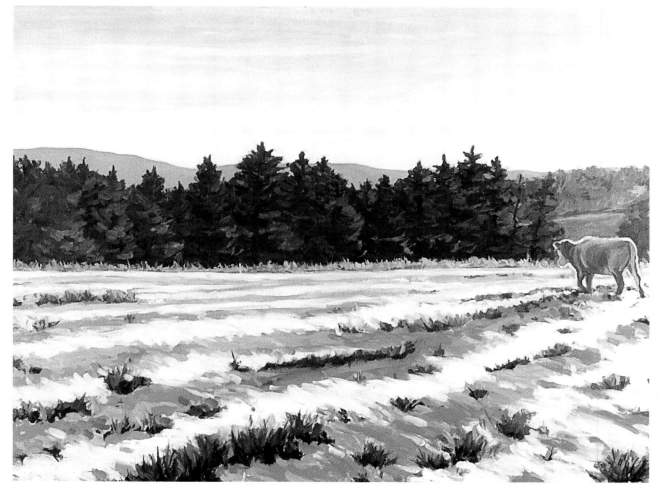

my inspiration

I live on a cattle farm in central Virginia, surrounded by striking vistas that I love to paint. The constant changes in color and light on the rolling hills and mountains of the Blue Ridge inspire my compositions. In this painting, the afternoon sun illuminated the first snow of the winter season and created the unique backlighting and striking diagonals on this snowy pasture.

my design strategy

By arranging this painting on a strong diagonal, I created a dramatic movement across the canvas. The contrasting position of the cow heightens the visual tension and establishes a narrative interest. The cows in my paintings often convey human emotions towards their surroundings.

my working process

• On the day of the snowfall, I rushed outside to photograph the splendid afternoon light.

• Using my photos as a reference, I drew several small sketches on paper, freely and loosely experimenting with different compositions in order to determine my final design. I painted in oils over the final sketch and made my color selections. By using a limited color palette, I forced myself to find color relationships throughout the painting that would enhance the mood I was after.

• My canvas was toned with a thinned wash of turpentine and Burnt Umber to establish an initial middle tone. After drawing my composition on the canvas in pure Burnt Umber, I added the light shapes with white paint and the dark shapes with Umber.

• After this layer dried, I blocked in the large shapes of color in stages and added more smaller shapes and details.

• I mixed linseed stand oil with the paint to thicken the final color layers and highlights.

HOT TIP!

Always trust in your passions. If you are moved by a subject, even if it has been done before, believe in yourself. Determine what has captured your interest: color, mood, narrative, design possibilities. Your painting should always reflect your unique personal voice.

what I used

support
Stretched canvas toned in Burnt Umber

brushes
Round brushes Nos. 1, 3, 5, 6

medium
Linseed stand oil

oil colors
Burnt Umber
Permalba White
Ultramarine Blue
Viridian
Permanent Rose
Cadmium Red
Cadmium Yellow Pale

Nancy Bass lives in Virginia, USA → www.nancybassartist.com

Once a strong abstract framework was in place, I could work loosely and intuitively.

. . . and the Livin' Is Easy, watercolor, 12 x 18" (31 x 46cm)

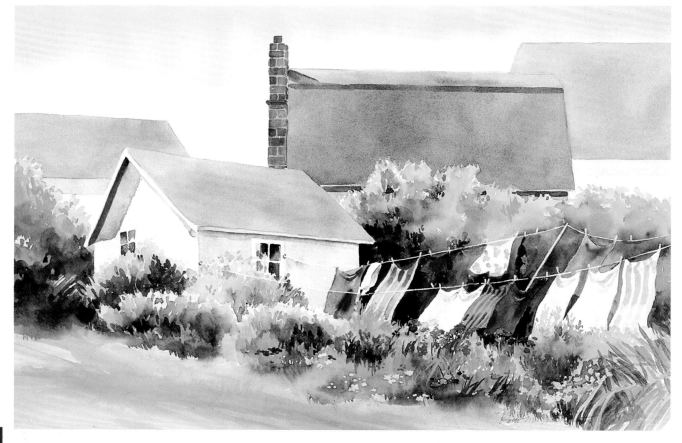

Patti MacHale Bartol

what I wanted to say

Maine's Monhegan Island offers a slice of inspirational impact, especially those places that invite one to sit and savor a slower pace. This particular view presented a study in contrasts between the solidity of the weathered houses and the fluidity of fabrics and flowers moving in the breeze. The scene excited me both visually and emotionally, a perfect combination for a promising painting.

my design strategy

My strategy was to establish a cohesive design by creating an abstract foundation. The primary design elements in this painting are shape and line, so I tried to vary the geometric rooftops, the arcs of the clothesline and the random patterns of clothing and garden areas.

my color philosophy

I wanted the color to indicate a sun-drenched, joyful light. Because the painting is primarily warm (high key), cool colors had to be used for contrast. I planned cool passages in the shadows on the houses, fabrics, window and even some cooler greens in the grass. I also utilized bright colors not typically on my palette to enliven the focal point of the clothesline.

my working process

- Time constraints allowed only a photograph. My reference photo contained just a few scattered houses and a clothesline with nondescript items, so it truly was only a reference. After establishing the abstract composition from several thumbnail value sketches, I drew the basic shapes on watercolor paper with an HB pencil.

- Working from top to bottom, I covered the sky with clear water and brushed pigment across the top area. I tilted my support board to allow the pigment to flow downward.

- I painted the roofs as a single shape, using glazes of transparent, primary colors to create a sense of luminescence. Each layer had a predominant color with the other two primaries mixed wet-in-wet on the paper. I allowed each glazed layer to dry before applying another.

- Before moving down into the foliage, I applied masking fluid to protect the clothesline and some flowers. I then worked light to dark, choosing colors intuitively and adding some darks for immediate contrast.

- I finished with a few touches of color.

a word on working from life

Why not try making color sketches out-of-doors to capture your direct visual and emotional response to the landscape? Quick paintings done on location strengthen one's abilities.

what I used

support
Gator board, which has a water resistant surface

brushes
A selection of flats, rounds and riggers

watercolors

Indian Yellow	Cobalt Blue
Green Gold	Compose Green No. 1
Quinacridone Gold	Turquoise Blue
Quinacridone Sienna	Quinacridone Violet
Permanent Rose	Prussian Blue
Scarlet Lake	

Patti MacHale Bartol lives in Virginia, USA

I introduced all types of value, shape and color contrast to give this subject more visual impact.

Evening at Melville Cove, watercolor, 22 x 30" (56 x 76cm)

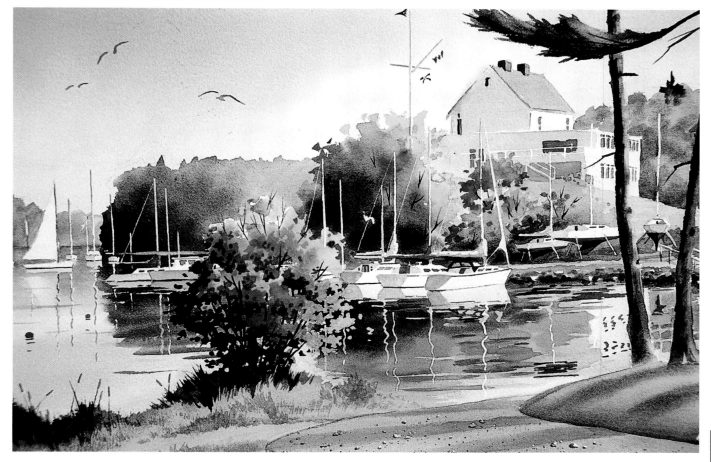

my inspiration

I paint what I know. Since I've lived on the ocean near water and boats all my life, I felt this yacht club made an interesting composition. However, I saw it on an overcast day, and I felt I could make it even more dramatic with brighter sunlight. The white clubhouse building and the white boats offered the chance for subtle, cool grays surrounded by vivid, warm colors, with a good balance of lights and darks.

my design strategy

I wanted to create as much interest as I could from value and color. So I decided to use strong contrasts for impact — light against dark, warm against cool, verticals balancing the horizontals. I also wanted a complementary color pair, orange and blue.

my working process

- I started with a value sketch on site, rearranging the light and dark shapes until I had an interesting composition. I also took photographs for some of the boat detail. Back in my studio, I lightly drew in the largest shapes with a 2B pencil on cold-pressed paper.
- I then soaked the paper with clean water, wetting around those shapes that were to be left white, such as the sunlit sides of the clubhouse and boat hulls. Painting from light to dark, I flooded in the sky and water areas. When the paper was dry, I painted the cool shadow shapes for the clubhouse and the boats.
- I then re-wetted the foliage areas with clean water and dropped in the warm colors,

ignoring the masts of the boats, which I lifted out later. While those areas were still damp, I painted the dark areas of the foliage.

- After drying the paper again, I painted the foliage reflections, being careful to paint around the reflections of the boats since they were lighter in value than the reflections of the foliage.
- The next step was to paint the darks, which made the lights sing.

- Since I didn't use staining colors, I was able to lift out the masts of the boats, as well as their reflections.

try this tactic yourself

To give the mast reflections a wiggled shape, I created stencils. I laid down masking tape on the dry paper and cut out the reflections with a sharp knife. I then lifted the exposed pigment with a damp brush.

what I used

support
300lb cold-pressed paper

brushes
Large flats and Nos. 4 and 30 rounds, all synthetic

watercolors
Aureolin Yellow
Raw Sienna
Brown Madder
Ultramarine Deep
Prussian Blue

I made friends with ornery Phthalo Blue and Green to make translucent cools.

Cottonwood Canyon, oil, 24 x 20" (61 x 51cm)

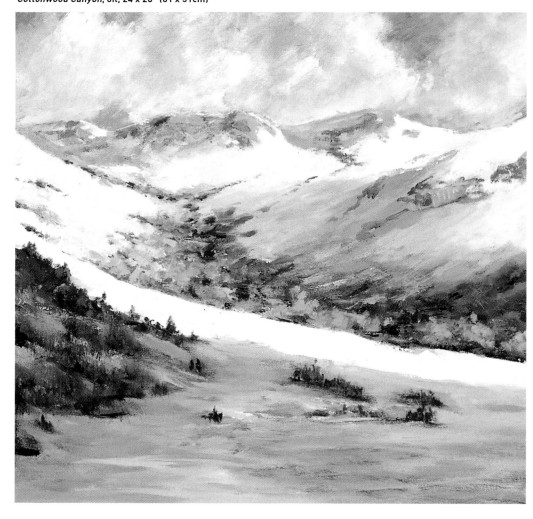

William Grinnell

ARTIST
66

the main challenge in painting this picture

Late afternoon on the final ski run of the day, I always stop at the canyon floor and look back at the strong mountains and enjoy the softening color values as they slowly ebb into darker shadows. But there's a challenge in painting this. As the light starts to wane, there remain areas of strong light next to softening cools. The task is to not let the cool values make the warm values too high.

about the light

In this painting I wanted to show the strength of the mountain along with the gradual dissipation of the light, yet still have some strong values.

my working process

- Since I always carry a camera plus several sketchbooks of various sizes, I was prepared to take some photos, do some thumbnail sketches and make a few color notes at various rest stops on the way down the slope.

- I started with a few general strokes roughly dividing the canvas into its several color-value areas.

- Next, I blocked in each area with a thin wash of color. I left the white snow as white canvas and established the darker areas so I could compare all of the subsequent values to these keys.

- I then used my palette knife to cover the main areas with paint, which I then softened with my brush. Mixtures containing Phthalo Blue allowed me to create softer cools where I needed them.

- I constantly stepped back 10 to 15 feet and looked at the entire subject through my paper towel roll or a reducing glass. This gave me a good overview of the composition and values.

- When I was 90 per cent complete, I put the painting aside for a week or two, occasionally taking critical looks to consider changes. I crossed the finish line with some fun impasto palette work for highlights.

try these tactics yourself

- Learn to mix soft, translucent cools with Phthalo Blue and Green. They tend to be ornery, so remember, a little dab will do you.

- When a painting is dry but you're unhappy with a particular color-value, go over that spot with soft pastels in other colors. When you find the one color-value that works, mix up some matching paint and apply.

what I used

support
Stretched canvas

brushes
Round and brights Nos. 4, 6, 12, 20; palette knife

oil colors

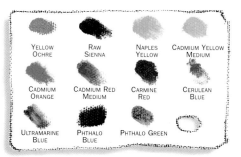

YELLOW OCHRE RAW SIENNA NAPLES YELLOW CADMIUM YELLOW MEDIUM

CADMIUM ORANGE CADMIUM RED MEDIUM CARMINE RED CERULEAN BLUE

ULTRAMARINE BLUE PHTHALO BLUE PHTHALO GREEN

William Grinnell lives in California, USA

The raking effect of late-day sunlight inspired me to interpret this familiar subject in a new way.

Blue Hill Evening, oil, 9 x 12" (23 x 31cm)

Steven Hileman

ARTIST 67

my inspiration

One evening, as my family and I visited a park along the harbor in Blue Hill, Maine, the effect of the late-day sunlight caught my eye. I saw an aspect of this landscape I had not noticed before. I decided I would return with my paints to capture these effects.

my design strategy

Color and contrast were my primary interests. The contrasts between the lights and darks and between the warm and cool colors were very striking. The sunlit trees, standing in stark contrast to the trees in shadow, created a dominant focal point. The strong vertical lines of the sunlit tree trunks also created an interesting counterpoint to the horizontal lines of the shore and the cast shadows.

my working process

- Upon setting up my easel on location, I used a large bristle brush to tone the canvas with a thin wash.

- After minimal drawing with a brush to indicate placement and composition, I blocked in the major masses of light and dark, using larger bristle brushes and thin paint. Not only did this block-in give me a clearer idea of the overall design and color harmony, it provided an underpainting for me to work over with thicker paint. Portions of this underpainting show through in the final painting, particularly in the foreground.

- With this painting, I completed the background first, then proceeded to the middle ground and finished with the foreground. I used various sizes of filbert and flat bristle brushes for the majority of the painting, reserving the thickest paint for the light areas and keeping the darks thin and transparent. By closely following the correct values, I was able to create depth and atmosphere while capturing the feeling of raking light.

- I then used a No. 2 flat sable brush to paint the tree trunks, branches and other details, and larger flat sables to soften edges.

my advice to you

- By painting directly from life, I have learned to:

- Interpret, not copy every detail I see. Interpretation involves discernment, simplification and emphasis.

- Squint. Besides allowing me to judge proper values and edges, squinting at the subject simplifies the overwhelming amount of information by eliminating unnecessary detail.

- Establish a definite center of interest by subordinating the other elements and emphasizing only the necessary elements.

what I used

support
Medium-textured, oil primed linen

brushes
Filbert and flat bristle brushes in Nos. 2 to 12; a few flat sables; palette knife

medium
Mineral spirits

oil colors
Titanium White
Cadmium Yellow Medium
Yellow Ochre
Cadmium Red
Terra Rosa
Transparent Oxide Red
Viridian
Cobalt Blue
Ultramarine Deep
Alizarin Permanent

Steven Hileman lives in Maine, USA → www.stevenhileman.com

I took all the classic design elements into consideration.

Fall Explosion, pastel, 17 x 23" (44 x 59cm)

my inspiration

When the fall color is at its peak and the lighting is special, I'm out searching for the right combination of design and impact. I have certain prerequisites that I look for, primarily balance, contrast of light and shade, provocative shapes and dynamic color. I immediately liked the combination of these various elements in this scene.

I actually began this as a demonstration for one of my landscape workshops, and completed the unfinished statement as a demo for another landscape workshop.

my design strategy

When I'm searching for inspiration for my paintings, I look for total context; not just one item, but all of the components in the composition that help to create a total statement. All the design elements were taken into consideration as the basis for my criteria. I also looked for an eye-movement that would add interest and lead the viewer into the picture plane.

my working process

- I concentrated on the abstract underpainting first, creating general shapes and value extremes without getting into any description. Because I did not get into premature definition and detail, I had the freedom to "play" with my colors and values (especially intense darks that gave the painting punch and vitality) while working out the design problems and producing dynamic tensions where needed.

- Once I was satisfied with my underpainting, I set it with blending. Wherever the grain of the paper had not yet been eliminated by my hand or by the initial layering, I used soft packing peanuts to push the colors into the tooth.

- Next, I began to define shapes and forms in general terms, evaluating my statement as I proceeded. I did not do any blending in this or the remaining stages so that I could retain the beauty and clarity of the direct color application.

- By the time I had gone through the preliminary stages, I was entirely satisfied with my composition, depth and form.

Some detail was the only embellishment required to complete the final statement.

HOT TIP!

Remember that you're creating a unique statement that represents your insights and expertise, and not duplicating a slide or photograph. Don't be afraid to push the boundaries into unknown territory. Your artistic growth improves by challenging yourself.

what I used

support
Neutral gray pastel paper

other materials
A variety of pastel brands, some home-made to get the perfect color or value

Larry Blovits lives in Michigan, USA → blovits@kvi.net

Touches of impasto paint helped me capture the intensity of a Southwestern sunset.

Nightfall, oil, 16 x 20" (41 x 51cm)

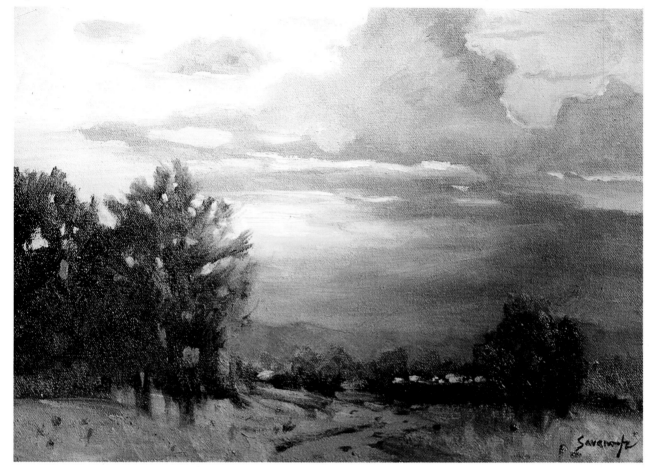

my inspiration

I'm inspired by the many dramatic sunsets in Arizona. My favorite time to paint begins about an hour before the sun goes down. It becomes a race against time as the colors quickly change and then disappear. The giant ponderosa pines behind my home also inspired me to paint light shining through tree branches.

follow my eye-path

A subtle path leads the viewer's eye up to the trees on the left and then to the yellow glow, which is the focal point. The backlighting then creates a warm glow around the trees' edges. Value and color are the dominant elements with an emphasis on color harmony.

my working process

- I made three five-minute value sketches, moving the elements around and leaving things out to make a strong design. I planned my light source, colors, darks and mood at this time. Then I did a rough, 6 x 8" preliminary study.

- Switching to a stretched canvas toned with a Burnt Sienna wash, I made a sketchy lost-and-found line drawing to indicate my large masses.

- Using hoghair filbert brushes, I laid in thin washes of the big masses, covering the entire canvas. Then I went back in to each area to break up the large masses into smaller masses, refining my values, colors and edges.

- I then established my darks in the trees and the mid-values in the foreground. With thicker paint, I applied the lighter colors in the sky, loosely using my photos as the basis for the shapes.

- Using thick impasto paint, I applied the yellow cloud edges and the yellow glow. I softened some edges and added an "orangey" tone to the edges of the trees and in the foreground.

- To finish, I added spots of broken color to suggest houses in the mid-distance.

the main challenge in painting this picture

The sky dictates the mood and establishes the color relationships of the rest of the painting. In the Southwest, the sunsets are often brighter than any paint colors so it is a challenge to capture that intensity.

my advice to you

- Paint outdoors as often as possible.

- Squint more to simplify and observe true relative values.

- Draw from life as often as possible.

- Have a variety of lost-and-found edges.

what I used

support
Stretched canvas toned with a Burnt Sienna wash

brushes
Hog hair filbert brushes in Nos. 2, 4, 6, 8; small No. 2 round

oil colors
Lemon Yellow
Cadmium Yellow Medium
Cadmium Orange
Raw Sienna
Permanent Rose

Alizarin Crimson
Sap Green
Ultramarine Blue
Turquoise
Titanium White

Sheila Savannah lives in Arizona, USA → s.savannah@att.net

I invite viewers into this painting with tone and light.

Mountain Air, oil, 12 x 24" (31 x 61cm)

what I wanted to say

I love these mountains, and have painted them many times during changing seasons and light conditions. On this particular day, I was moved by the atmospheric conditions bringing cool, breezy, sweet-smelling air. The late afternoon light also created dramatic effects. Through these two elements, I wanted to invite the viewer to stay awhile, enjoy the fresh mountain air and enjoy a peaceful late afternoon.

my design strategy

Influenced by the light and atmosphere, I mapped out my design. I used warmer colors and lighter values with more detail in the foreground to invite you in. I then used cooler colors and diminished value contrast in the background to sweep you back into the receding distance and atmosphere.

my working process

- I started by tinting my canvas with a warm wash to unify the work and eliminate the white of the canvas, which can cause annoying glare outdoors.

- To lay in the painting, I used sturdy hog-bristle brushes and paint thinned with turpentine. I quickly sketched in the shapes of my design, remembering that I could change things easily until I got it right.

- Squinting to see my correct tonal values, I painted the darkest and lightest values close to their local color. Still squinting, I continued to cover the canvas before the light changed. I painted all over, relating each value and color to the previous one and constantly looking at what nature was showing me so I could stay true to her.

- After all the large shapes were in, I changed to softer sable brushes to put in more definition and details. But the old cliché of "less is more" holds true, so I stopped before I told the viewers everything they'd rather figure out for themselves.

the best of both worlds

Painting on location is a wonderful way to record nature as it is. I seldom complete outdoor paintings back in the studio because, except for minor touches, they're usually best left alone. However, I do use many of my location studies to paint larger, more detailed studio pieces. There, the atmosphere is unhurried and I may spend weeks on one painting. In either case, my goal is always to pass the same feelings on to the viewer.

what I used

support
Stretched canvas

brushes
Hog hair and sables in a variety of shapes and sizes

medium
Turpentine

oil colors

CADMIUM LEMON YELLOW CADMIUM YELLOW DEEP CADMIUM ORANGE ROSE MADDER

CADMIUM RED DEEP PHTHALO BLUE ULTRAMARINE BLUE WHITE

A well thought-out design helped me convey the quiet continuity of this classic landscape.

Sentinel, oil, 16 x 20" (41 x 51cm)

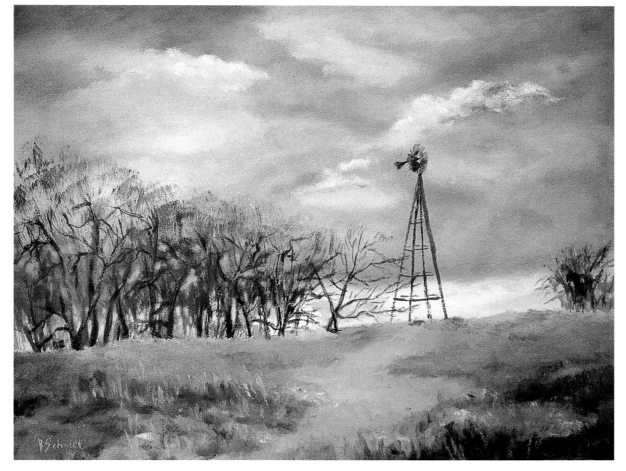

Betty Schmidt

ARTIST 71

what I wanted to say

Each year I pass this location on the way to a historical re-enactment. The old farm buildings on the site disappeared and only the windmill was left to watch over the countryside. I always feel a sense of relief and peace when I see that the windmill is still standing. Perhaps it represents quiet continuity in a sometimes chaotic world.

my design strategy

First, I developed the format, value pattern and design with a pencil on a small sketchpad. To begin, I lightly marked an approximate grid pattern dividing the format into thirds, horizontally and vertically. Knowing that any one of the four intersections of these lines would make a good location for my focal point — the windmill's wheel — I decided to position it in the upper right quadrant. I also avoided placing the horizon line in the center of the image. To create an entrance into the painting, I allowed the pathway, tree line and clouds to form an S-curve to the focal point.

my working process

- After determining the basic design and canvas size, I toned a canvas with a thin wash of Turpenoid and Terra Rosa. Still using thinned paint, I lightly marked on the canvas only the intersecting points of those imaginary grid lines. I could then clearly see where to position the windmill. I continued lightly sketching in the rest of the main compositional lines with thinned Ultramarine Blue.
- The major masses were developed first while constantly watching for color harmony and eye movement. Warm and cool autumn colors were interwoven to create interest among the grasses.
- The distant white bank of clouds on the horizon were a key factor in bringing life to the painting.
- As I moved closer to the foreground, I took greater care with detail. I painted the weeds in the direction of their growth. The tree line and windmill were added last.

my advice to you

- Paint something that has meaning to you.
- Constantly step back from the canvas.
- Continuously take care to balance warms and cools. To make that easier, I recommend putting a warm and a cool of each of the three primaries on your palette.

what I used

support
Canvas on stretcher bars

brushes
Filbert bristle brushes, ranging from Nos. 12 to 4; some small sables

medium
Turpenoid

oil colors
Zinc Yellow Hue
Cadmium Yellow Pale
Naples Yellow
Cadmium Red Light
Permanent Alizarin Crimson
Rose Madder
Cobalt Blue
Ultramarine Blue
Titanium White

Betty Schmidt lives in Illinois, USA → www.bettyschmidt.com

Linear and atmospheric combine to give a sense of depth.

Monfort Stream, oil, 16 x 20" (41 x 51cm)

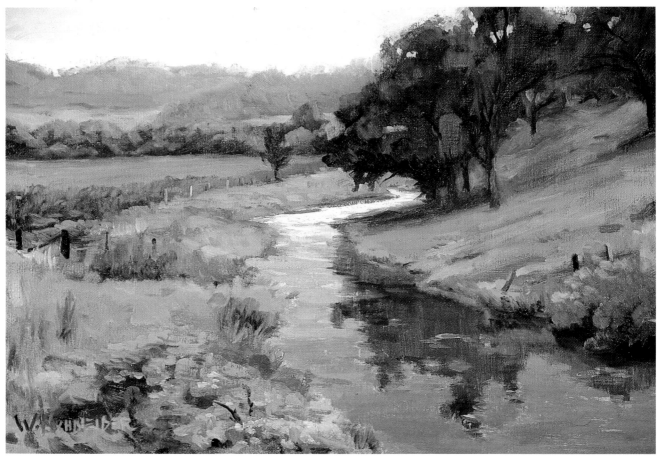

William A Schneider

my inspiration

I was inspired by the color harmony of the Wisconsin countryside — creation in all its simple perfection. My goal was to capture my impression of that place and time as honestly as I could. This required standing on the spot and painting from life.

follow my eye-path

I wanted to lead the viewer to the focal point (the place where the river curves beneath the middle ground grove of oak trees) and then to the exit in the distant hills. The river provides the basic design structure, a reverse "S". To create a sense of depth, I used a combination of linear perspective (the converging bends of the river) and atmospheric perspective (cooler colors and diminished value contrast as the landscape recedes). I also tried to emphasize the sense of depth by showing more texture in the foreground and less as the picture plane recedes.

my working process

- First, I toned the canvas with a thinned wash of Viridian and Terra Rosa. Then I used Ivory Black thinned to the consistency of weak tea to establish my horizon line and place the main pictorial elements. Since I was concerned with accuracy, I measured carefully.

- After squinting to simplify the values and edges, I established my lightest light and my darkest darks. I also indicated my sharpest edge (the lower edge of the dark foliage of the oak tree) and placed a dab of the purest color (the green of the foreground grass on the left).

- Once I had established my extremes, I started with the sky and began to work my way forward, putting in each mass. I constantly compared their values and colors to what I saw and to each other, often stepping back 10 to 15 feet from my easel to check my accuracy.

- Later I returned to add details and adjust (usually soften) the edges. But because the value and color relationships were correct, I didn't need a whole lot of detail.

why I paint from life

Painting from a photo is like listening to music while wearing ear plugs — you can get the general melody but all the nuances are gone. The camera distorts value, color, edges and even perspective, which is why paintings done from photos often seem to suffer the same flaws: the lights are too washed out, the darks are too dense and inky and the edges tend to be too sharp.

what I used

support
Linen support double primed with white lead

brushes
Large bristle filberts in Nos. 4, 8, 10, 12, 14; smaller sable flats in Nos. 4, 6, 10; 2" and 1" painting knives

medium
Mineral spirits

oil colors
White
Cadmium Yellow Light
Raw Sienna
Terra Rosa
Permanent Alizarin
Transparent Oxide Red
Viridian
Ultramarine Blue
Ivory Black

William A Schneider lives in Illinois, USA → www.schneiderart.com

I know it is the light that determines the color and mood.

View From the Road — Utah, oil, 16 x 20" (41 x 51cm)

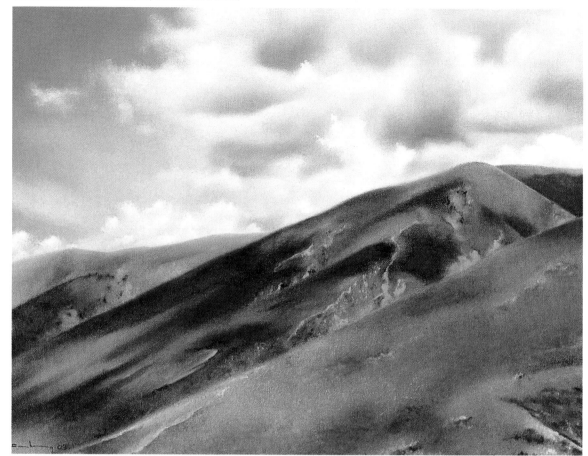

Michael Schoenig

ARTIST
73

the main challenge in painting this picture

I was inspired by the incredible beauty of the Utah landscape, which I discovered on a driving trip across the US. But I'm fairly new to landscapes and find them more difficult than still life or figurative subjects. I'm challenged by the need to keep them loose and natural, not painting every detail, while striving for the degree of realism I prefer.

my color philosophy

While the colors in the painting appear to be quite different from one another, I tried to harmonize them by having all of my colors share at least one color, Raw Umber. I also mixed the blue of the sky with some Sap Green, the predominant color of the hills, and put the same French Ultramarine used in the sky into the darker areas of the hills.

my working process

• To knock back the whiteness of the canvas, I applied a ground of Raw Umber mixed with French Ultramarine. Using a thicker version of the same mix, I laid in the shapes and dark areas.

• Once that dried, I began by painting the sky, because it is the light source and determines the color variations and mood of the whole painting. I used large, soft brushes to achieve a smooth blending, then a smaller brush to bring out details and contrast.

• I then built up the hills in a series of light layers, which I allowed to dry between each application. (A quick-drying painting medium sped-up this process.) I made the darks darker and the lights lighter to enhance the effect of light and shadow. I used large brushes to create soft edges in the earlier layers, but again used smaller

brushes to add detail in the final layers.

• As a final refinement, I lightened and softened the edges of the hills to make them recede even more.

try these tactics yourself

• When I paint from photographs, I like to use black-and-whites. They give me the freedom to

create my own palette, to decide the direction and mood of the piece, and to work from my imagination.

• To keep myself from painting every unnecessary detail found in a photo reference, I will sometimes turn it and the canvas upside down to paint. This forces me to focus on shape and form, rather than a specific object.

what I used

support
Stretched canvas toned with a mixture of Raw Umber and Ultramarine Blue

brushes
Palette knife;
No. 2 round bristle brush;
No. 16 flat sable brush;
Nos. 6 and 18 soft wash brushes;
No. 12 round white sable brush

other materials
Painting medium

oil colors
Titanium White
Unbleached Titanium
Yellow Ochre
Cerulean Blue
Burnt Sienna
Sap Green
Ultramarine Blue
Raw Umber

Michael Schoenig lives in California, USA → www.mschoenig.com

To prevent hard edges, I spattered random color onto pre-wet paper.

Birches by the Brook, watercolor, 19 x 28" (49 x 71cm)

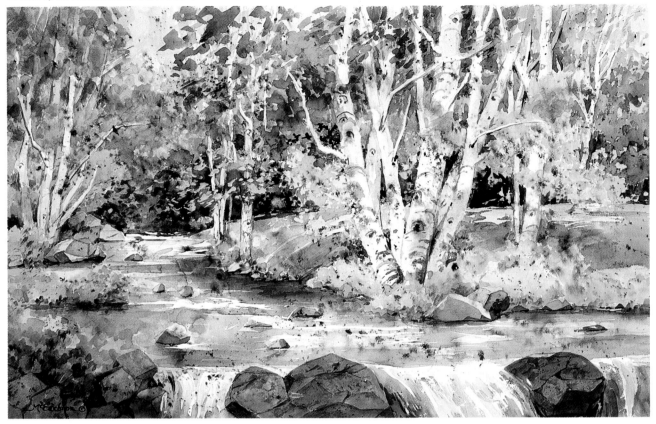

Ann McEachron

**ARTIST
74**

my inspiration

I have jumped from boulder to boulder in streams like this many times, and have fond memories of those experiences. In addition to expressing this peaceful feeling, I wanted to provide interesting nuances for the viewer's eyes: the white bark and knot holes of the birch trees; their lacy, shiny leaves that catch the sunlight; the rushing, rock-strewn brook; the shady forest behind and the sunny area in the foreground.

my design strategy

To show aerial perspective and depth, I accentuated the diagonal lines of the stream bank and diminished the sizes of the trees. I also allowed the intense foreground colors to gradually become more neutral and grayed, and positioned the highest value contrast where the stream vanishes into the forest to draw your eye back. Other design elements included variations in the size, value and intensity of the trees and sparkling pairs of complementary colors.

my working process

- First, I did several small, thumbnail sketches to determine the placement of the main shapes and the value pattern. I then transferred this drawing to my watercolor board.

- Before starting to paint, I randomly sprayed and spritzed some areas of the paper with water. Then I used my large sable brush and an old toothbrush to randomly drop and spatter dark blue pigment across the surface.

- When dry, I applied masking fluid to the waterfall, a few level areas in the water and some trunks and branches. I used the edge of a paper clip to apply fine lines of fluid to the tiniest branches.

- Following my value sketch, I applied several wet-into-wet applications of various greens for the foliage, drying between each one. Over this, I put in some of the smaller shapes, such as the branches, rocks and tree trunks.

- After laying in the blues, grays and greens in the water, I removed the mask and defined the waterfall and added shadows in the water.

- Last, I had to decide what color the sunny area behind the main clump of trees should be. I painted small pieces of paper in that shape in various colors to test my choices, eventually settling on a violet, which I also applied to some tree trunks for unity.

HOT TIP!

You might like to try spattering pigment into both wet and dry areas to create a loose, splotchy underpainting. This impressionistic, painterly look keeps the painting from appearing too hard-edged.

what I used

support
Cold-pressed watercolor illustration board clamped to foam core board

brushes
All Kolinsky sables, Nos. 3, 5, 9 and 12 rounds, plus a No. 3 rigger;

other materials
Masking fluid
Toothbrush

watercolors
Phthalo Yellow
Cobalt Blue
Permanent Rose
Cadmium Orange
Burnt Sienna
Quinacridone Gold
Sap Green
Phthalo Green (blue shade)
Phthalo Blue (red shade)
Ultramarine Blue
Alizarin Crimson Permanent
Indigo

Ann McEachron lives in Virginia, USA

The contrast of light and shadow provided a mysterious point of interest for my painting.

Late Afternoon Light, oil, 18 x 24" (46 x 61cm)

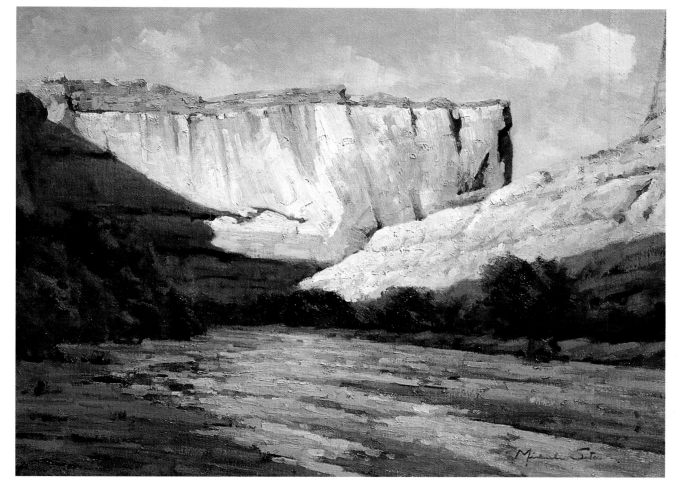

what I wanted to say

I recently joined a group of 21 artists in Canyon de Chelly, Arizona, to camp and paint the canyon. I was awed by its quiet, simple and undisturbed beauty. At one point, I was walking around the bend to my campsite, and the scene before me took my breath away. If someone viewing my painting is moved by the canyon's majestic spirit, I will feel that I have captured the moment.

my design strategy

I wanted the composition to express the fascination I felt when I saw afternoon light moving across the canyon, highlighting the contrasting colors there. The focus of the piece is where the distant water follows the bend of the land and disappears. It made me wonder what was around the bend. The elements of this piece,

such as the creek's path, the trees along the bank, and the shadows on the cliffs, bring the viewer to that focal point.

my working process

- The process began with a small plein-air color sketch and several digital pictures for reference. The composition was already there.

- On my larger canvas, I used a No. 4 brush to put in all of the basic shapes in Light Red. I made sure my shapes were balanced and led to the focal point.

- Since all of the lines of the piece converge at the focal point, I began there, using black and green to ground the piece with darks. The focal point is what brings the painting together.

- Then I took two No. 10 flat brushes — one for cool colors and one for warm colors — to

paint outward from the focal point. I paid close attention to laying in the correct values and balancing my warms against my cools, with plenty of variation. When the canvas was completely covered, I stopped.

- I waited for the basic layer of paint to dry a little, then went in to add definition and detail to the piece. I used small- to

medium-sized flats for strong brushwork.

- Finally, I went back to my warmest places to add thicker highlights. I finished the piece in one sitting so that the mood was cohesive. Only a few refinements were made the next day, when I could see the painting with a fresh eye.

what I used

support
Stretched linen

brushes
Round brushes Nos. 2 and 4; flat brushes Nos. 6, 8 and 10

medium
Turpenoid and linseed oil

oil colors
Cadmium Yellow
Yellow Ochre
Light Red
Cadmium Red
Alizarin Crimson
Cerulean Blue
Ultramarine Blue
Viridian
Ivory Black
Titanium White

Michael Situ lives in California, USA → www.michaelsitu.com

Variations in tone and color temperature allowed me to recreate the illusion of depth and backlight.

Afternoon Shadows, acrylic, 18 x 24" (46 x 61cm)

my inspiration

Even in the concrete jungle of New York, oases of nature and beauty can still be found, such as the Brooklyn Botanic Garden, where I was especially drawn to this moment of dramatic light. It infused the painting with mood and intensified nature's colors, which are qualities I look for in my subjects.

my design strategy

I deliberately placed my horizon line at the mid-point to showcase the shadows on the grass as well as the light filtering through the trees. I used the thick trunk of the foreground tree to tie the halves together and the long horizontal branch to frame the main subject. I also took great care with value contrast to accentuate the light and shadows, and was sensitive to color variations to distinguish foreground from background. Note that I included a small painter in the background to provide scale and a sense of life. I worked from a photograph to get both the composition and the transient light effect I was after.

my working process

• With a wide, flat bristle brush, I eliminated the white of the canvas with a thin wash of the dominant green. Using thinned Burnt Umber, I plotted out on the canvas the horizon line and other elements.

• Starting in the background, I began to layer on color to suggest the forms of the trees and foliage. I used mixtures of mostly cooler greens to suggest depth, applied with an old, worn brush to create the look of dappled light.

• As I put in the grass, I adjusted the values within that large shape to suggest depth. Then I glazed on the long shadows.

• Finally, I used warm, very dark color mixtures for the large silhouetted tree and the patch of dirt at the base. Mixtures of Hooker's Green and Turquoise provided the foreground leaves and touches of Cadmium Orange created highlights.

three tips for painting on site

1 Keep equipment to a minimum for convenience, and check to make sure you have everything you need before heading out.

2 Don't feel intimidated by the public looking on and commenting on your work. They often provide a fresh perspective and constructive criticism.

3 Take pictures before you begin. If you have to complete the painting back in the studio for any reason, you'll have a photo reference.

what I used

support
Primed and stretched canvas

brushes
Several sizes of synthetic brights

medium
Water

acrylic colors
Cadmium Yellow
Cadmium Orange
Leaf Green
Light Green
Hookers Green

Phthalo Turquoise
Ultramarine Blue
Burnt Umber
Titanium White

I resolved my design up front, then painted spontaneously and intuitively.

Early Light, watercolor, 24 x 22" (61 x 56cm)

what I wanted to say

Well known for its beauty, Oak Creek Canyon near Sedona, Arizona, is a magical place I visit and paint every autumn. I have painted many watercolors and oils of the creek, both on site and from photographs. Sometimes the beauty overwhelms me to the point of poignant tears. I'm unable to express these emotions with words, so I do the best I can to paint with my heart.

my design strategy

Someone once said, "Color gets all the credit — value does all the work!" Were truer words ever spoken? Therefore, a preliminary value sketch and thoughtful drawing of interlocking positive and negative shapes on the watercolor paper allowed me to resolve my design up front. This in turn allowed me to be more spontaneous and intuitive with my color choices and paint handling.

my working process

- I had been daydreaming of painting this particular spot — 100 miles from my studio — so I had to work from a photo that vividly brought back my memories of the scene. I drew the composition onto my watercolor paper, using expressive pencil lines.

- I first wet the entire area above the rocks, then dropped in light to medium tones of yellows and reds. I sprayed with water and tipped the painting to make the paint and water flow. After a sprinkle of salt here and there, I left it to dry.

- Next, I painted the larger rock shapes wet-into-wet. The smaller rocks were painted on dry paper, but with plenty of water for soft edges.

- For the water, I painted wet-on-dry, including some spattering. I moved my brush to rhythm of the creek so that I could better represent its natural action.

- I then moved on to layers of darker values, adding more intense colors as I defined shapes with both positive and negative painting. I put in a little salt and some spattering as the spirit moved me.

- As often happens, an area of the painting that I had assumed would be easy wasn't! I had gone too dark in the area next to the orange tree, so I lifted out the paint and later re-applied lighter tones mixed with a little gouache.

- For the final touches, I spattered on a couple of leaves and placed my signature so that it worked with the total design.

what I used

support
140lb cold-pressed watercolor paper

brushes
1½" 1", ¾" and ½" watercolor brushes; Nos. 8 and 14 Kolinsky sable rounds; a sable rigger

other materials
Titanium White gouache

Sturdy plastic palette

Table salt

watercolors
Lemon Yellow

New Gamboge Yellow

Phthalo Red

Cerulean Blue

Antwerp Blue

Julie Gilbert Pollard

ARTIST 77

Julie Gilbert Pollard lives in Arizona, USA → www.JulieGilbertPollard.com

By exaggerating the temperature of my colors, I was able to create the sensation of warm light on a snowy morning.

Route 22, oil, 18 x 24" (46 x 61cm)

Gabor Svagrik

ARTIST 78

my inspiration

I've driven by this farmhouse many times in different seasons, but on this particular morning I couldn't help but notice the warm light casting these beautiful shadows and hitting the trees and the building. I'm also a sucker for freshly fallen snow, and I liked the way the brilliant Cobalt Blue sky played beautifully against the warm trees.

follow my eye-path

The farmhouse was my main center of interest. Everything around it would be a supporting element. The row of pine trees played a main role in leading the viewer into the painting. The big

shadow on the bottom was extended to hug the bottom of the painting. I even pushed the colors of the trees and the sky to give it a really nice feeling of light.

my working process

As always, I toned my canvas with a mixture of Ultramarine Blue and Burnt Sienna. Then I began to draw in basic shapes with a small round brush. Next, I began to paint in the sky and then the trees wet-into-wet. The building followed and finally the foreground. I like to work from thin to thick. For me, it is important to have a variety of textures because it makes for a more interesting painting.

my advice to you

- Make sure that you paint from life as often as you can. It's the only way you will learn about color, light and values. Also, it will keep you from getting too involved with detail and will make you understand why certain things work better than others.

- Make sure to spend time in the studio, too, to work on bigger paintings and to analyze the knowledge you gained outdoors.

- Paint as much as you can! Do not wait for inspiration to come around.

what I used

support
Tightly stretched canvas with one coat of rabbit skin glue and two coats of oil primer

brushes
Nos. 8 and 6 flats and a No. 6 round

oil colors
Cadmium Lemon
Yellow Ochre
Raw Sienna
Burnt Sienna
Alizarin Crimson
Ultramarine Blue
Cobalt Blue
Titanium White

Gabor Svagrik lives in Arizona, USA → www.svagrikfineart.com

To add greater depth and interest to my painting, I semi-mixed and applied my colors with a painting knife.

Crisp Day in March, oil, 14 x 11" (36 x 28cm)

my inspiration

I am a native of Wyoming, and live in an area very similar to the subject of my painting. I love painting the wide expanses of prairie as well as the various mountain ranges of our beautiful state. I wanted to show how the warm reds and golds of early March trees and grasses contrasted so well against the cool colors of the sky and distant mountains.

my design strategy

I placed the fence close to the viewer and then leading up to the tree, which I chose as my focal point. I also used the ditch and lighter grasses to lead the eye into the tree. I then balanced these verticals with several horizontal lines in the sky, the distant trees and bushes and the shape of the mountains.

my working process

- I sketched a very simple design on my blank canvas.

- Starting with the sky first, I painted the clouds and the Cerulean Blue of the sky. Using the larger knife, I carefully scraped across the sky to make the clouds look soft and windswept.

- Working background to middle ground, I used the smaller knife to lay in each horizontal band. I kept these areas somewhat smooth for contrast against the thick, textured paint to come in the foreground.

- As I moved into the immediate foreground, I concentrated on using a wider variety of knife strokes, trying to match the shapes and textures there.

- Last, I painted in the trees with Burnt Umber, Light Red, Cobalt and Cadmium Orange. Instead of completely mixing the colors, I picked up bits of three or four of these colors on the knife (plus white) and blended only slightly before applying to the canvas so that the colors looked random and interesting. I varied the combinations of colors to get different values.

something you could try

Try using a painting knife to paint all areas of a painting, not just for certain details and effects. It's fun to see the "accidents" you can achieve with a knife that you can't get with a brush. For best results, start with the most distant area of the painting and then work forward in a layering method, making sure you complete each particular area while the paint is still wet. Otherwise, the paint will form a skin and look chewed up if you rework that area.

Carol Swinney lives in Wyoming, USA

Carol Swinney

ARTIST
79

what I used

support
Tightly stretched canvas with a medium to rough tooth

tools
Tapered 2" painting knife and 1½" painting knife

oil colors

BURNT UMBER · LIGHT RED · MARS VIOLET · ULTRAMARINE BLUE · COBALT BLUE · CERULEAN BLUE · YELLOW OCHRE · ALIZARIN CRIMSON · CADMIUM ORANGE · CADMIUM YELLOW MEDIUM · TITANIUM WHITE

Using wet-into-wet washes, I was able to link the elements of my painting.

In October, watercolor, 14 x 20" (36 x 51cm)

my inspiration

I wanted to portray the autumn sunlight warming the weathered wood of this lovely old barn.

follow my eye-path

The road makes a natural eye-path into the painting. However, to keep the eye from traveling down the road and out of the painting, I added the white fence-section and the bright stripe of sun leading from the road to the barn. The long shadows from unseen trees across the road keep the road from assuming too much prominence. Because I wanted to convey the warmth of October sun, I used a warm palette throughout, even warming the cooler blues and greens.

my working process

• Because I have painted this barn before, I needed only a minimal drawing.

• I began with a light wash of Naples Yellow over the entire paper. When that was dry, I rewet the sky area and ran a wash of Cobalt Blue down from the top of the paper.

• Next, I added Naples Yellow and Yellow Ochre to the hillside, working wet-into-wet. I put an initial wash of Burnt Sienna on the barn, and while that was still wet, I added strokes of Vermilion and Brown Madder in random areas.

• I drybrushed the fall foliage with Cadmium Orange and Burnt Umber, spraying with clear water. While the area was still damp, I added the darks at the base of the trees, using a little salt to soften the edges.

More details included the dark openings in the barn, the barn details, the tree trunks, the telephone poles and the fence posts.

• Last, I put the shadow wash over the road and hillside. Then, because the spots of sun on the road looked too harsh, I softened them with a damp, stiff-bristled brush.

try these tactics yourself

Although I am primarily a studio painter, I find painting outdoors is invaluable in learning to really see my subjects. It is especially helpful for landscape painting, when doing quick on-site studies gives my studio paintings more life and vitality. I also like to return to an area in different seasons. I discover something new each time I return to a favorite spot.

what I used

support
300lb cold-pressed paper

brushes
2" wash brush;
Nos. 8 and 10 mops;
Nos. 2, 6 and 8 rounds

other materials
Spray bottle
Salt

watercolors
Naples Yellow
Yellow Ochre
Cadmium Orange
Vermilion
Burnt Sienna
Brown Madder
Burnt Umber
Cobalt Blue
Indanthrone Blue
Phthalo Green
Sepia

Joan Reeves

ARTIST
80

Joan Reeves lives in Washington, USA → joan-reeves@webtv.net

I made this composition more interesting by playing up the shapes and lines.

McCue's Farm From Beech Mountain, oil, 22 x 50" (56 x 127cm)

what I wanted to say

On the way up Beech Mountain, on Mount Desert Island, Maine, there is a spot from which you can see two lakes, one on either side of a ridge. The potential of this composition escaped me on the several occasions I'd seen it. I thought it had no focal point — until one late afternoon I was out hiking and noticed the farmhouse lit up with a brilliant light! I found myself wondering what it would be like to live there.

my design strategy

I often try to make my compositions more interesting with subtle asymmetry within symmetry. There is the small hump in the center, bodies of water on both sides, rock stretching across the foreground. But the rocks slope slightly down from left to right, the nearby trees slope up, and the lake on the left is a different size and shape than the one on the right, plus on the far right is a third body of water.

my color philosophy

I find it helpful to decide on a color framework before I begin. This gives me something to fall back on if I'm ever in doubt about which colors to mix. Based on the color of the light (golden yellow), I chose an atmosphere color (Cadmium Orange) and a shadow color (Ultramarine) that I relied on throughout the painting process. Combined, they made a nice neutral gray. The atmosphere is slightly redder than the light because it is actually diffused light that becomes dominant as objects turn away from the light source.

my working process

- I took a series of photographs of the scene with a 55mm lens and created a panorama by piecing the photos together. After deciding on the exact composition, I sketched the outlines of basic forms onto the canvas with Burnt Umber.

- After blocking in the large areas of color, I then went over the canvas two or three times, gradually increasing the thickness of paint with each layer. I kept the brushstrokes soft and avoided fussy detail by using paint almost directly from the tube for the final layer.

what I used

support
Stretched linen, primed with acrylic gesso

brushes
Filberts Nos. 10, 8, 6 and 4; sable flat No. 4

oil colors

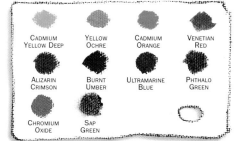

CADMIUM YELLOW DEEP YELLOW OCHRE CADMIUM ORANGE VENETIAN RED

ALIZARIN CRIMSON BURNT UMBER ULTRAMARINE BLUE PHTHALO GREEN

CHROMIUM OXIDE SAP GREEN

Alexandra Tyng

ARTIST
81

Alexandra Tyng lives in Pennsylvania, USA → info@fischbachgallery.com

Just two colors and splatter allowed me to get the feel of this scene.

Pemaquid Point, Side View, watercolor, 15 x 22" (38 x 56cm)

Marc van der Leeden

ARTIST
82

my inspiration

Lighthouses in general evoke a nostalgic response and in combination with their humanitarian function, they are an appealing subject. Pemaquid Point specifically represents the quintessential New England lighthouse. This lighthouse has become the focal point of my paintings, all created with differing design elements and compositions.

my design strategy

For this painting, negative white space was created to form a harmonious composition. Tension was created by the linearity of the roofline. Interlocking shapes of various sizes further reinforce the basic design concept. A very limited palette of two colors unified and accentuated the composition of the painting.

my working process

- With my board raised at an approximate 2" slope, I began the painting with a pencil sketch.
- Working very quickly with a 1" nylon flat brush, I began with the dark, abstract forms and continued to define the structure. I used two colors in varied combinations to create the desired effects.
- I painted the sky while the abstract form was still wet to create a softer edge.
- Detail and shadowing were then added with the smaller ½" brush to create contrast between the shapes.
- Finally, tapping my two brushes together, I splattered the painting to create further interest.

please notice

This painting is based on a black-and-white photograph, although it is not strictly representational. I have used this lighthouse many times as the basis for many works. Each is distinct as I use my imagination to manipulate its appearance. The photograph serves as a foundation to give me the opportunity to expand and experiment with color and design.

Because this is not a representational painting, the challenge was in developing a painting that contained the elements of my basic design based on the picture in my head. The subject matter is altered by my own imagination in order to create a pleasing composition.

what I used

support
140lb watercolor paper

brushes
½" and 1" nylon flats

watercolors
Raw Umber
Prussian Blue

Marc van der Leeden lives in Massachusetts, USA → www.marcvanderleeden.com

This reflection was tricky, but essential to suggest a quiet mood.

Bridge in the Light, oil, 20 x 24" (51 x 61cm)

my inspiration

One autumn day, I returned to a little old town while the afternoon sun's rays spread upon it. It was silent, but warm. The reflection under the bridge showed the golden sunlight from the blue sky. It attracted me with the melody of color. I could not help but to describe it with my painting.

my design strategy

I used the perspective line of the house to stretch the viewer's sight to the furthest point. The old bridge was placed in the center of the painting to balance the stretched movement of the perspective line. Through the arch of the bridge, the colorful reflections on the water become the focus of the whole painting.

my working process

- Because of the complicated relationships between the elements, I made a preliminary sketch to ensure the structure of my painting.
- On the larger canvas, I used Raw Sienna mixed with turpentine to sketch my design. For underpainting, I used Cobalt Blue on the shadow portion.
- After the underpainting had dried, I used Nos. 5 and 6 flat hog brushes to paint the dark portions of the painting.
- Then I painted the mid-tones of the sky and its reflection on the water.
- Next, I put in the structures and bridge. I enhanced the brightness of the wall of the house in order to provide a significant contrast with the shadow.
- Using Nos. 2 and No. 3 flat sable brushes, I painted the detail of the bridge and the window on the left. I also used the edge of a No. 6 flat sable brush to paint the leaves on the upper right.
- The greatest challenge was to interpret the interaction of the wind on the water without taking away from the reflection of the house.

what I used

support
Stretched linen canvas

brushes
Nos. 2 and 3 flat sables;
Nos. 5 and 6 flat hog hair;
palette knife

medium
Turpentine

oil colors
Alizarin Crimson
Raw Sienna
Cadmium Yellow
Permanent Light Green
Viridian Hue
Cobalt Blue
Ivory Black
Titanium White

Jiemei Wang

ARTIST
83

Jiemei Wang lives in California, USA → jiemei62@Yahoo.com

I used exciting effects to recreate my impressions of a powerful place.

San Juan Islands, watermedia, 22 x 30" (56 x 76cm)

Thomas A Wayne

ARTIST 84

my inspiration

I spend much of my time rambling along the margins of northern Puget Sound, sketching, photographing and just absorbing. The powerful presence of the San Juan Islands provokes intense reaction from me, and painting allows me to express this. I regard my landscapes as visual metaphors for my experiences.

my design strategy

I try to minimize the importance of objects and limit the number of recognizable symbols. I want my sense of composition and not the subject matter to drive my design. For this painting, I selected water hues — blues, greens and lavenders — which I accented with complements. I established an interplay of organic and soft-edged shapes against geometric shapes for dominant contrast. I also included a secondary contrast in texture and tried to create rhythmic patterns of light against mid-tone to open up the painting and create movement.

my working process

• I began by working directly with watercolor on wet paper. I used a 2" flat wash brush to divide the space with soft-edged, gestural strokes of cool colors while also preserving ample white space.

• As the paper began to dry, I switched to thinned acrylic paint and began exploring contrasts by overlaying geometric shapes and introducing complementary hues. Each stroke of the brush was a response to the developing composition.

• After the paper dried, I continued overlaying different sections by transferring paint on sheets of plastic wrap, waxed paper and patterns cut out from watercolor paper. This provided textural contrast and solidified the final space divisions.

• Having concentrated on my design, I was finally ready to begin integrating the subject with symbols. A few island shapes established a horizon. The sun symbol filled the need for some high chroma colors above the horizon.

• Finally, I worked on the overall harmony, tension and detail by adding some new geometric elements and adjusting hues by glazing and overpainting. In some places, I outlined the area with masking tape to control the edges, then dropped in multiple hues, which merged and diffused. I also dripped, splattered and spritzed with a toothbrush. I was careful to stop when I had defined only as much as was needed.

what I used

support
140lb cold-pressed, acid-free watercolor paper

brushes
1" and 2" flat wash brushes; a No. 14 round; a No. 4 liner

other materials
Waxed paper, plastic wrap, scissors, toothbrush, small pipette and masking tape

acrylics and watercolors
Titanium White
Hansa Yellow
Cadmium Yellow Medium
Yellow Ochre
Cadmium Orange Deep
Permanent Carmine
Cadmium Red Medium
Cerulean Blue
Cobalt Blue
Phthalo Blue
Anthraquinone Blue
Dioxazine Purple

Thomas A Wayne lives in Washington, USA

What could have been a fairly dull landscape was energized by color and light.

Dawn Fields, pastel, 24 x 24" (61 x 61cm)

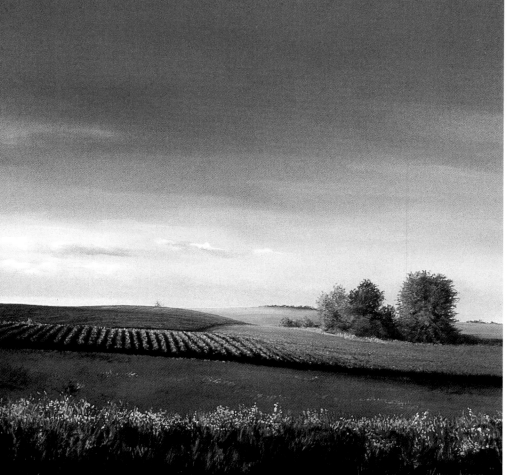

my inspiration

Having lived in the US Midwest all my life, I have a passion for the gently rolling farmland of my community. I also have a penchant for skies. With this painting, I imagined a sky that moved from lavender through mauves up to a dark gray-blue. I then searched my extensive photo collection for an additional land reference that would fit with the colors and light source I envisioned. I found this relatively simple view of soybean fields with light raking across them.

my design strategy

The group of trees provided a nice vertical element amidst the horizontal bands of the field, so I used it as my focal point. Angling the clouds, using intense colors around the trees and contrasting the busy detail of the foreground against the simple shapes of the background also helped to bring the eye to the center of interest. I chose a square format for a welcome change, and placed the horizon line relatively low so the sky would dominate.

my working process

- I jumped right into the painting process with no preliminary sketches or drawing.

- Using medium hard pastels, I quickly roughed in the sky colors, then blended them thoroughly. I refined the clouds with softer pastels, being mindful of a variety of edges, shapes and textures.

- Next, I laid down a neutral green over the total land area and rubbed that in well. From there, I completed the distant fields and group of trees quickly, working in a variety of colors so they would read as strong form but retain some interest close-up.

- I took a lot of time and care in putting in the rows of soy beans so that their scale and direction would read accurately. But once the perspective was correct, I quickly executed the highlights.

- After rubbing greens and blacks into the foreground, I masked off the rest of the painting with glassine paper and sprayed with workable fixative to create a dark, velvety finish. I then used a variety of strokes to put in the flowers and leaves.

- Finally, I went back and made a few minor adjustments to the sky.

something you could try

I like to keep my paintings fresh, energized and challenging by working out the composition and color problems directly on the painting.

what I used

support
Sanded, archival pastel paper

pastels
About five different brands, chosen for a combination of color and hardness

Marcia Wegman

ARTIST
85

Marcia Wegman lives in Iowa, USA → wegman6711@msn.com

This symbolic painting was achieved with limited color and a wide range of tones.

Starry Night, watercolor, 14 x 21" (36 x 54cm)

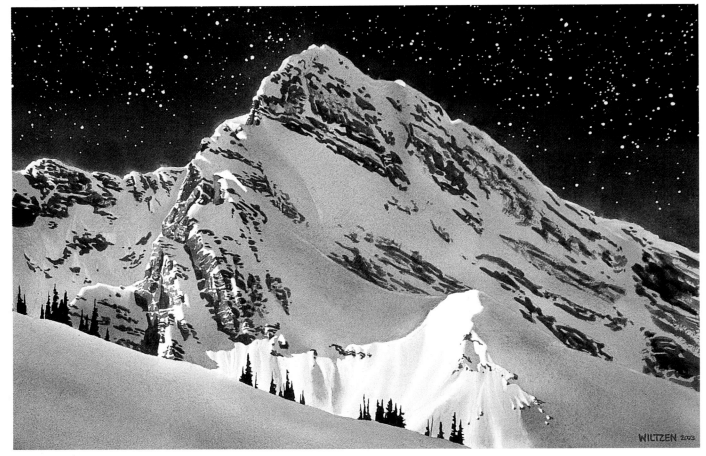

Elizabeth Wiltzen

what I wanted to say

The inspiration for this painting came to me at a time in my life when I was very conscious that there are powerful, invisible forces at work in our lives. I had recently experienced this magic and beauty on a very personal level, and I had a strong desire to express what I felt. The choice of a moonlit mountain under a sky full of stars represented for me the infinite reaches of this power and the daily evidence of its existence in our lives.

my design strategy

I intentionally chose a mountain with lines of strata that thrust toward the summit, compelling the viewer's eye upward into the star-filled sky. The moonlit shoulder was, of course, elemental to suggesting the presence of a full moon, and the small silhouetted trees on the foreground slope emphasized the magnitude of the mountain. I also introduced some soft warm color into the shadow areas of the snow in order to capture its luminous quality.

my working process

- After doing a simple line drawing of the mountain, I masked out the areas of it that were to remain white using masking fluid.
- When preparing for my large initial washes, I made sure I mixed up plenty of paint so I wouldn't run out mid-wash. I then wet the entire mountain and foreground and laid in a cool wash. I dropped in a warmer shadow color while the wash was still wet.
- Once this wash was dry, I wet the sky area and painted it with a strong Cobalt Blue. When that was dry, I rewet the sky and painted it again with a darker, grayer mix. This created the sense of lighter sky at the mountain edge gradating to darker as it got higher. I used a very soft hake brush for the second layer so as not to lift off the underlying layer.
- After removing the masking from the white areas, I softened these edges by gently lifting paint away with a moist brush and a paper towel. I then painted the rock of the mountain and the silhouetted trees with the same sky colors for unity.
- To create the stars, I first taped paper over the entire area of the painting that wasn't sky. I then used slightly watered down white gouache to spatter on some stars.

what I used

watercolors

Raw Sienna
Burnt Sienna
Rose Madder Genuine
Alizarin Crimson

Cobalt Blue
Ultramarine Blue
Winsor Blue
White Gouache

Elizabeth Wiltzen lives in Alberta, Canada → www.mountainartist.com

By exaggerating the complements of yellow and purple, I dramatized my painting.

Clouds Over Haystacks, pastel, 19 x 26" (49 x 66cm)

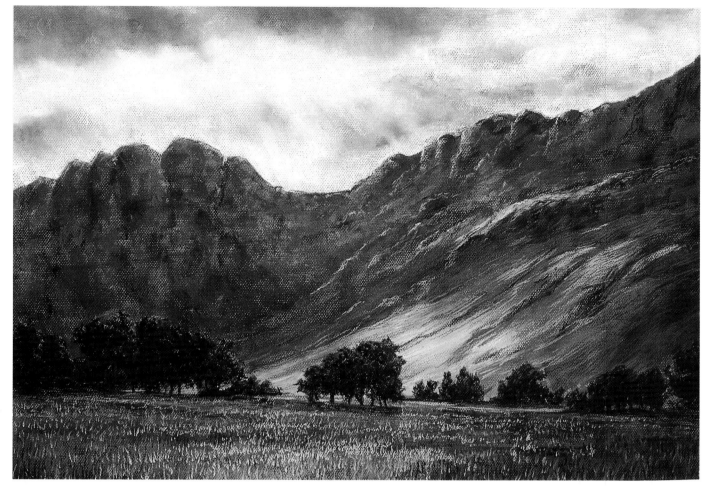

my inspiration

On an otherwise dull day in the Lake District in England, the sun suddenly broke through and lit up the flank of my favorite mountain, Haystacks. The slanting sunlight and sweeping cloud formation transformed the whole scene, I wanted the painting to capture the drama I felt in the fleeting few seconds the light lasted. I have never seen an effect like it before. The photograph I took simply could not portray the full impact of the moment.

my design strategy

The initial structural design for the painting was made in the camera viewfinder, and then followed fairly faithfully in the final painting. However, I chose to exaggerate the contrasts. For instance, I added yellow highlights in the grass, sunlit slope and rock outlines to intensify the sense of drama, and complemented these with strokes of deep purple used throughout for unity.

my working process

- To expedite the underpainting quickly, I put in the whole of the land mass in black to establish the darkness of the shadows.
- In the sky, I worked from the dark tones first and added successive layers of lighter clouds. I then fixed the pastels with spray before continuing.
- For the mountains and foreground, I started from the outside edges first to ensure that the depth of the shadows on both sides was equivalent, and again progressively worked to the lighter color. The picture literally joined up at the sunlit patch in the middle.
- After spray-fixing the painting once again, I added delicate highlights on the rocks, "planted" the dark trees where the silhouette showed best, and put the final contrasting textures in the grass.

my advice to you

- Work with a limited number of pastel sticks, no more than a dozen, and blend freely. This enables you to concentrate on the mood, atmosphere and image you want to express.
- Use the colors you chose everywhere in the picture to create a sense of unity.
- Work from a black-and-white photograph and rely on your memory, enhanced by your imagination, to create a uniquely personal color scheme.

what I used

White pastel paper
About 10 sticks of very soft pastels

Rob Evison

ARTIST
87

Rob Evison lives in England → www.robevison.com

I made an exciting discovery when I used my computer to zoom-in on my reference photo.

Jumpin' Off, St Joe, oil, 22 x 28" (56 x 71cm)

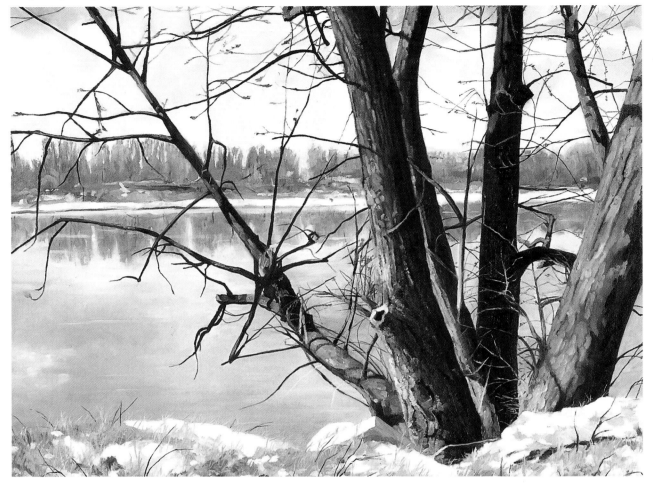

Kevin Brunner

ARTIST
88

what I wanted to say

My hometown of St Joseph, Missouri, was once the "jumping off" point for settlers heading west in the 1800s and especially during the Gold Rush days of the late 1840s. One warm January morning, as I looked west across the river, I thought about the courage those pioneers must have had to head out for places and situations unknown. I can relate to this, since I once spent almost a year in California attending acting school, and my restless, adventurous spirit often entertains the possibility of returning. This painting represents the personal courage and leap of faith involved in making such a decision.

about light and color

The dominant element in this design is the tree. I placed the trunks to the right so the left branch stretches diagonally across the canvas, guiding viewers to the river so they can visually leap to the other side. I was lucky that the harsh lighting on this particular morning brought out the color of the tree trunk, which was a rich brown. Calm waters also allowed the river to reflect the sky color, creating a beautiful harmony of browns, orange and its complementary blue.

an "aha" moment

Back in my studio, I loaded the digital photos I had taken onto my computer and called them up in Photoshop, a software program. I decided to experiment with the program more than I usually do, so used the "zoom" tool to focus in tightly on the picture. Because the computer dissolved the image into tiny chunks of color called "pixels", I could suddenly see that portions of the trunk were a celebration of colors — not only browns, but blues, reds, oranges and greens. I immediately decided to incorporate my findings into the painting.

As I painted the image, I mixed these other colors into my browns (Burnt Sienna or Burnt Umber). In some cases, I applied them onto my canvas in their pure form. The sparks of color throughout the painting added so much to its richness and, to my surprise, its realism. It was an "aha" moment for me. I No longer look at objects as one color.

what I used

support
Canvas

brushes
Mostly small flat brushes, with some filbert and round brushes

medium
Odorless turpentine

oil colors
Burnt Umber
Burnt Sienna
Ivory Black
Cobalt Blue Hue
Sap Green

Raw Sienna
Cadmium Red Hue
Cadmium Red Light
Cadmium Orange Hue
Titanium White

Kevin Brunner lives in Missouri, USA → www.homepage.mac.com/singingpainter

To give my focal point an authentic glow, that's where I laid in the thickest paint, brightest colors and sharpest edges.

Edge of Field, oil, 24 x 30" (61 x 76cm)

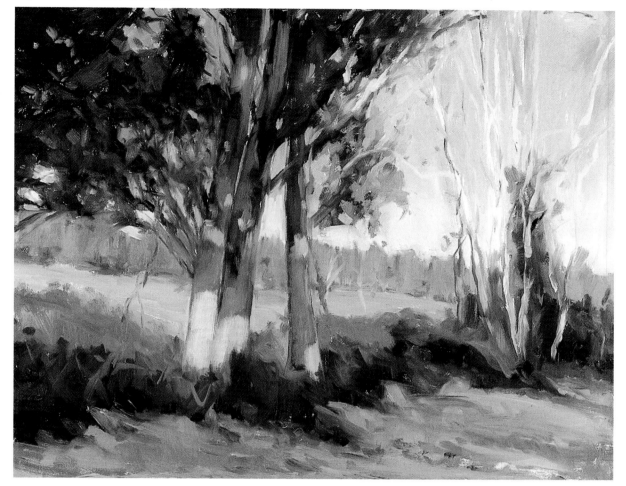

my inspiration

The Tennessee landscape is full of nuances: forgotten fence lines overgrown by trees, vast forests and beautiful streams. As I was driving down the Natchez Trace, I turned down a country dirt road and came across this little jewel. The light was bouncing off the trees, and the field behind was lit up with a cool blanket of light. I thought to myself, "It doesn't get any better than this". The light effect on the trees — almost making them lighter than the sky — caught my eye. They practically glowed.

my design strategy

The first thing I ask myself when I view a subject is, "What do I want to say?" In this situation, I wanted to comment on how the light was bouncing off the trees. Everything else in the painting was used to support this idea. I strategically placed the trees and manipulated color and edge to draw the viewer's eye from the clump of trees to the field in the background, and back to the trees again.

try these tactics yourself

- After exploring the area a bit to get a better understanding of the subject, I did a field study on location, capturing as much information as possible about the colors, values and subject. I also took several photos to record the specific details.

- Back in the studio, I visualized how I wanted my finished painting to look. In my mind, I put the painting into words poetically. This helped me with the emotional aspect of the piece.

my working process

On the canvas, I sketched in the image, working from the darkest to the brightest colors and the thinnest to the thickest paint. I worked around the entire canvas, never completing one section. This allowed me to orchestrate the painting and constantly relate one area to another — temperature relationships, color relationships, edges and values. This also helped this painting become more spontaneous and painterly. The final touches on the canvas were the most important. This was when I concentrated on my focal point and laid in the thickest paint, brightest colors and sharpest edges.

IMPORTANT HINT!

Keep control of your painting by mastering the art of comparison. Find the brightest color and relate all other colors. Find the sharpest edge and relate all other edges. Find the darkest value and relate all other values.

what I used

support
Canvas

brushes
No. 8 bristle flat

other
Painting medium

oil colors
Titanium White
Cadmium Yellow Light
Cadmium Red Light
Ultramarine Blue
Alizarin Crimson

Roger Dale Brown

ARTIST
89

I captured the mysterious atmosphere of a lonesome Irish landscape with subtle glazes and diffused edges.

Secret of the Lakes, oil 12 x 15½" (31 x 40cm)

my inspiration

Not so long ago, I spent part of September traveling through Ireland, a country I am fond of because of its secluded and peaceful places full of scenic beauty. I took many pictures of special, inspiring places to catch the spirits and atmosphere that radiate there. Of course, I also had my sketchbook with me and made color studies on site. When I arrived at the Lakes of Killarney, I found a magnificent panorama. I followed the road around the deserted countryside until I reached, for me, the most appealing perspective. I was inspired by the peace and vastness of the countryside as well as the mist wrapping the hills in milky, soft, slightly yellow light.

my design strategy

The outlines of the hills and the wavy lines of the water create a zigzag line that draws the eye of the viewer into the depth. The viewer on the hill feels like flying over the country. The mild light gives the feeling of calmness and seclusion.

my working process

- I drew a sketch with charcoal directly on a toned canvas. Then I underpainted the shadows and dark parts with Raw Umber.

- Next, I started with the hills in the background and worked toward the foreground. I laid in the colors from dark to bright with various flat hair brushes.

- After this layer had dried, I painted the sky with a mixture of Titanium White and Naples Yellow. I pulled this wet layer across the hills so that they softly vanished into the fog.

- Finally, I put in the fine details in the foreground with small watercolor brushes and oil colors fattened up with linseed oil.

the main challenge in painting this picture

Representing a certain mood — the aspects of silence, loneliness and mystery — without seeming shallow was a challenge. Thus, I had to be careful in the selection of my colors. I also had to suggest diffuse light with soft, vague edges in order to contribute to this special atmosphere.

HOT TIP!

For various reasons, you will often have to paint from photos, not from life. Just remember to trace your thoughts back to the feelings you experienced at that time until you rediscover the subject's spirit on the canvas.

what I used

support
Canvas

brushes
Flat hair brushes in Nos. 4 and 5; bristle brush No. 6; watercolor brushes Nos. 0 and 1

medium
Linseed oil

oil colors
Titanium White
Naples Yellow Hue
Yellow Ochre
Indian Red
Raw Umber
Permanent Green

Jolanda Richter

Jolanda Richter lives in Austria → www.jolanda.at

Warm light coupled with cool shadows helped me suggest the intensity of the sun.

Carmel Valley Spring, oil, 12 x 16" (31 x 41cm)

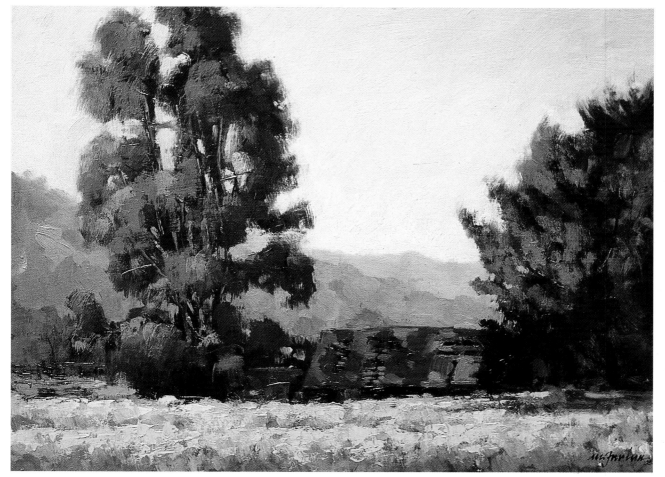

my inspiration

I was inspired by the bright yellow mustard blossoms set against the dark shapes (trees and barn) of the middle ground.

my design strategy

I decided to divide the picture plane into four unequal, horizontal bands of value and color, with the sky being the lightest and largest. The background hills create a necessary diagonal to relieve the eye, and the trees and barn also provide some contrast in the form of dark shapes and vertical elements. Finally, the color-saturated foreground, which is the simplest shape, acts as the focal area.

my working process

- I worked on a smooth wood panel toned with a thin wash of Terra Rosa. I started by blocking in the darkest shapes — the trees and barn — with a thin, dark purple mixture. By contrast, I then mixed my lightest value — the sky. As I applied it, I refined the shapes of the trees. The hills were put in next with a grayed-down mixture to suggest distance. To create a foundation for the foreground, I scumbled in a dull green on the remaining bottom portion.

- By this time, the dark wash for the trees and barn had set up so I mixed a dark green for the trees. As I applied this, I started to work the outer contours of the trees so they were soft. I mixed a lighter, warmer shade of yellow-green for the light side of the trees.

- I applied the same warm light/cool shadow concept to the barn.

- With a palette knife, I applied the intense yellow mustard in the foreground. I carried additional touches of warm yellow light to the sunlit foliage of the trees, sky and hills, always keeping the edges of distant shapes soft.

my advice to you

I feel there is no substitute for painting on the spot to capture the spirit of a place and the light of the scene. Although I may be after a fleeting light effect, I think it is imperative to experience a place for a certain length of time in order to observe and absorb the surroundings. Even better is to experience a location at various times of the day or evening. This is why smaller studies done on location are so helpful in creating larger studio pieces.

what I used

support
Birch plywood, gessoed and then single-coated with oil ground

brushes
Various sizes and types; palette knife

medium
Walnut alkyd medium

oil colors
Titanium White
Cadmium Yellow Light
Raw Sienna
Cadmium Red Light
Quinacridone Crimson
Cobalt Blue
Ultramarine Blue
Burnt Umber
Ivory Black

Mark Farina

ARTIST
91

Mark Farina lives in California, USA → mfarinaartstudio@hotmail.com

I used the classic techniques to bring depth to my grand, sweeping landscape.

Sierra Vista, oil, 20 x 30" (51 x 76cm)

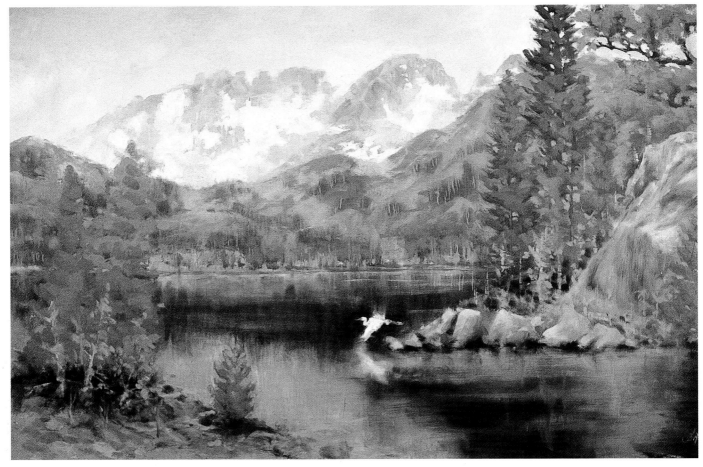

my inspiration

I love to watch large birds glide over the surface of water. They exhibit a certain grace that is spiritual and ethereal. Place this in a setting of pristine grandeur, such as a mountain vista, and I have the makings of an interesting, challenging painting that provides a relaxed atmosphere for the observer.

my design strategy

I like to establish a clear sense of depth through the classic means of aerial perspective: warmer and brighter colors, harder edges and greater value contrast in the foreground; cooler and grayer colors, softer edges and less value contrast as I go deeper into the background. Whenever possible, I also like to provide an entry pathway to escort the viewer into the primary focus area. In my painting, a dark shadow in

the lower right corner leads the eye to the flying bird.

my working process

- After working out a suitable composition and value pattern in a few, quick thumbnail sketches, I drew my design freehand onto the canvas with graphite pencil. I sprayed the drawing with fixative, and then washed a transparent, mid-value earth tone over the whole thing. With a rag, I rubbed out the lighter areas. Seeing the pattern of mid-darks and lights immediately gave me a good feel for what the piece would look like.

- Squinting at my reference materials, I started with thinner layers of color. I tried to minimize my brush strokes by putting down the correct color notes and leaving them alone. I checked to make sure my values were

accurately creating depth in the painting.

- As I progressed, I laid down thicker brush strokes in the lighter areas, especially in the focal area around the bird. I was always thinking about values and edges, as this would make or break the painting.

my advice to you

Painting the same object, such as a pine tree or mountain, from life

repeatedly helps you develop a technique that you can use every time you render that object. It may seem that painting can then become formulaic, but I think it actually allows for more creativity. The better you master formulas for familiar objects, the easier it becomes to manipulate the environment of your painting and the more success you will have in involving your memories and imagination in your compositions.

what I used

support
Canvas

brushes
Bristle and/or synthetic brushes in a wide range of sizes and styles

other tools
Painting medium
Walnut oil
Retouch varnish

oil colors
Titanium White
Cadmium Yellow
Lemon Yellow
Yellow Ochre
Cadmium Red
Alizarin Crimson
Cerulean Blue
Ultramarine Blue
Burnt Sienna

Julio Pro lives in California, USA → www.juliopro.com

The raw, elemental beauty of the Southwest inspired me to paint quickly on site.

Catalina State Park, oil, 12 x 9" (31 x 23cm)

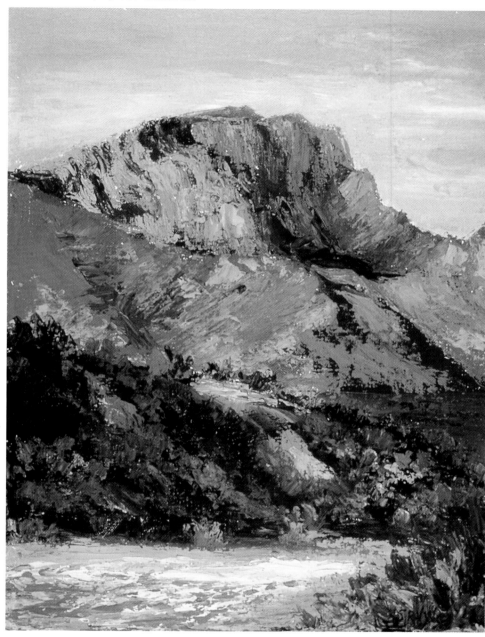

how I discovered outdoor painting

After hiking in the mountains of Southern Arizona for many years and painting in my studio on still lifes and portraits, the dramatic light of the landscape kept beckoning me to paint outdoors. I became a member of the Tucson Plein Air Painters Society, which gave me the opportunity to meet and paint outdoors with other artists. I've been hooked ever since. In my opinion, painting outdoors is the best way to learn to truly see values and color temperature. Nature is the best teacher.

my inspiration

There is a painting at every turn on the more than 100 trails in the Catalina Mountains near Tucson, Arizona. Living in their foothills, I am always finding inspiration. For this painting, I hiked into Catalina State Park. I could not resist the morning light on this scene, and I tried to capture the raw, elemental beauty of the Southwest.

my design strategy

As I stood in this desert wash and looked through my view catcher, the picture before my eyes was already composed. My plan was to paint an uneven distribution of dark and light and give a feeling of balance and weight.

my working process

- After setting up my pochade box on my tripod and attaching my umbrella to shade both my canvas and palette, I set out my paints. Next, I drew the composition directly on my canvas with thinned Ultramarine Blue.

- Work quickly before the light changed too much, I used a bristle brush to get my darks, mid-tones and lights laid in.

- After this, I used my palette knife to mix the paint colors needed. I compared each color-value with the scene to match nature's palette, then laid in my strokes, working the whole surface.

something to consider

Simple ideas are what good paintings are all about. Complexity comes from your choice of values, color changes, arrangement, drawing, surface variety, edges and so on.

what I used

support
Linen canvas glued to board, primed with three coats of acrylic gesso

brushes
Bristle brushes Nos. 4, 6 and 8; palette knife with pointed edge, size 6

medium
Painting medium

oil colors

NAPLES YELLOW · CADMIUM YELLOW LIGHT · CADMIUM ORANGE · PERMANENT RED MEDIUM

ALIZARIN PERMANENT · TRANSPARENT OXIDE RED · SAP GREEN · VIRIDIAN GREEN

COBALT BLUE · ULTRAMARINE BLUE · TITANIUM WHITE

Sandra Vanderwall

ARTIST 93

Sandra Vanderwall lives in Arizona, USA → SRBVW@aol.com

This snow scene was enlivened with all the basic colors on my palette.

Crisp Winter Day, oil, 18 x 24" (46 x 61cm)

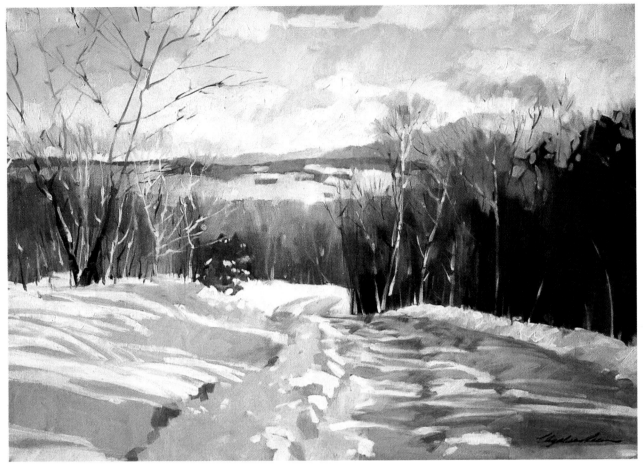

Elizabeth Allen

my inspiration

I was inspired by the beautiful turquoise sky against the browns and whites of the season. I wanted to convey the feeling of a bright, crisp, winter day in Vermont.

my design strategy

The ready-made composition was ideal as the road led the eye through the painting to the mountain patchwork and up to the sky. I dramatized the focal point by the burst of sunlight at the end of the road and by throwing the foreground section of the road into shadow. The triangle shapes created by the row of trees and the road also helped lead the eye up through the painting. Although the existing color scheme of the winter subject was somewhat subdued, I knew I would need to include all of the basic colors in my palette — warm and cool versions of all the primaries — in order to give the scene some life.

waiting for my moment

Though I had a pretty good slide to work from for this scene, it didn't have nearly the amount of light and shadow, plus it didn't include the snow. Since it is just up the hill from my house, I was able to wait and revisit the scene after a fresh snowfall, sketching the effects of afternoon shadows on a snowy road.

my working process

- On a finely grained portrait linen toned in Burnt Sienna mixed with odorless thinner, I used pure Burnt Sienna to lay in my sketch.
- When that had dried, I worked all over the canvas, starting with the shadows and working up to the brightest lights.
- I drew the tree branches in at the end, working wet-on-wet.

my advice to you

- An accurate representation of a scene is not enough to inspire the viewer. You must choose a theme to bring your subject to life — color, light, movement, temperature, atmosphere, anything to give the viewer a sense of momentarily being in the scene.
- It is more important for your brushstrokes to be juicy and confident than precise.
- Warm and cool colors should be present in every painting, but not in equal proportions. One should dominate the other. An all-cool or all-warm painting is not only tiresome to look at, it is not possible in nature.

what I used

support
Belgian, double-primed portrait linen

brushes
Bright bristle brushes; very small sables

mediums
Linseed oil
Odorless thinner

oil colors
Lemon Yellow
Cadmium Yellow Light
Cadmium Orange
Cadmium Red
Alizarin Crimson
Ultramarine Blue
Phthalo Blue
Yellow Ochre
Burnt Sienna
Titanium White

A solid foundation of abstract shapes holds my painting together.

Trees North of Taos, pastel, 7 x 10" (18 x 26cm)

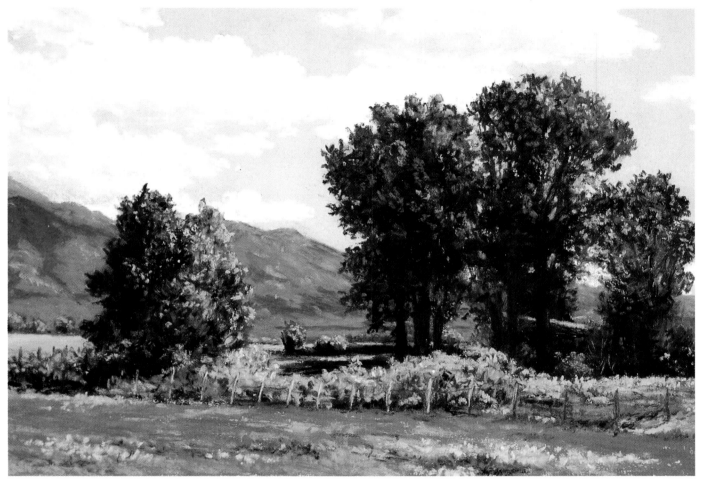

my inspiration

This is a scene just north of Taos, New Mexico. I was impressed with the analogous colors of blue and green, as well as the underlying abstract composition.

my design strategy

The components of trees and fields in this landscape are arranged in horizontals and verticals. While the predominant color scheme is analogous blue and green, there are subtle complementary colors in the mountains and golden fields. I liked the contrast of the dark shadows of the trees against the blues of the mountain and sky.

follow my eye-path

I lead the viewer's eye across to the trees with the fence and up into the sky and back across through the clouds. The clouds on the left lead the eye downward to the tree located on the left. The viewer's eye is able to circle around the painting instead of staying with the contrast of the dark trees against the sky.

my working process

- After sifting through numerous photographs of this location, I chose this scene that I had already composed through the camera's viewfinder.
- I started directly on white sanded paper with a very cursory sketch in light blue pastel pencil. I blocked in my colors with pastels, then scrubbed in my colors with a cellulose packing peanut to create an underpainting of

abstract shapes. I used a deep purple to get a rich, dark value under the trees.

- When this was complete, I began with the light values of the sky and clouds, working there until it was mostly complete. This helped to prevent the dark colors to come from migrating into this light area.
- I then began layering on the pastels in the rest of the painting, going back and forth between the darks and lights to develop the forms in a more realistic fashion.

what I used

White sanded paper
A wide range of pastels

try these tactics yourself

When working from photographs, don't become a slave to the photo:

- Consider cropping the composition, combining photos, moving elements and heightening the values and colors to improve your design.
- Understand that dark shadow areas go black in a photo, and learn to compensate for that with more interesting darks, such as deep purples, blues and greens. This will give the painting more vibrancy and richness.

Lee H McVey

ARTIST
95

Lee H McVey lives in New York, USA → www.leemcvey.com

Working with picture planes guarantess drama.

No Power, No Phone, watercolor, 19 x 25½" (49 x 65cm)

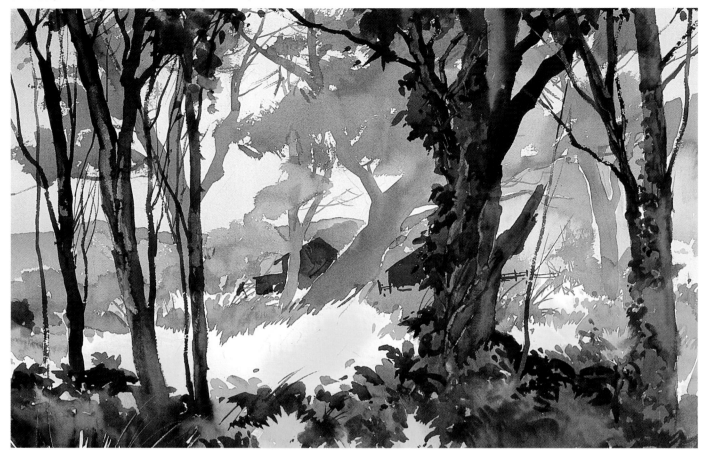

my inspiration

This painting was inspired by a gold mining town in the heart of California's Sierra foothills. I take delight in scenes such as this, in which nature reveals performances of light interacting with atmosphere to create dramatic moods. My recollection of the subject gave me an opportunity to demonstrate a simple painting design and strategy for my students.

about light and color

In any painting, a simple plan in which value and color contrasts are assigned to the three planes — foreground, middle ground and background — will always provide maximum drama. As such, I assigned light values of warm, bright orange to the middle ground plain; complementary, cool, mid-value gray-blues to the background; and warm, dark values for the foreground. Repeating the warm oranges throughout unified the entire painting. I used nothing but various combinations of three, transparent primaries for guaranteed color harmony.

my design strategy

The dark foreground trees frame the lightest area in the background, creating a focal area where a tree has grown out at an angle, providing even more visual impact. Notice that I spaced the trees unequally and varied their widths and foliage for added interest.

my working process

- I started with warm oranges, applying them in a wet-into-wet wash in the background and in greater strengths to the entire middle ground and the low foliage in the foreground.

- Once that layer was dry, I used a cool, darker mid-value blue-gray to glaze in the silhouettes of the background trees. I added a small amount of orange to the cool glaze before putting in the mountain and the background tree foliage. While still damp, I applied a lighter blue-gray glaze over the sky, lightening some treetops with a tissue before it all dried.

- I then mixed up dark browns and oranges for the foreground trees and foliage. As I put them in, I created plenty of variety in their values, colors and brush strokes, in some places using the end of a wash brush to scrape out damp pigment. Through negative painting, I preserved some bright oranges at the bottom.

- It took me an entire year to determine how to strengthen the focal area. Finally, I added the neutral dark silhouette of the farmer, the farmhouse and the barn.

what I used

watercolors

I use three basic colors to mix every color I need:

Phthalo Red
Phthalo Blue
Permanent Yellow Deep

Juan Peña

Juan Peña lives in California, USA → www.paintingsbyjuanpena.com

I chose to make a personal interpretation rather than a faithful copy of the scene.

At Sunset, oil, 16 x 20" (41 x 51cm)

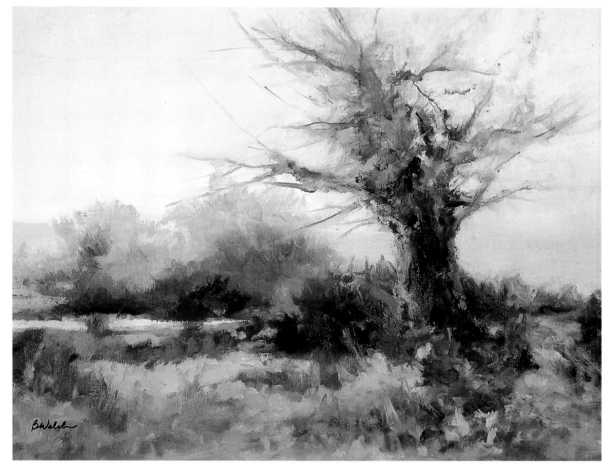

my inspiration

Seeing the last, evanescent rays of sun among the distant willows was a visual poem for me. Nature gave me the motive; my challenge was to represent it on canvas. I was helped by a slight haze in the background that enveloped the scene with subtle light.

my design strategy

The main item of interest in the scene is the old, decaying sycamore tree. Since it is large and essentially vertical in nature, no other vertical elements that would compete with it were incorporated in the painting. Rather, both the foreground and the background feature horizontals, which serve to complement the tree. Finally, the old tree was placed near the center of the composition, rather than closer to the edge, to guide the viewer's eye into the landscape.

my working process

- First, I used a thin charcoal reed to sketch in the basic shapes of my composition, keeping everything very simple.
- The dying sunlight led me directly to putting in the sunset colors in the sky and the warmer accents across the foreground.
- To ease the transition between the sky and darker foliage at the horizon, I included a cool, mid-value distant mountain range that did not exist in reality. I then scumbled in the distant willows with thinned paint, merging lines and producing soft gradations to create an atmospheric effect that pushed this entire area into the distance.
- I laid in the foreground quite loosely so that it would not detract from the main object of interest, the old tree in the middle ground. This I painted with bolder, more emphatic brush strokes.
- Since last-minute embellishments can easily make a painting look overworked, I stopped when felt I had achieved maximum quality and satisfaction.

something to consider

Standing before nature, there are always two choices: depicting reality faithfully or creating a more personal interpretation. Go for the second choice. It is undoubtedly the better route to ensuring individuality.

HOT TIP!

For a vivid foreground, try using an old bristle brush previously mutilated with a pocket knife. It will produce uneven, loose brush strokes and enhance texture.

what I used

support
Stretched canvas

brushes
Extra-full filbert bristles in Nos. 4, 6 and 10; a synthetic small liner

medium
Linseed oil and odorless turpentine

oil colors
Titanium White
Cadmium Yellow Medium
Yellow Ochre
Cadmium Green Pale
Olive Green
Transparent Red Oxide
Alizarin Crimson
Burnt Umber
Ultramarine Blue
Paynes Gray

Beatriz Welch lives in Texas, USA

Beatriz Welch

ARTIST
97

This vase scene demanded careful recession and color.

Olive Lake, oil, 24 x 24" (61 x 61cm)

my inspiration

On my way to a paint-out in the Rocky Mountains, I passed a particular mountain lake near Radium. Stop the van! There's a painting in there. The radiant, clear green water and the way the yellow weeds were meeting the logs at the bottom of the lake caught my eye. It was spring, and there was still some snow under the trees. Always looking for something that makes a painting, I knew this moment was rare and seized the opportunity to take many photos.

my design strategy

In this painting, I used size variation from the foreground, middle ground and background. Notice how the foreground dominates. To create a sense of depth, I also reduced the values and cooled off the temperatures as objects recede into the distance. I tried to create a circular eye path to hold the viewer's attention inside the painting.

my working process

- By doing a few thumbnail sketches and a small painting, I worked out my value pattern and determined that a square format was best.

- I started by covering the canvas with a thin coat of painting medium. I then proceeded to draw in the major shapes with a thin wash of a mixed red and a No. 4 flat hog hair brush.

- Using transparent color, I put in the fairly dark areas first, leaving room for the darkest accents. Then, working from dark to light, I built up all areas of the painting, concentrating on value exchanges and edges.

- I finished with opaque lighter values as well as dark accents.

my advice to you

- There is no destination, so enjoy the journey. Struggles don't go away because there is always more to learn.

- Don't underestimate technical knowledge and rules. As D.B. Swinton said, "True freedom comes by understanding rules".

- Make time to paint outside and understand color and value relationships in nature because photos are not accurate, especially in their values. Cameras make darks too dark and lights too light.

what I used

support
Canvas

other
Painting medium

brushes
Hog hair flats Nos. 2 to 18; hog hair rounds Nos. 2 to 5; two sizes of palette knives

oil colors

TITANIUM WHITE · CADMIUM YELLOW · CADMIUM ORANGE · YELLOW OCHRE · CERULEAN BLUE · TRANSPARENT RED OXIDE · VIRIDIAN · SAP GREEN · ALIZARIN CRIMSON · ULTRAMARINE BLUE

Jerry Markham

I loved the color contrast of the red barn against the green trees.

my inspiration

I have known this Northern California barn all my life, and I love its nestled-in look. The complementary colors of the red barn and green surroundings is also quite compelling and inspiring.

my design strategy

An imaginary "tic-tac-toe" grid has proven very successful in my composition planning. In this case, I situated the barn on the grid lines' intersection in the lower left quadrant of the paper, roughly one-third up from the bottom and one-third in from the left side. I loved the contrast of the red barn against the green trees. I was also taken in by the big shapes of the clouds, the hillock, the trees and the road all leading the eye toward the barn. But first I had to omit the high voltage power lines obliterating the foreground!

my working process

• Because my subject was predominantly green, I chose a complementary terra cotta sanded paper for my surface to make the painting come alive and sing. Using my photographs as a guide, I sketched in the main shapes with vine charcoal and used a chamois to soften and correct.

• Satisfied with the layout, I started the sky in the upper left corner, moving across the paper in short, diagonal strokes. I worked in touches of violets and pink with my blues, getting lighter in value as I approached the horizon. The white cloud shapes included several shades of gray, violet, blue and ochre, still applied in diagonal strokes. Then I used my fingers to massage them all together.

• Next, I painted the distant hills and middle ground trees. I used cooler greens in the distance and slightly warmer greens in the trees to suggest depth, and added in bits of other colors besides green for more variety, interest and unity.

• After blocking in the barn, I added details with pastel pencils and sticks sharpened on sandpaper or with a craft knife. I wanted this area to be the sharpest in focus since it is the center of interest.

• When I got to the foreground, I kept the blending to a minimum in order to preserve the wonderful intensity of the pastel pigments. For this same reason, I did not spray with fixative.

HOT TIP

A towel on the floor below your easel helps prevent dropped pastels from shattering.

The Red Barn, pastel, 27½ x 17½" (70 x 45cm)

Suzi Marquess Long

ARTIST
99

what I used

support
Sanded paper

other materials
Hard and soft pastels
Vine charcoal
Chamois
Stumps
Small hard-bristle brushes
Old toothbrush

Suzi Marquess Long lives in Oregon, USA → www.whimsywalls.com

To suggest a penned-in feeling I cropped in tight.

Under the Walnut Trees, watercolor, 5 x 12" (13 x 31cm)

my inspiration

It was a winter's day. The whole landscape was dull and gray, and this bright red tractor appeared unseemly, out of place and nearly theatrical. Jammed under this walnut tree, imprisoned behind solid fences, visibly in a state of neglect, it no longer evoked strength or power. It seemed overcome totally by snow and nature. This is just the kind of common, yet universal, image I enjoy painting.

my design strategy

The composition evolved autonomously, instinctively. The tractor dominates half of the space, surrounded by more or less powerful verticals and horizontals. The oblique lines (the diagonal and tractor's fork) emphasize the remains of life existing in this big, wounded animal. To support the penned-in feeling of my subject, I chose to crop tightly into a very small format.

my working process

- After making a very precise drawing on my paper, I preserved all of the white areas with liquid masking fluid.
- Next, I laid out my extremely limited palette, which I find quite easy to work with. Having so few colors ensures harmony while still allowing for invigorating nuances. Plus, there's no hesitation when dipping paintbrush into color!
- I then built up all parts of the image, except for the tractor, by layering a great many washes. The first were very diluted while the later layers became increasingly intense until I obtained sufficient contrasts.
- I then put in the tractor with brighter colors.
- Finally, I removed the mask and adjusted the white areas.

why I chose this medium

I particularly like painting winter and gray days in watercolor. Because of its subtlety and lightness, this medium is the closest thing to snow, which is why I'm able to use it to capture snow's ephemeral and fragile appearance. Through its transparency, we can sense the most tenuous nuances of colors we can hardly discern. But I never add white paint or pencil. I prefer to preserve the pure paper, which is brighter.

what I used

support
Watercolor paper

brushes
A selection of smaller, soft brushes

other
Masking fluid

watercolors

NEUTRAL TINT
TRANSPARENT RED OXIDE
PERMANENT MADDER LAKE BROWN
TRANSPARENT YELLOW OXIDE

Annie Chemin

Terms you should know

abstracting Taking from reality, usually simplifying, to suggest a general idea. Not necessarily related to real forms or objects.

acid free For greater permanance, use an acid free paper with a pH content of less than 7.

acrylic Viewed historically, this is a fairly recent member of the color family. Waterbased, so it can be diluted to create thin washes, or mixed with various mediums to make the paint thicker or textured.

aerial perspective Dust, water droplets and impurities in the atmosphere gray off color in the distance. These impurities block light, filter reds and allow blues to dominate, so that in the distance we see objects as less distinct and bluer. This is an important point for landscape painters to grasp. Objects in the foreground will be sharp, more in focus and will have more color.

bleeding Applies mainly to watercolor where the pigment tends to crawl along the surface outside the area in which it was intended. Can be a good or a bad thing, depending on your intention.

blending Merging colors so that they intermix, with no sharp edges. Applies to pastel, where you blend colors by rubbing them with fingers or paper stumps, and to oil, where you would use a broad soft brush to blend colors.

body color Mainly gouache or opaque paint, as opposed to transparent paint. Can be used to create richness of color or to cover up errors. Chinese White (a zinc opaque watercolor) is often used to restore or create highlights. Many watercolor purists insist that a watercolor painting should only be created using transparent pigments, but countless leading artists use opaque paint in moderation. That is the key — use the minimum opaque color on transparent watercolor paintings.

brushes
Wash A wide, flat brush used for applying washes over large areas, or varnishing.
Bright A flat paintbrush with short filaments, often called a short flat.
Filbert Similar to a flat brush, with rounded edges.
Round A pointed brush used in all mediums.

Spotter A brush with a tiny, pointed head which is used for fine details.
Liner/Rigger A brush with a long brush head used for fine detailing.
Fan A crescent-shaped brush head for blending and texturing.

brush sizes The size of flat brushes is expressed in inches and fractions of an inch measured across the width of the ferrule. For instance, No. 12 = 1 inch (25mm) and No. 6 = ½ inch (12.5mm).
 The size of a round brush is the diameter in millimetres of the brush head where it emerges from the ferrule. For instance No. 5 measures 5mm (¼ inch) in diameter.
 Be aware that sometimes brush sizes may vary slightly between brands, even though they may both be labelled say, No. 10 round. Instead of choosing numbers, choose a quality brush in the size you prefer.

canvas Mainly for oil painting. Canvas can be bought in rolls, prestretched or already stretched with support strips or mounted on a still backing.
Canvas is fabric which comes in cotton, linen and synthetic blends.
 Linen is considered better than cotton because of its strength and appealing textured surface. Newer synthetics do not rot and do not sag. You can buy canvas raw, (with no coating), or primed, (coated with gesso), which is flexible with obvious canvas texture. You can also buy canvas that has been coated twice — double primed canvas — which is stiffer and has less texture.
Canvas board is canvas glued to a rigid backing such as cardboard, hardboard or wood. Note that cardboard is not suitable for serious work because cardboard is not acid free, and will not last.
 Wood and hardboard must be prepared properly.

cast shadow A cast shadow is one thrown onto a surface by an object blocking the light. It is important to remember that the edges of a cast shadow are not sharp.

center of interest (focal point) This is the area in your painting that you want to emphasize. It is the main point. You can create a center of interest with color, light, tone, shape, contrast, edges, texture, or any of the major design elements. Any center of interest must by supported and balanced by other objects. Avoid placing your center of interest smack in the center of your painting! Make it your mission to learn something about the elements of design.

chiaroscuro This is an Italian word meaning light and dark. In art is means using a range of light and dark shading to give the illusion of form.

collage A work that has other materials glued on, including rice paper, paper, card, cloth, wire, shells, leaves.

color temperature This term refers to the warmness or coolness of a paint. Warm colors are those in the red, orange, yellow, brown group. Cool colors are those in the blue and green group. However, there are warm yellows and there are yellows with a cooler feel to them.

composition and design Composition refers to the whole work, while design refers to the arrangement of the elements.

counterchange This happens when you place contrasting elements — dark against light.

drybrush Mainly for watercolor. If you use stiff paint with very little water you can drag this across the paper and produce interesting textured effects.

frisket Frisket fluid (masking fluid) can be painted over an area to protect it from subsequent washes. When dry the frisket can be rubbed off. You can also use paper frisket that you cut to fit the area to be covered.

gesso A textured, porous, absorbent acrylic paint that is used mainly as a preparatory ground for other mediums such as oil or acrylic.

glaze A thin, transparent layer of darker paint applied over the top of a lighter wash. This richens, darkens, balances, covers up or adds luminosity.

high key/low key The overall lightness (high key) or darkness (low key) of a painting.

impasto Applying paint thickly for effect.

lifting Removing pigment with a brush, sponge or tissue.

Collect all these titles in the Series

100 ways to paint
STILL LIFE & FLORALS
VOLUME 1

ISBN: 1-929834-39-X
Published February 04
AVAILABLE NOW!

100 ways to paint
PEOPLE & FIGURES
VOLUME 1

ISBN: 1-929834-40-3
Published April 04
AVAILABLE NOW!

100 ways to paint
LANDSCAPES
VOLUME 1

ISBN: 1-929834-41-1
Published: June 04

100 ways to paint
FLOWERS & GARDENS
VOLUME 1

ISBN: 1-929834-44-6
Publication date: August 04

100 ways to paint
SEASCAPES, RIVERS & LAKES
VOLUME 1

ISBN: 1-929834-45-4
Publication date: October 04

100 ways to paint
FAVORITE SUBJECTS
VOLUME 1

ISBN: 1-929834-46-2
Publication date: December 04

How to order these books

Available through major art stores and leading bookstores.

Distributed to the trade and art markets in North America by

F&W Publications, Inc.,
4700 East Galbraith Road
Cincinnati, Ohio, 45236
(800) 289-0963

Or visit: www.artinthemaking.com